the knot
OUTDOOR WEDDINGS

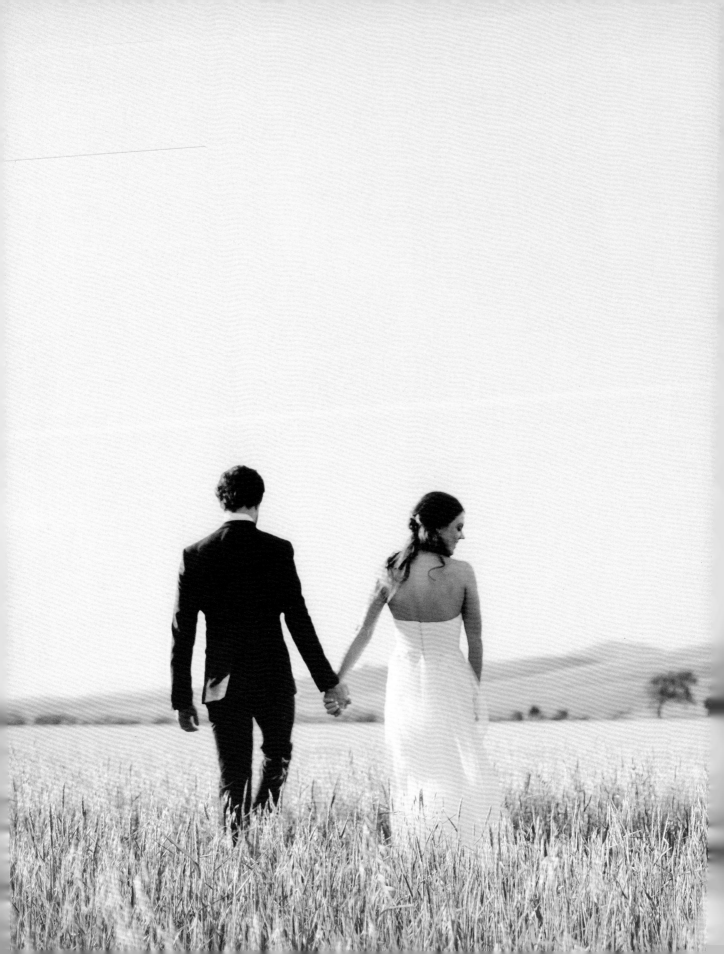

the knot
OUTDOOR
WEDDINGS

FRESH IDEAS FOR EVENTS IN GARDENS, VINEYARDS, BEACHES, MOUNTAINS, AND MORE

by Carley Roney
and the editors of TheKnot.com

Potter Style

New York

Published in the United States by Potter Style,
an imprint of the Crown Publishing Group, a
division of Penguin Random House LLC,
New York.
www.crownpublishing.com
www.potterstyle.com

POTTER STYLE and colophon are registered
trademarks of Penguin Random House LLC.

Library of Congress Cataloging-in-Publication
Data
Roney, Carley.

The Knot Outdoor Weddings: Fresh Ideas for
Events in Gardens, Vineyards, Beaches,
Mountains, and More / Carley Roney and the
editors of TheKnot.com.—1st ed.
 p. cm.
Includes index.
1. Estate. 2. Waterside.
3. Garden. 4. Ranch.
5. Cityscape. 6. Vineyard
I. Knot (Firm) II. Title.
TT149.R65 2010
745.594'1—dc22 2009051949

ISBN 978-0-8041-8603-2
Ebook ISBN 978-0-8041-8604-9

Printed in China

Design by Renata De Oliveira
Front cover: Jen Huang Photography;
bouquet by Poppies & Posies
Back cover: Yvette Roman Photography;
event design by Mindy Weiss Consultants;
flowers by Mark's Garden

See pages 282–286 for additional
photography and vendor credits.

10 9 8 7 6 5 4 3 2 1

First Edition

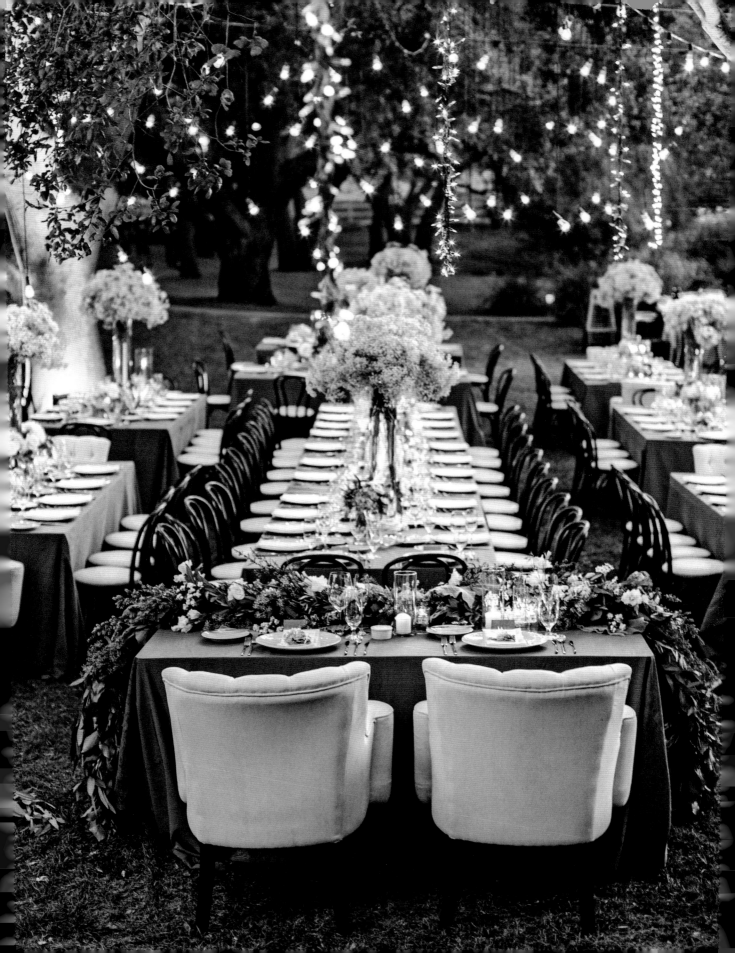

CONTENTS

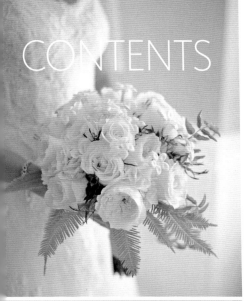

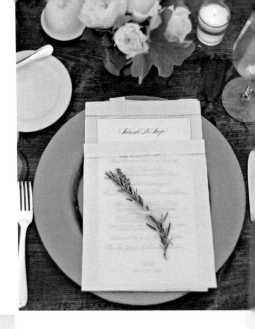

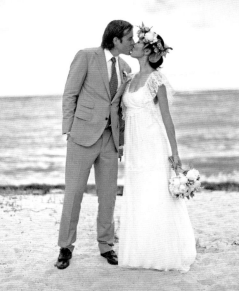
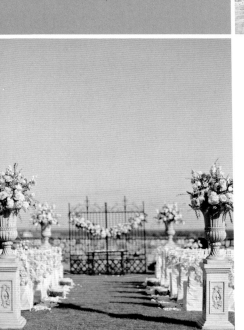

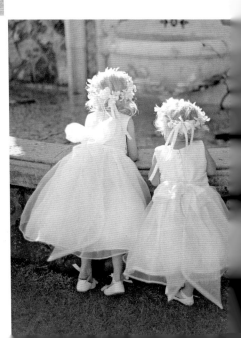

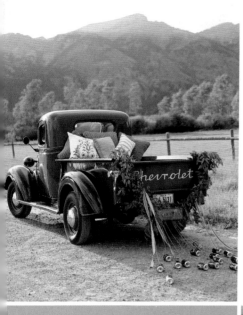

RANCH

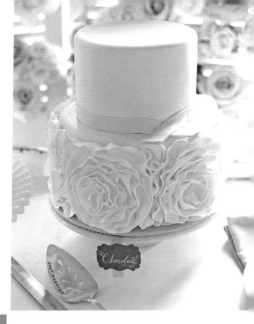

CITYSCAPE

VINEYARD

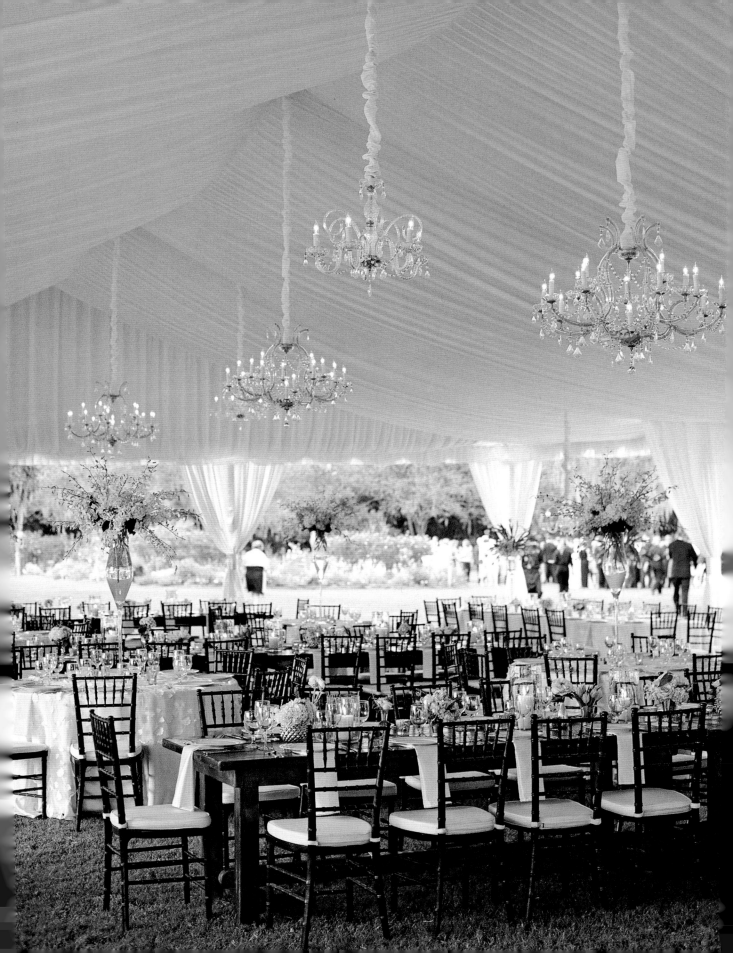

INTRODUCTION

FEW PLACES IN THE WORLD ARE MORE INSPIRING for a wedding than nature itself. There is something about a background of gardens, grass and sky, or sea and the feeling of a vast, wide-open future that makes the occasion feel even more special. Not to mention that so much beautiful décor is already built into the landscape. Most couples don't initially plan to have an outdoor wedding per se, but they know they want to get married in a vineyard or they have their hearts set on a wedding by the water. From there, the search for the perfect location begins, and an outdoor wedding is born.

START EARLY

Just because you're not booking a ballroom doesn't mean you can postpone reserving an outdoor venue. The same timeline applies—you should book your space 10 to 12 months in advance. Researching and reserving your site not only takes time, but many outdoor locations require permits, which can take a few months to receive. You'll also have to think more about logistics in advance. For instance, some public beaches ask you for specific details about the equipment you will need to bring in, as well the menu you'll be serving. Additionally, each town might have its own regulations about tents, noise ordinances, alcohol, and open containers. You will also need to determine whether you have to file for a permit to park cars along the street. To find out about all these nuances, contact the parks department in your area. Leaving no stone unturned when it comes to the logistics will ensure that your wedding day runs smoothly and is as worry-free as possible.

SET THE STAGE

The advantage (and challenge) of an outdoor wedding is that you're not confined to a particular room or area and you can create your own parameters. Options for décor are as vast as the imagination. You are creating a space that didn't exist before, which means you get to choose seating, tables, linens, furniture, lighting, and flowers. The best place to start is with the location itself; consider the surroundings and build on them. There are no hard-and-fast rules when it comes to the color palette and theme.

For a rustic setting on a ranch or mountainside, faint hues, such as matte bronze, tea rose, and ivory, pop against natural wood accents, while deep colors, such as orange, red, purple, and brown, lend a rugged feel. You might have reclaimed-wood tables with formal white linens and birch-bark vases filled with earthy arrangements or more elegant décor elements, such as crystal chandeliers and antique silver, to create a beautiful juxtaposition of masculine and feminine.

In a vineyard, shades of pale yellow and plum are a fitting option. Or, for a more opulent feel, go for gold, mauve, and green. Consider topiaries or mixed flowers in terra-cotta pots for the centerpieces. Escort cards inserted into wine corks are a clever way to lead guests to tables named after bottles of wine.

If your wedding is in a garden or backyard, take a cue from the colors, flowers, trees, or topiaries. Lush shades of cream create a romantic feel, while green and brown give off an earthier vibe. If you love a vintage look, you may opt for different china patterns at each place setting, varying vessels filled with garden roses, and antique table lamps. A more formal look

could include all-white flower arrangements in crystal vessels with sparkling chandeliers overhead.

Nautical colors are a traditional option for a celebration by the water. Soft hues of white and pale blue pick up the beauty of the water and sky. Using playful touches, such as a lifesaver or anchor, amid the décor helps further the theme. If a beach is your destination, you might opt for flowers in large conch shells or colorful beach pails to decorate tables. You might even create a walkway made of seashells or string colorful fish lights or paper lanterns above the reception tables.

These are just some options; the sky is the limit when it comes to décor and theme. By paging through this book, you'll find inspiration and thousands of ideas, plus practical information specific to outdoor weddings.

DESIGN THE SPACE

Creating a reception space from scratch means you'll need to bring everything in. Your caterer or florist might provide linens and china. And if you're having a tent, many tent rental companies also include chairs, tables, and lighting. Extras, such as lighting fixtures and lounge furniture, will give the setting even more personality, but these are elements you (or your wedding planner) will need to order from outside professionals.

You will also want to think about the shape and size of your reception tables ahead of time. Remember: Round tables take up a different kind of space than rectangular tables, so keep the total amount of square footage you need in mind. A good rule to go by is to have at least 10 square feet per guest. Factor in space for the band, bar, and dance floor as well. Have the professionals help you figure out the number, size, and shape of tables. It is better to err on the side of caution, so if you are unsure, you can always go up one tent size. You might also consider dividing your tent into two parts, with dinner on one side and dancing or cocktails on the other. Talk to the venue's event coordinator or your wedding planner to determine the best layout possible.

HAVE A PLAN B

Anything other than your clear vision for your wedding might seem hard to imagine, but unfortunately, Mother Nature may have other ideas. And though you will undoubtedly have everything planned to a T, weather is the one thing about your day you just cannot control.

Having a backup plan is the best way to ensure your day goes off without a hitch. Figure out an alternate site for the ceremony and reception just in case. For example, if you are planning a beachfront celebration at a hotel, it may be a good idea to put down a deposit on an indoor room for safety. Just include the alternate address and a number to call within the invitations, so guests can easily find out if the ceremony has moved.

Another option to consider is a tent. While an open-air celebration may seem romantic, the reality is you will need some type of covering, especially if the weather refuses to cooperate. This is where tents come into play. Depending on the location and level of formality, a tent can be as casual or dressy as you would like it to be. If you are worried about closing off the reception to the natural surroundings, opt for a clear-top or open-air tent, which can bring the beauty of nature indoors.

Work with your wedding planner or your venue's event coordinator to determine the type of tent that will complement your theme and hold up best on your surface, be it grass, sand, or pavement. Popular options include pole tents and frame tents. Pole tents have high peaks and roofs and are fitting for formal celebrations. There are also new types of pole tents constructed from sailcloth with support poles made of wood; the natural feel is ideal for a slightly preppy, rustic-inspired look. Frame tents are more flexible in where they can be erected. For example, they can be placed adjacent to buildings, on hard surfaces, and in areas where the deep staking of a pole tent will not work. The tent company will also scope out whether they will need to put down a foundation to even out the ground before creating the tent flooring. With so

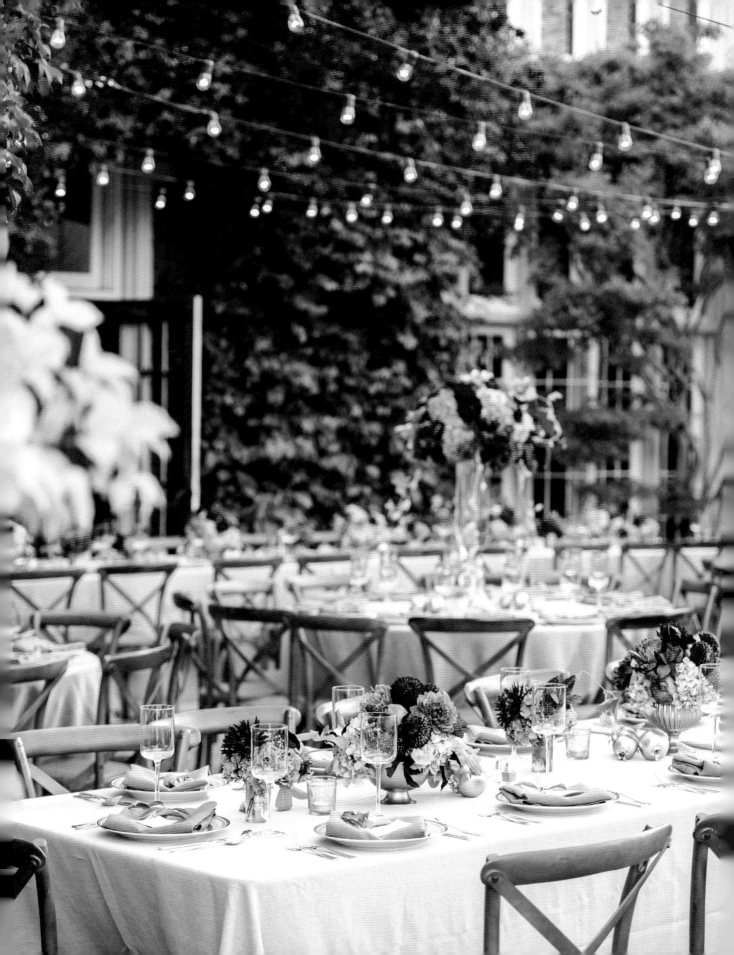

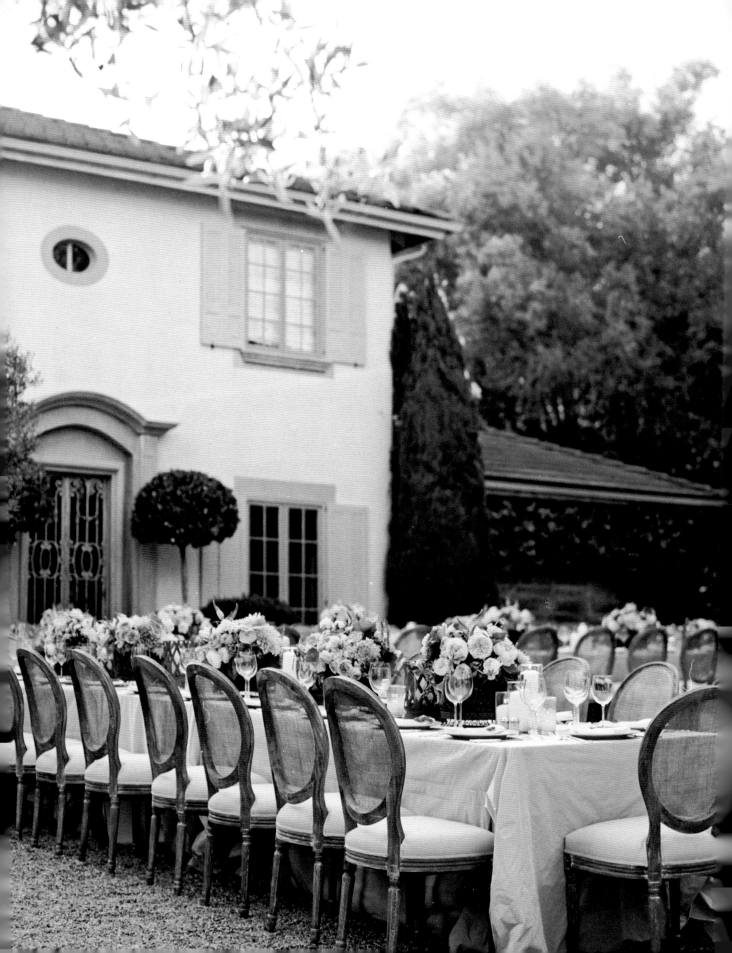

many logistics to think about, hiring accomplished professionals can set your mind at ease and help you flawlessly execute your vision. Most tent rental companies will allow you to cancel up to two days before the wedding.

Remember: Rain is not the only foil. Extreme heat can be just as much of a problem for an outdoor affair. Place ceremony chairs out of direct sunlight and provide refreshments and paper fans, or consider saying your vows at sunset. You and your guests will appreciate the setting more if it is as comfortable as possible.

CATER TO THE CROWD

Your wedding is one of the only times in life when all of your friends and loved ones will gather together, so you will want to make everything as easy as possible for them. The first necessity is to make sure they can get there. Take any guesswork out of finding their way to the ceremony and reception, especially if you have chosen a secluded area. Have signs that point the way to each part of the day, so the areas are easily identifiable. If you know it will be hot, leave a basket at the front of your ceremony site filled with warm-weather essentials, such as suntan lotion, bug spray, sunglasses, and paper fans. You might even ask an usher to pass out icy hand towels or place decorative tubs filled with chilled bottles of water around the area to keep guests cool and comfortable. Greeting your guests with a nonalcoholic signature cocktail is another way to guarantee that everyone stays happy and well hydrated.

If your ceremony is on the sand, leave flip-flops out so guests can easily traverse the beach to their seats (it is hard to walk in sand, especially in heels). Also, consider setting up chairs nearby on pavement for guests who have difficulty walking on a sandy or rocky surface—just be sure there are speakers close by so they will be able to hear everything. And do not forget your wedding professionals: If the setting is uncomfortable for guests, it will be even more uncomfortable for your hardworking staff. Provide them with plenty of cold beverages and heat relief in the way of extra fans and portable air conditioners to keep them safe and their morale high.

Timing is another big factor when it comes to the weather: Try not to schedule your wedding to begin in the middle of the day, especially in the summertime or if the location is tropical. With the sun at its strongest, guests will become tired very quickly, which means they might not be in the mood to party. Midday sun can also be harsh for photos. The best time to have the ceremony is late afternoon or early evening. It is your wedding ultimately, but giving the people you love the best experience possible will help ensure a memorable and special day for everyone.

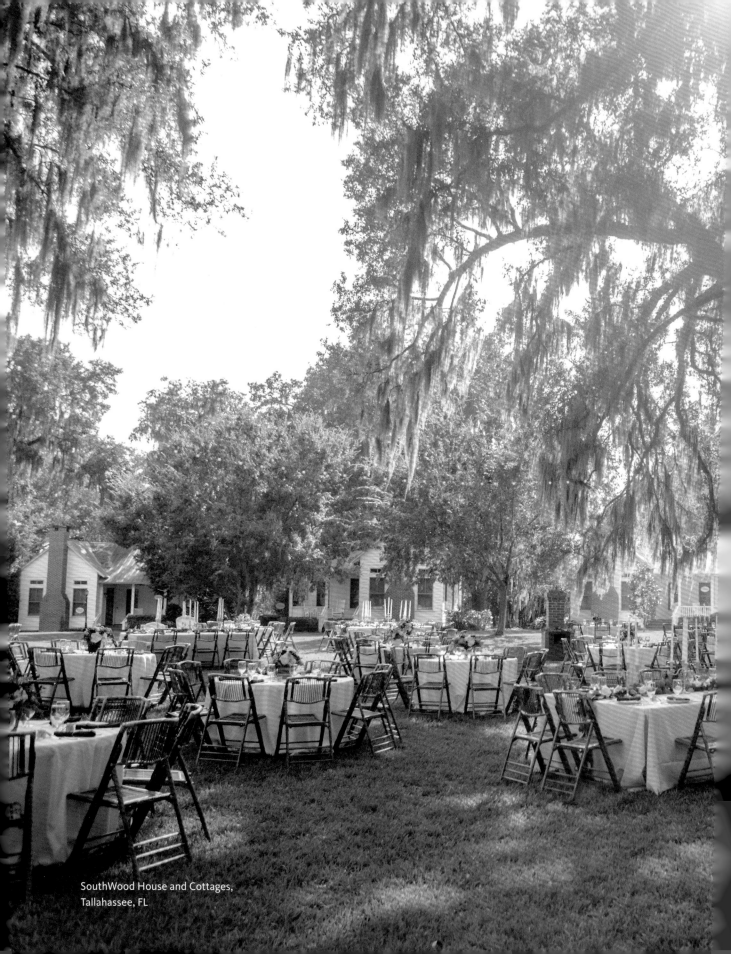

SouthWood House and Cottages,
Tallahassee, FL

1
ESTATE

Sprawling green lawns, towering trees, a gorgeous house nearby . . . these are just a few of the advantages of an estate wedding. Keep in mind that the style of the grounds and the buildings on it will help set the tone and the direction for your overall décor. For example, a Spanish-style house with colorful stone pathways lends itself to a vibrant, laid-back feel, while a traditional colonial with a swath of picture-perfect green grass—think *Father of the Bride*—is perfect for a classic, more formal wedding. But no matter whether the setting you choose belongs to your own home, a friend, a family member, or a historic mansion or club, you can count on your event having that intimate, residential feel.

If you're getting married at a private home, there are some things to consider. First things first—tell the neighbors! The last thing you need is to hear the buzz of a lawn mower as you say your vows. It is also a good idea to ask if you can use their driveways for extra parking, or find out if guests can park at a nearby school or house of worship. Holding your wedding at a manor or club? These spaces typically come event-ready, so there are fewer logistics to figure out.

The style of an estate wedding can be cozy or regal, depending on your vision. If it's more intimate, think about going for a homemade feel with mixed china patterns, paper lanterns, tiny lights strung on trees, and flowers that have a fresh-picked look. Or if you have the space to work with and plan to put up a tent, options are endless when it comes to the ambience and level of formality—let your imagination run free!

KATHRYN & CAL ▪ JUNE 1

tradition
with a twist

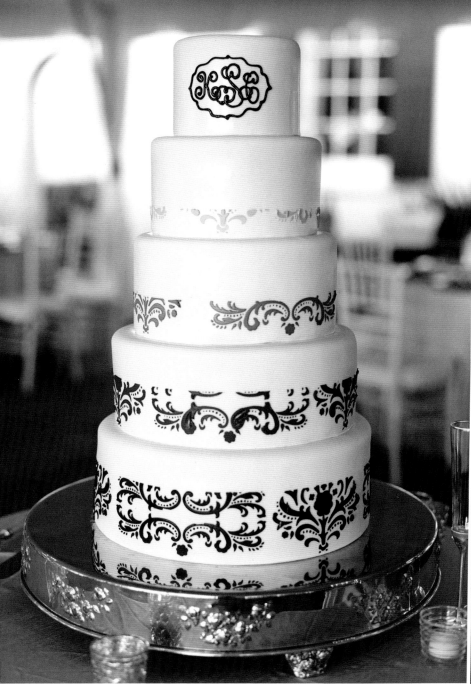

clockwise from opposite:
Monogrammed throw pillows added color and formality to an all-white couch. ▪ The piped damask pattern on Kathryn and Cal's fondant confection had a stunning ombré effect. ▪ Cocktail hour included "His" and "Hers" signature drinks, like a peach Bellini. ▪ Unripened blueberries added a pop of green to the guys' white freesia boutonnieres.

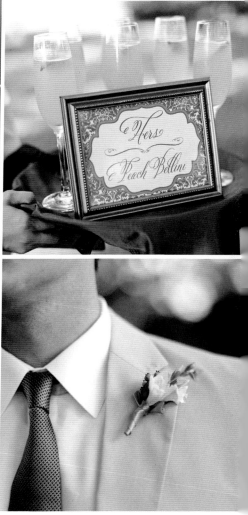

Kathryn and Cal celebrated their nuptials in true Southern style at a plantation in Charleston, South Carolina. The couple chose a navy and white color palette, which they incorporated into their décor with regal damask accents. A relaxing cocktail hour, complete with lawn games, added playfulness to the day.

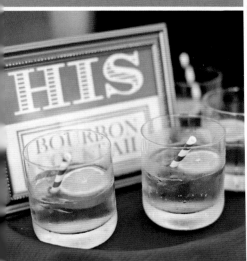

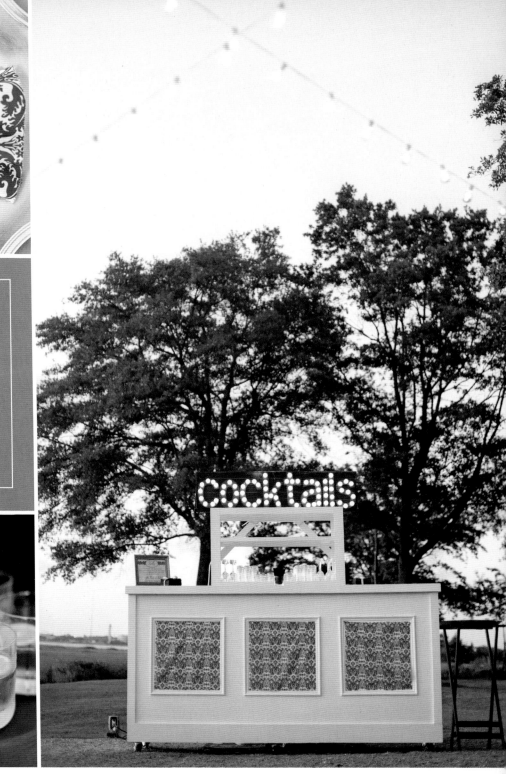

clockwise from top left: Napkins folded into a bow tie shape were classic yet whimsical. ▪ A marquee sign led the way to the bar. ▪ Cal's drink of choice? A bourbon cocktail with fresh slices of lime and navy-and-white-striped straws.

Bunches of greenery
gave a wild look to the
colorful mix of roses
and hydrangeas.

TESS & PETER ▪ JUNE 4

homegrown whimsy

clockwise from opposite:
Arrangements of orchids, lilacs, flowering dogwood, clematis, and sage gave each square table—set for eight—a more intimate dinner-party feel. ▪ Tess and Peter made the most of the property's existing décor. ▪ They mixed and matched vintage furniture for a cozy lounge area. ▪ A sparkler send-off ended the night on a high note. ▪ Tess's bouquet of orchids, passion vine, and parrot tulips was full of color and texture and had an undone look, like she just picked it herself.

TIP

When your backdrop is soft and natural, choose flowers in earthy tones that complement, rather than compete with, your surroundings.

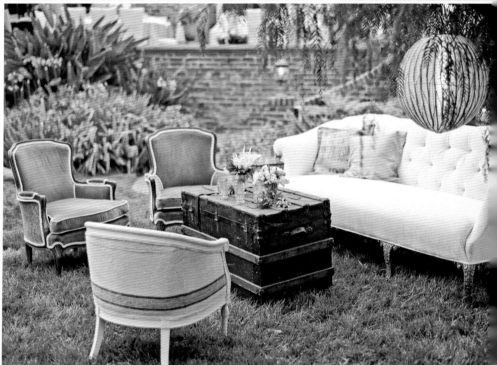

With a warm color palette of burnt orange, green, gold, and ivory, Tess and Peter transformed a luxe Bel Air, California, estate into the cozy wedding venue of their dreams. The result was a unique combination of woodsy, classic, vintage, and—most important to them—unfussy details for a completely laid-back day.

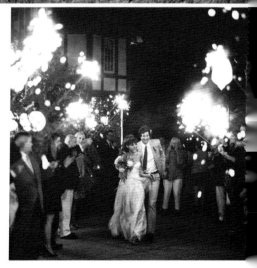

classic club

Sarah and Mark used light, summery colors such as navy, white, pale pink, and green to dress up their country club wedding. By using off-white blooms, monograms, and a sailcloth tent, they created a look that was preppy, carefree, and perfect for their Vermont setting.

Beneath the tent, long
rectangular wood tables and
wood flooring made for a
more natural aesthetic.

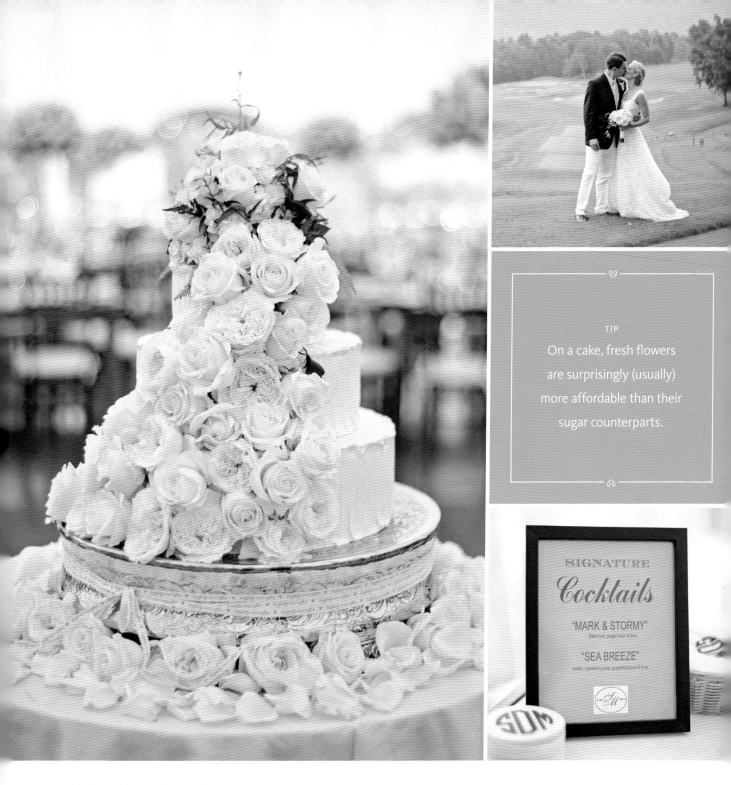

clockwise from above left: A cascade of fresh creamy-white roses gave their buttercream confection serious drama. ■ Mark combined white pants and a navy jacket for a summery look. ■ A mix of typefaces on the cocktail menu created a vintage feel. The couple's signature drink, the "Mark & Stormy," was a deliciously clever play on the popular cocktail.

TIP
On a cake, fresh flowers are surprisingly (usually) more affordable than their sugar counterparts.

SIGNATURE
Cocktails

"MARK & STORMY"
Dark rum, ginger beer & lime

"SEA BREEZE"
Vodka, cranberry juice, grapefruit juice & lime

FLOWERS

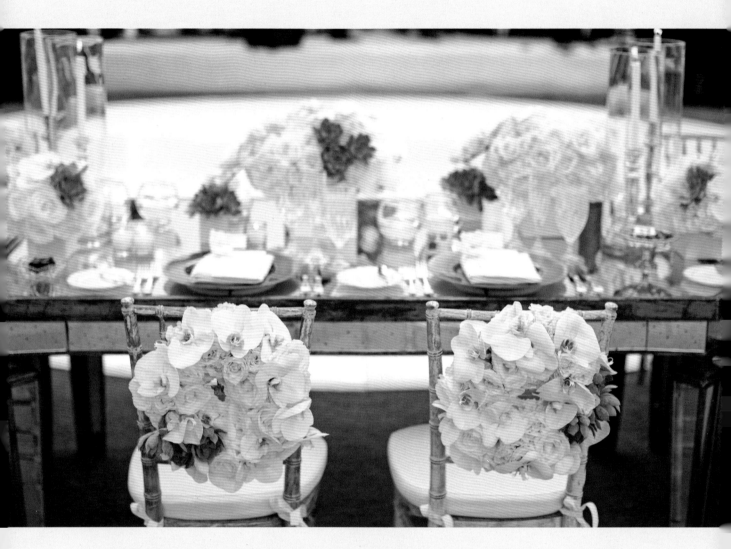

FROM A GATHERING OF FRESH-FROM-THE-GARDEN FLOWERS TO A TIGHT MONOCHROMATIC
BUNCH, YOUR OPTIONS ARE LIMITLESS FOR AN ESTATE WEDDING.

clockwise from above: Whether you stick with a simple color scheme or go with one that's more varied depends on the wedding location. White flowers with succulent accents have a lush feel and look classic in a setting rich in foliage. ■ For a garden ceremony, all-white lily of the valley and orchids make a sweet bouquet combo. Pops of greenery and an unstructured composition give that just-picked vibe. ■ Take your décor to new heights with a floral-embellished chandelier suspended from a tall tree. The contrast of glam lighting with a down-to-earth location is swoon worthy. ■ The sky is the limit in a high-ceilinged tent! Lofty centerpieces of branches, roses, and hydrangeas help draw the eye up. ■ Mixed with leaves, pink and white flowers create pretty arrangements for a ceremony in a backyard garden. Stone planters make a dramatic impression.

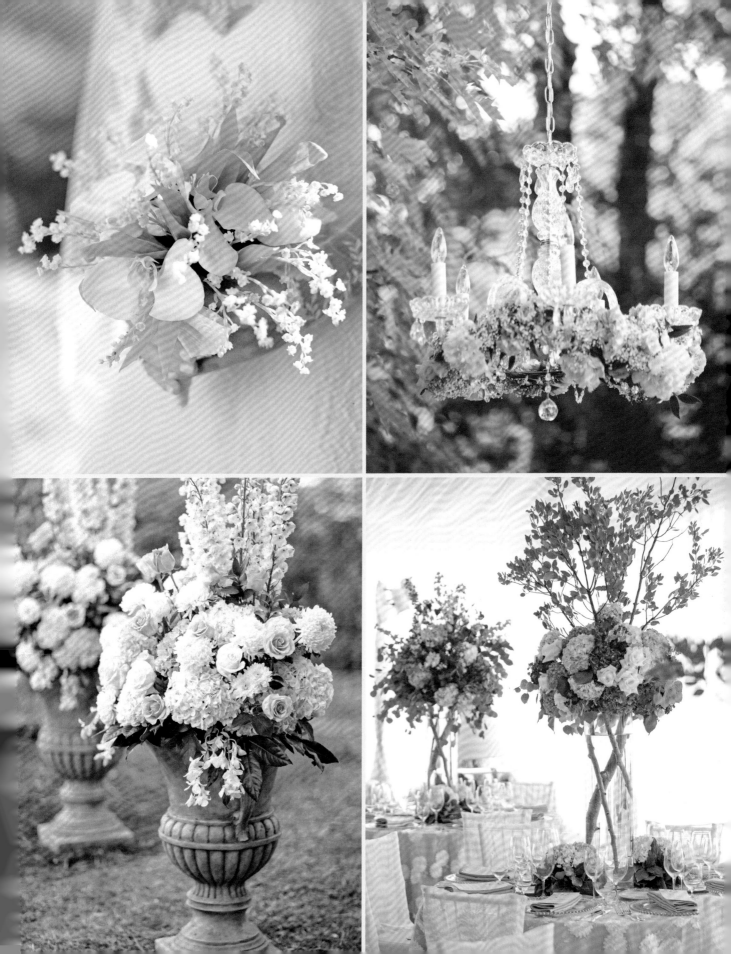

STEPHANIE & JOHN ▪ SEPTEMBER 22

bohemian fiesta

Stephanie and John wanted a hip, soulful celebration with bold hues, textures, and little nods to their careers as runners, like race flags! Bright colors—red, teal, and yellow—created a fiesta vibe (honoring her Mexican heritage) and an atmosphere of playful romance at a countryside estate in Scottsville, Virginia.

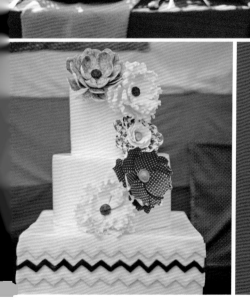

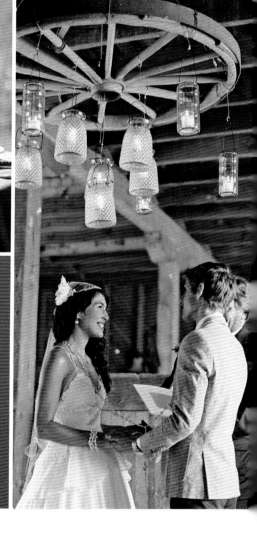

clockwise from opposite: Stephanie had one requirement for her bouquet—that it be so large, she'd have to carry it like a baby! ■ Petite sugar cookies finished with sprinkles in their wedding colors made an appearance at the dessert bar. ■ The couple was married in a barn beneath an old wagon wheel suspended from the ceiling. ■ Sugar blooms mirrored the fabric bunting décor. ■ Flags numbered in Spanish sprouted from the centerpieces as cute table numbers.

The couple spent some of their engagement sewing fabric bunting, which they strung across the roof of their soaring pole tent.

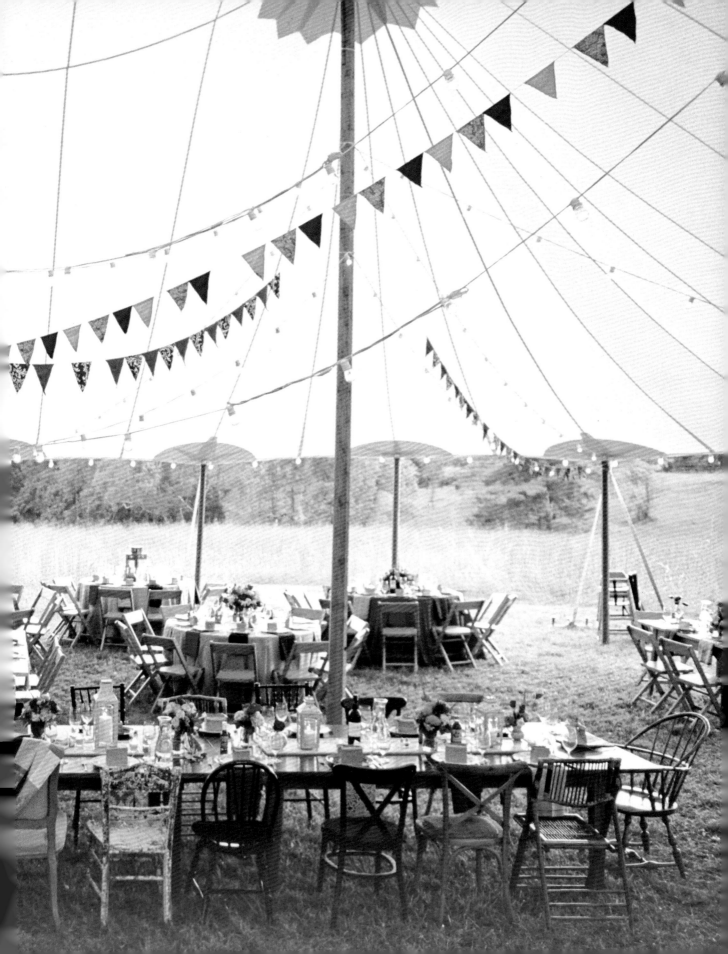

french countryside

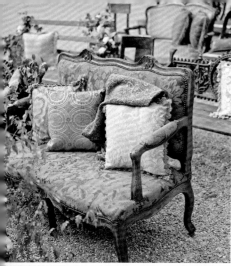

Jessica and Chetan drew their wedding inspiration from the decadent history of their venue, Château d'Esclimont in France. Evoking the nostalgia of the French countryside, they outfitted their event in flea-market finds. Choosing a black-tie-optional dress code and a color scheme of pastels paired with crimson and aubergine accents helped make the formal setting feel natural, relaxed, and not at all stuffy.

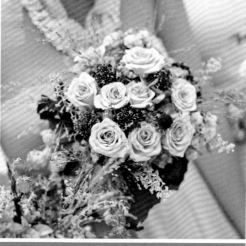

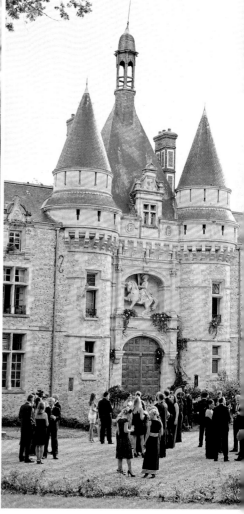

> **TIP**
>
> A destination wedding is the perfect excuse for a vacation. Help your guests make the most of it by loading the weekend with local activities.

clockwise from opposite: A vintage crown cake topper looked fit for royalty. ■ An eclectic mix of vintage furniture gave the ceremony an organic and natural vibe. ■ Bridesmaids carried a mix of roses, sweet peas, lavender, berries, crab apples, and Queen Anne's lace. ■ Guests stayed in the historic château. ■ Tablescapes of overflowing florals and candlesticks created an old-world feel. ■ The invitations were letterpressed on textured paper and sealed with a wax stamp.

JENNIFER & PHILLIP ∙ MAY 26

haute home

clockwise from opposite:
Yellow becomes the focal point of the ceremony thanks to a blanket of petals that formed the aisle. ■ The four-tier ivory cake was decorated with mini flowers made of fondant and a whimsical cake topper. ■ White numbers marked the reception tables. ■ A craspedia and rose boutonniere complemented Phillip's yellow tie.

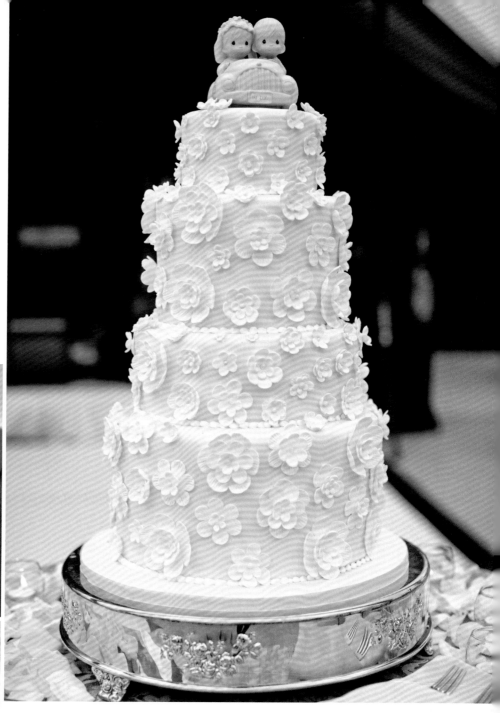

The moment Jennifer and Phillip got engaged, they knew they wanted to have their wedding at his family's vacation home in Michigan. With an elegant-meets-country theme in mind, the high school sweethearts jazzed up the house's rustic décor with vivid yellow blooms, crystal chandeliers, and silver accents.

clockwise from right:
Dressy crystal candlesticks combined with rustic burlap runners and wicker chargers echoed the country-chic vibe. ■ The airy reception tent looked more interesting thanks to brown fabric draping and chandeliers decorated with yellow flowers. ■ A pair of cedar-log rocking chairs was a no-brainer for an adorable couple shot! ■ Guests sipped cocktails from yellow-and-white-striped straws wrapped in flags with cute sayings.

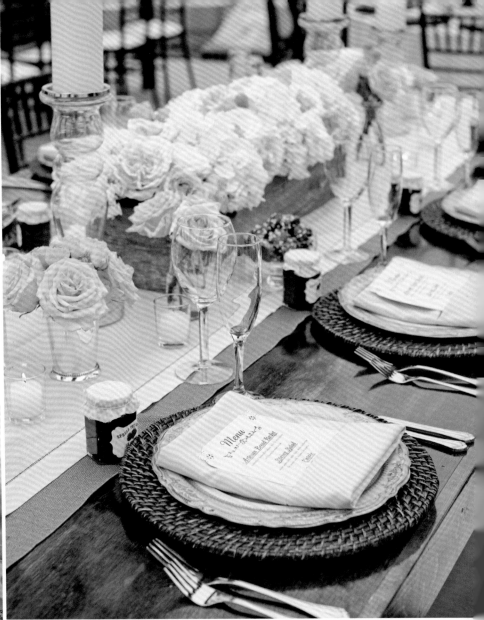

TIP
When your palette has a strong hue, such as yellow, either pair it with a lighter, more subdued shade, such as white, or a bright color used sparingly.

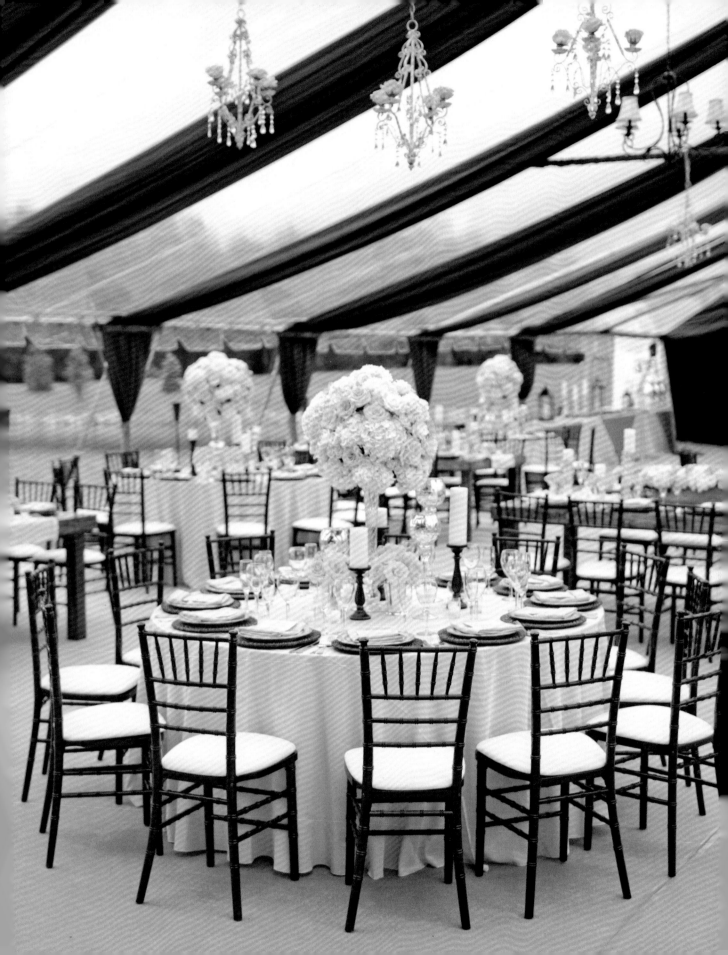

CAKES

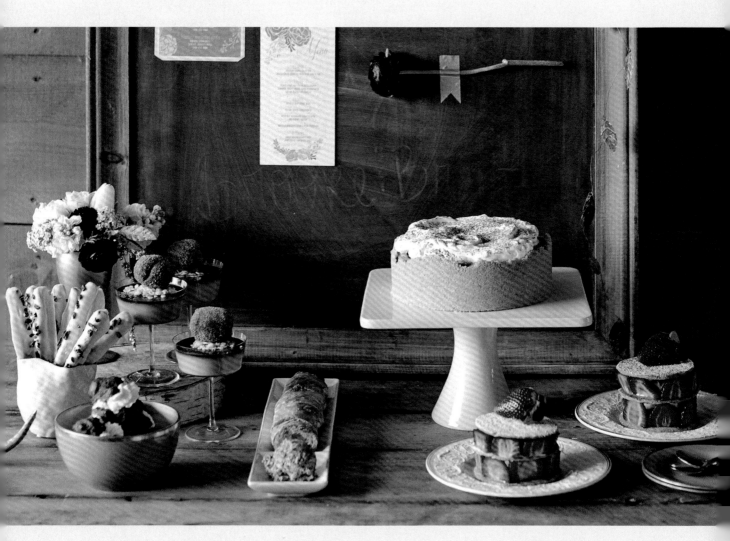

WHETHER YOU PICK A CAKE LIKE GRANDMA USED TO MAKE, SERVE CLASSIC WEDDING FAVORITES, OR GO COMPLETELY OUT OF THE BOX, A RESIDENTIAL AFFAIR IS A CHANCE TO INFUSE A PERSONAL TOUCH.

clockwise from above: Give guests a taste of home with a charming assortment of goodies. The setup can be just as sweet. Here, a rustic table and chalkboard offer a sense of nostalgia. You could even showcase old family recipes, like strawberry shortcake or peach cobbler. ■ Mismatched tiers and visible frosting strokes convey a homemade look, while sugar pearl embellishments spiff up the modest three-tier confection. ■ This five-tier wonder is a feast for the eyes and stomach. Hand-painted gold accents and intricate detailing look simply too good to eat. ■ Share what's important to you and your family by highlighting your heritage. Here, fresh flowers are scattered on a croquembouche, a French cream-puff dessert traditionally served at weddings. ■ An opalescent finish is a subtle, and sophisticated, way to add some bling to your wedding cake.

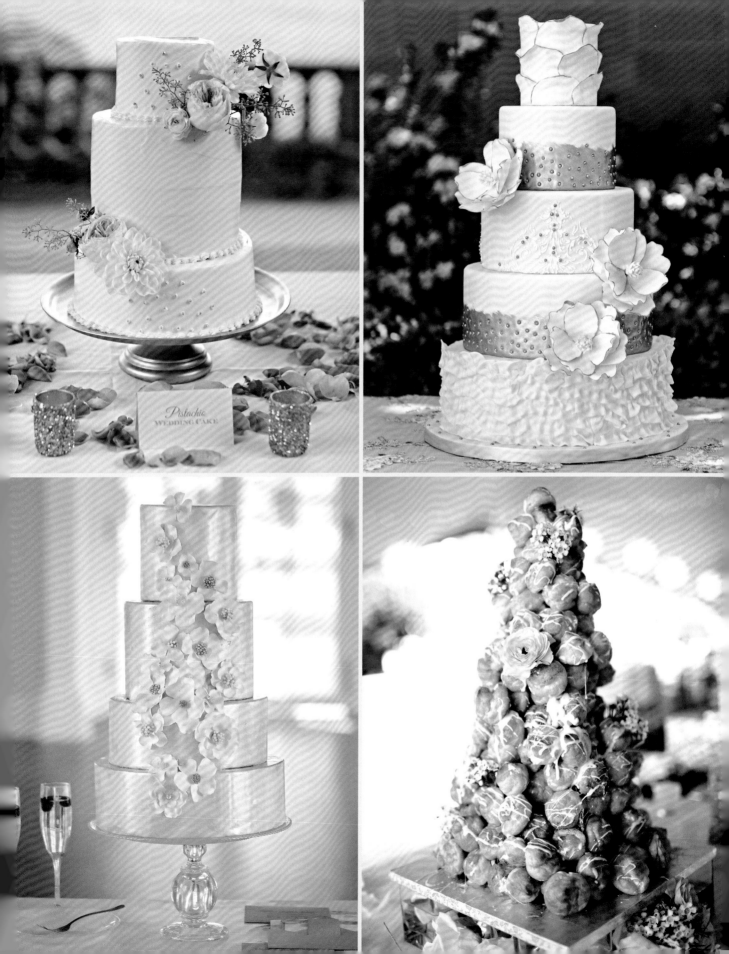

Pistachio
WEDDING CAKE

easy elegance

When one half of a couple is a wedding designer, you can count on a day filled with special details. From a vintage-inspired sign-in table to their dog's adorable French cuffs, photo-worthy vignettes were everywhere at Kim and Lexi's nuptials, held in Kim's parents' Bridgehampton, New York, backyard.

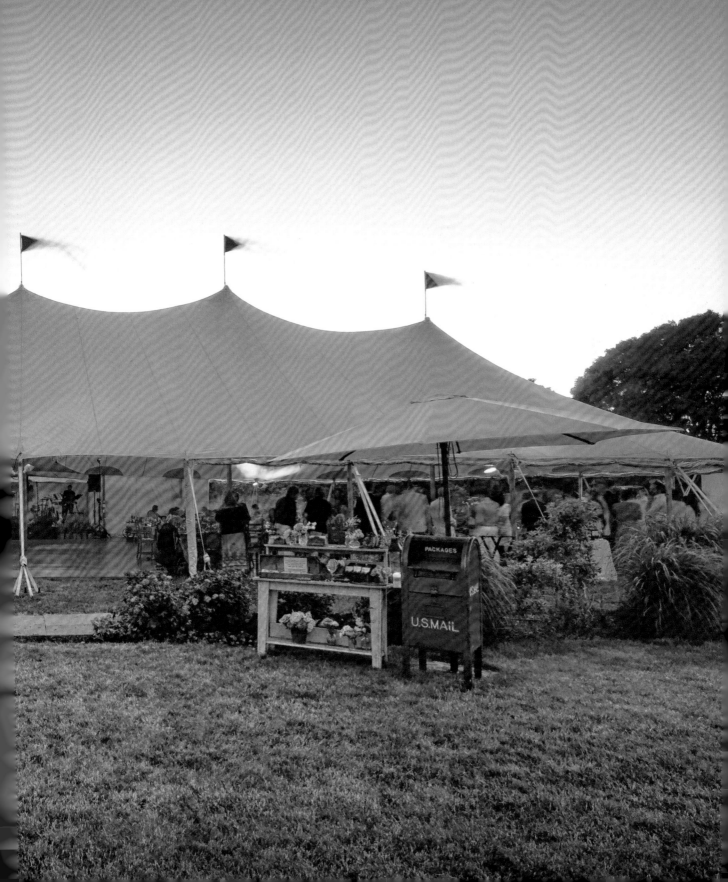

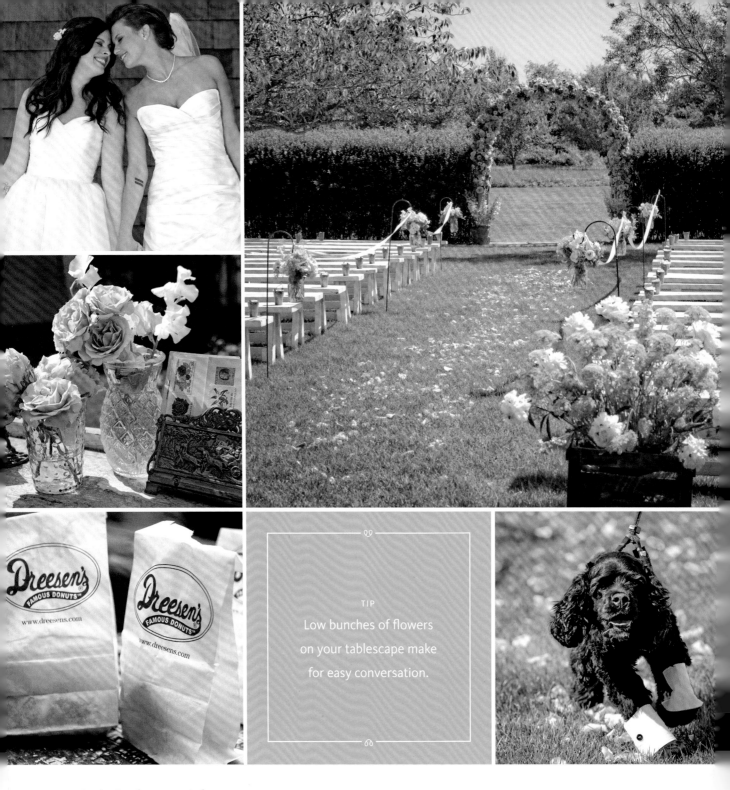

TIP

Low bunches of flowers
on your tablescape make
for easy conversation.

clockwise from top left: Both Lexi (left) and Kim wore strapless white gowns that fit their individual styles. ■ The couple wed under a lush, flower-covered arch. ■ Their dog, Izzy, played the part of ring bearer in dapper French cuffs. ■ Guests ate up the favors—bags of donuts from a favorite local bakery. ■ Simple arrangements of pink roses and white sweet peas accented the sign-in table, which was complete with prestamped postcards and a rented mailbox.

Antique chandeliers and mismatched chairs brought a shabby-chic vibe to the tent.

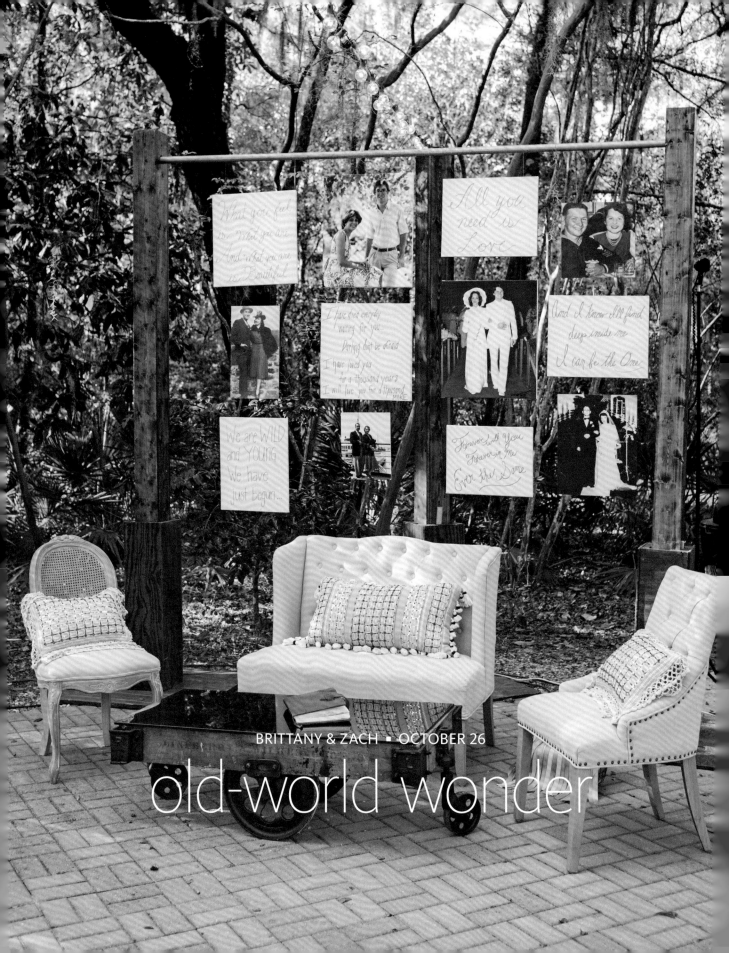

BRITTANY & ZACH • OCTOBER 26

old-world wonder

clockwise from opposite: Photos of the couple's parents and grandparents and lyrics from their favorite love songs were displayed in the lounge area. How romantic! ▪ An antique desk held photos of past generations and was accented by vintage suitcases. ▪ Brittany's bouquet of antique brooches doubled as her "something old." ▪ A relatively small guest list made personalized escort cards possible.

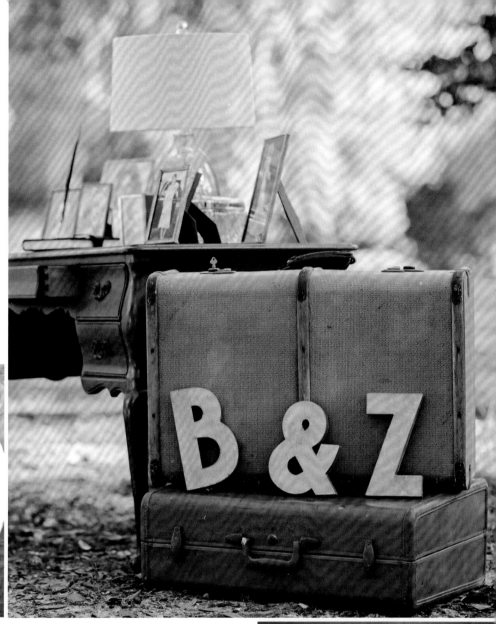

L ove letters—an age-old symbol of romance—inspired nearly every aspect of Brittany and Zach's intimate outdoor wedding at a state park in Santa Rosa Beach, Florida. Vintage touches and keepsakes lent a heartfelt and personal feel to the day, while an earthy color scheme of white and brown hues kept it from looking too feminine.

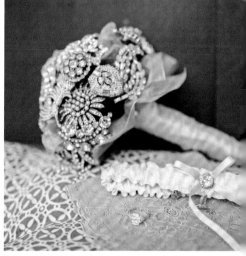

Vintage pews and salvaged
doors created the look of an
outdoor church beneath a
600-year-old oak tree.

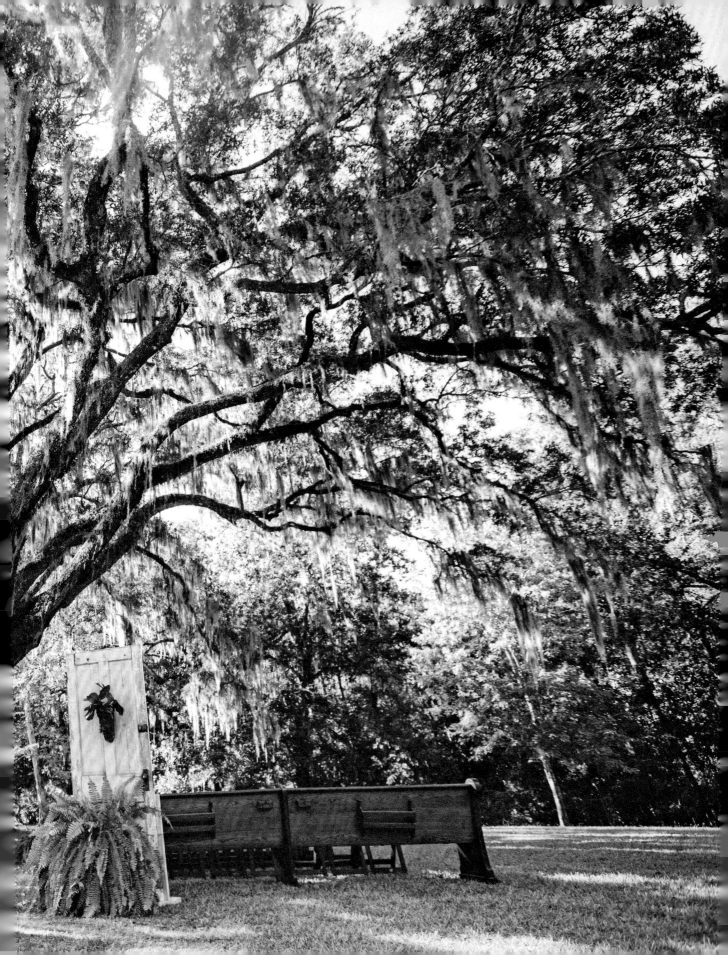

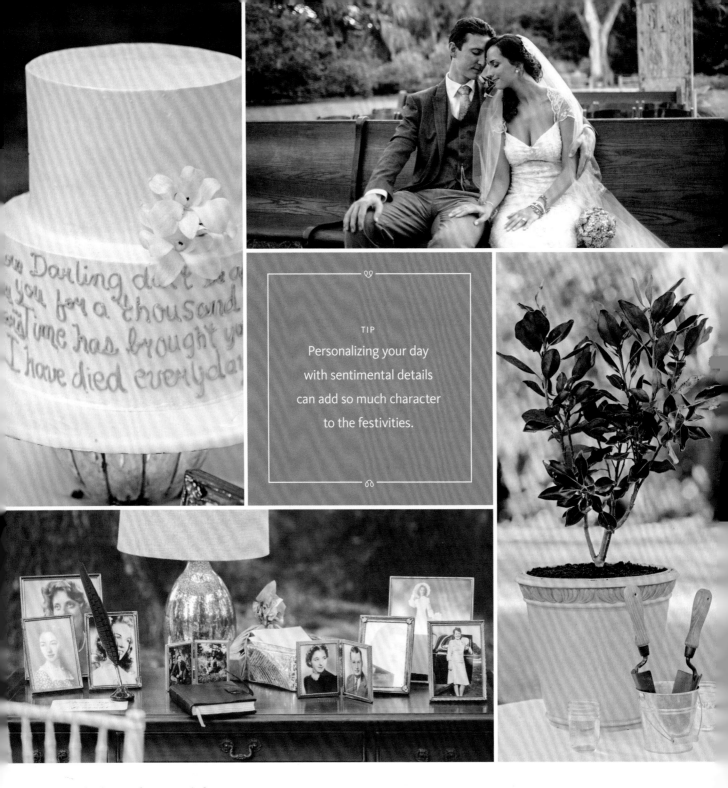

On the cake: Darling don't be afraid I have loved you for a thousand years Time has brought your heart to me I have loved you for a thousand

clockwise from top left: The bottom tier of the buttercream cake was decorated with lyrics from the pair's first-dance song, "A Thousand Years" by Christina Perri. ■ Brittany and Zach both wore vintage-inspired attire— all the way down to Zach's pocket watch. ■ A tree-planting ceremony was a nontraditional alternative to a unity candle. The tree now grows in their yard! ■ Framed photos were a tribute to their loved ones. It was important to the couple that the day reflected their love, as well as the love of those who raised them.

backyard chic

After touring a number of venue options, Haley and Riley decided there was no place like home for their outdoor wedding. The couple decked out the backyard garden of Haley's childhood home in Marin County, California, in pretty blooms and an upbeat color palette of orange and white, balanced by shades of rust, green, and yellow (her favorite color).

TIP

Make the most of your landscape. Here, setting up the ceremony seating around the pool creates an unforgettable arrangement.

clockwise from opposite: Small tables enhanced the personal, backyard feel of the cocktail hour. ■ Tiny arrangements of vibrant dahlias resembled potted plants for the ultimate garden effect. ■ The escort cards were wrapped around two trees in the bar area, tying the stationery into the setting. ■ A chic updo completed Haley's romantic day-of look. ■ Mount Tamalpais provided a breathtaking backdrop for the ceremony at the end of the pool.

venue transformation

THE BEAUTY OF A NATURAL CANVAS IS YOU CAN MAKE IT TRULY YOUR OWN.

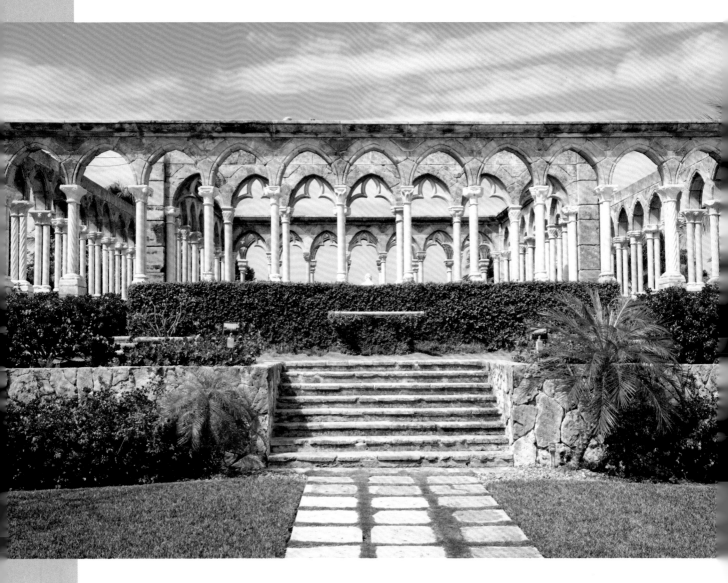

before

A LUSH BLANK SLATE

A 12th-century cloister at the One&Only Ocean Club in the Bahamas provides a dramatic backdrop for a wedding. It's easy to imagine a couple walking down the stone path and climbing the stairs to marry in front of the ancient arches. The verdant greenery would pair well with any color, making it a perfect spot to add as much (or as little) decoration as you'd like.

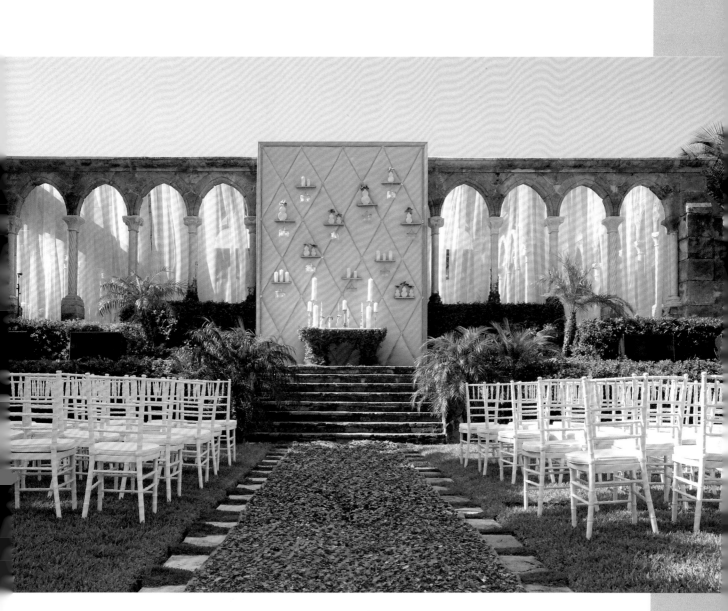

after

AN ENCHANTED DREAM

This already beautiful structure becomes incredibly dreamy thanks to a petal-paved aisle leading up to a candle-filled altar. Sheer curtains and a temporary framed wall help focus attention on the ceremony space, while white chiavari chairs line each side of the aisle. Lighting the candles for an evening ceremony adds the final romantic touch.

estate wedding basics

Read on to learn our tips and tricks for an outdoor estate wedding you and your guests will love.

colors

If you've chosen to get married at home (or a home), it's probably loaded with meaning, so use your color scheme and décor to highlight details that are significant to you. Is there a patch of sunflowers—your favorite blooms? Infuse yellow into your day. Is a beloved tree on the property? Let the color of its bark serve as inspiration. What's great about an estate wedding is you can totally customize it. Use any color—so long as it doesn't conflict with the scenery.

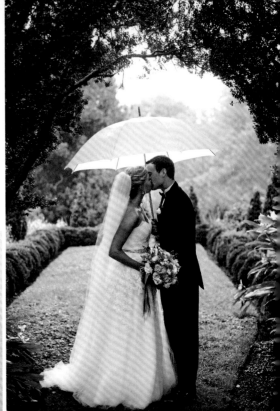

stationery

Your stationery is an opportunity to explain to your guests why you chose to have your wedding where you did. Is there a great view? Show it. Did you grow up there? Mention it. You can also work with your stationer to come up with an illustration of the property and the house. Not only is this a sentimental touch, but it's likely that most of your guests will recognize it too.

attire

Your day-of look will rely heavily on the event's overall vibe. A lawn is easily the most casual setting for weddings, but that doesn't mean you can't transform it into a gilded ballroom—with some elbow grease and a good tent. The formality of your gown should go with the overall aesthetic of the wedding, regardless of the locale. If you are planning a relaxed barbecue with a few close friends, you will probably want to wear something that reflects the casual feel. Think tea-length or sheath gowns for you and your ladies, and no jackets for the men.

try these
color combos

rose & cream

blue & taupe

yellow & brown

menu

There is no better time for a little bit of home cooking. A residential wedding is the perfect opportunity to slip some home-style favorites into your menu. Mac and cheese, lasagna, potato salad, burgers, and corn on the cob are all fair game. Work the casual angle by serving a family-style dinner and inviting guests to help themselves to large portions, or class things up with a plated meal including upscale versions of American classics. Go for lamb sliders, mashed potatoes, or even artisanal sausages.

favors

Personal favors go a long way with an estate wedding. After all, you want guests to feel as if they have been invited into your home—even if it isn't. Providing guests with your wedding playlist is a thoughtful and unique takeaway, as are frames for them to put their photo-booth strips in. If either you or your groom is especially crafty, think about working a little DIY magic into your day. Consider canning your own preserves or putting the ingredients for your family's secret chocolate-chip cookie recipe in a jar.

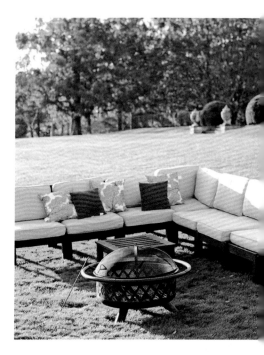

other considerations

Electricity and running water are necessities for the caterer, the DJ, and the tent itself. You might need to bring in an extra generator so you have enough power to last the length of the party. Also, most city ordinances won't allow outdoor music late into the evening, so find out when your band or DJ needs to unplug. And finally, if there aren't any restrooms nearby or if there are just one or two, consider renting extra facilities. As a general rule, it's best to have one bathroom or stall per 35 people. You can find luxury portable restrooms with amenities like in-room music, granite countertops, and air conditioners or heaters, depending on the season.

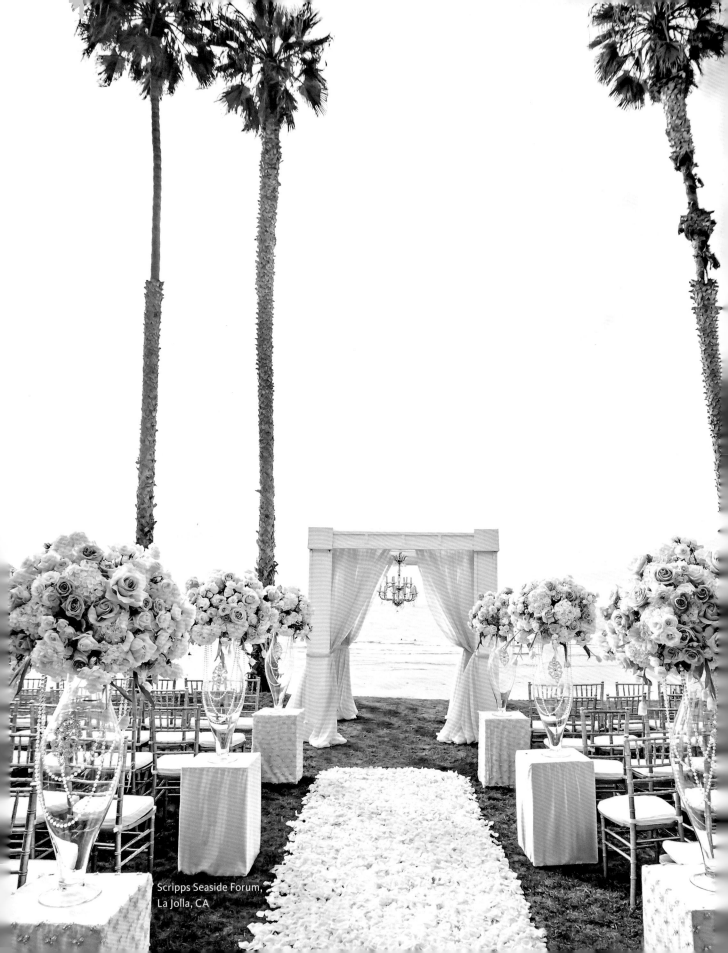

Scripps Seaside Forum,
La Jolla, CA

2
WATERSIDE

There is so much to love about a wedding on the water. It doesn't matter if it is a lakefront, a cozy spot by the bay, or on a beach—it could even be by a pool—anywhere with water nearby instantly sets a scene. Not to mention, all of your guests will feel like they're on vacation. A waterfront wedding is also an opportunity to carry out a clearly defined theme, from the ceremony to reception, and really have fun with the décor. The setting itself—the water, the sand, the bay, the lake, the sky— provides so many ideas for details. You can be literal with your theme or go in a direction that's totally unique. If it's a beach wedding, consider displaying your centerpieces in large conch shells, paving the aisle with crushed seashells, or using sand as a bed for your escort cards. For a bayside wedding, you could go all-out nautical by having life preservers as decoration and a playful rope motif on your stationery suite.

But just because your wedding is by the water doesn't mean the overall look has to reflect it. If your style is modern, why not go for a chic all-white affair with white linens and flowers? Or, if your wedding is by a lake and you gravitate toward a down-to-earth vibe, then a palette with shades of orange, red, and brown would set a more rustic tone. The most gorgeous photo opportunities are at sunset, so ideally you'll want to plan to take your vows as the sun goes down. Also remember: Waterside locations are often breezy, so keep your decorations well grounded and offer blankets for guests should they get chilly.

island elegance

Winnie and Mike had two requirements for their wedding: a tropical setting and lots of quality time with their guests. With that in mind, the couple decided on a four-day destination event in Jamaica.

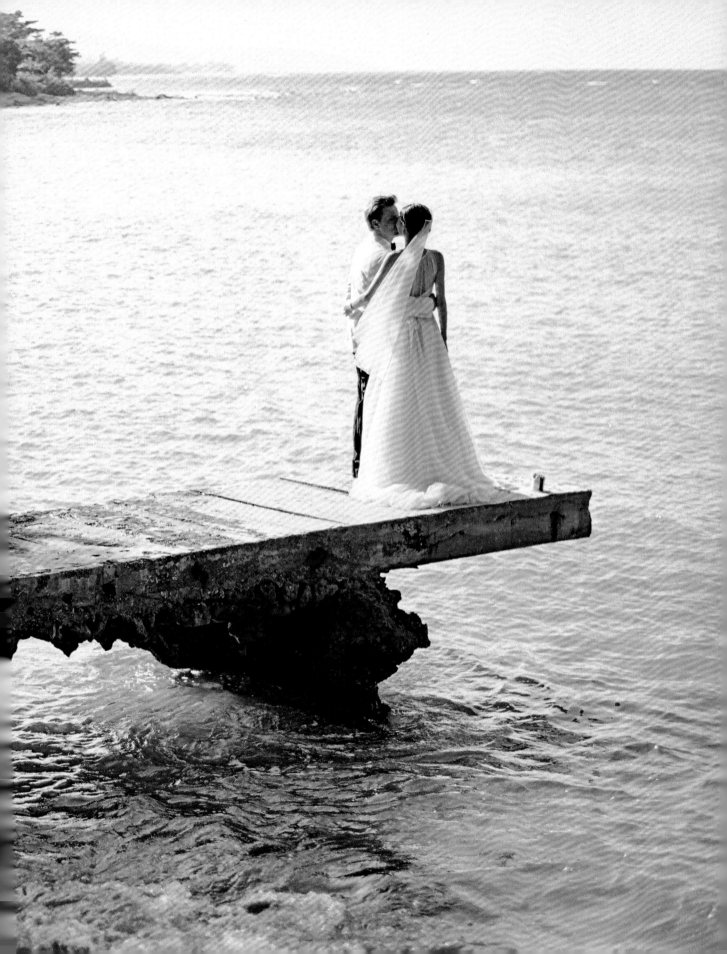

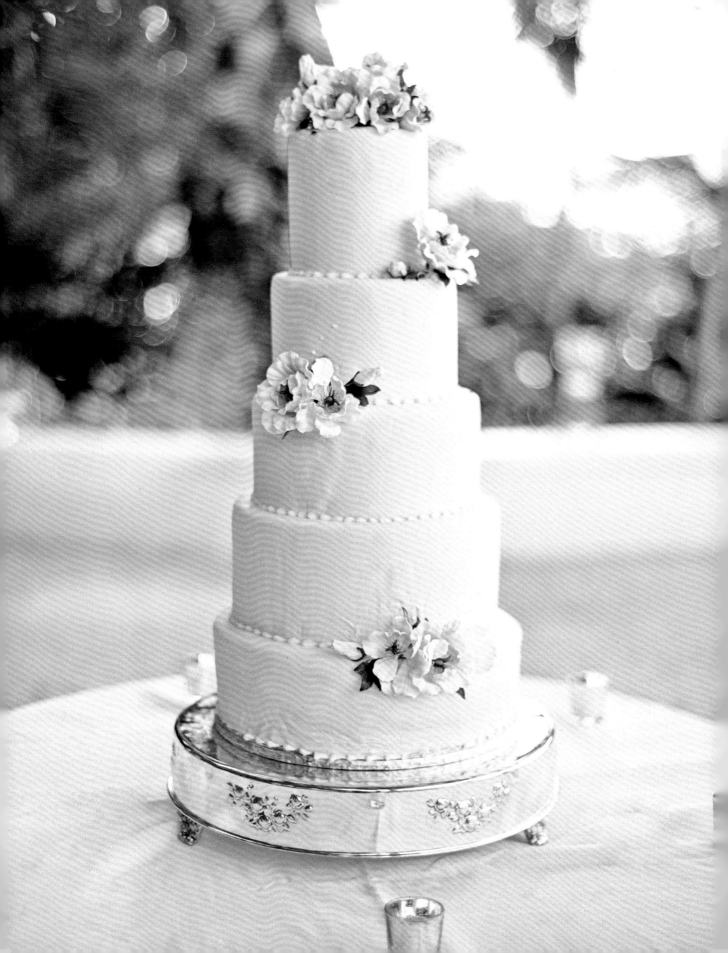

Mr. Jennie Ma & Mr. Daniel Blank
39 Grand Street
Apartment 2
New York, New York 10013

DETAILS

Thursday, December 12th - Welcome cocktail
Friday, December 13th - Rehearsal dinner
Saturday, December 14th - Wedding ceremony and reception
Sunday, December 15th - Farewell brunch

Kindly RSVP by November 9th
WinnieandMike.com
Password xquarrely

Mr. and Mrs. Joseph Ma
and
Mr. and Mrs. Eric Gorzynski

Request the pleasure of your company
at the marriage of their children

Winnie & Michael

Saturday, the fourteenth of December
Two thousand and fourteen

Round Hill Hotel & Villas
Montego Bay, Jamaica

Black Tie

> ### TIP
> Turn your destination
> wedding into a mini vacation
> and encourage guests to
> celebrate for multiple days
> by providing a schedule of
> planned activities.

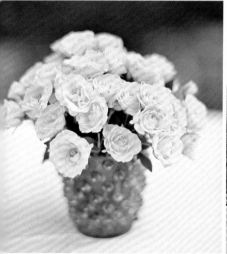

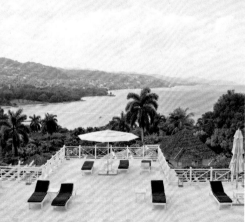

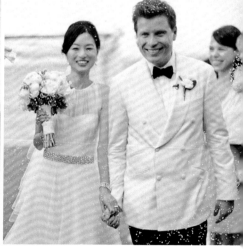

clockwise from opposite: Their all-white confection offered guests flavor options: carrot, chocolate, or red velvet. ▪ A pineapple—one of many tropical details that took on a black-tie feel—was used throughout the stationery to mimic the venue's logo. ▪ White roses, ranunculus, and pink peonies stayed within the neutral color scheme. ▪ The groom looked dapper in a white dinner jacket. ▪ What a view! ▪ Understated blooms allowed the setting to shine.

JACKIE & JONO ▪ OCTOBER 15

autumn inspiration

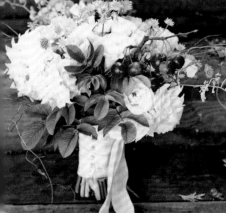

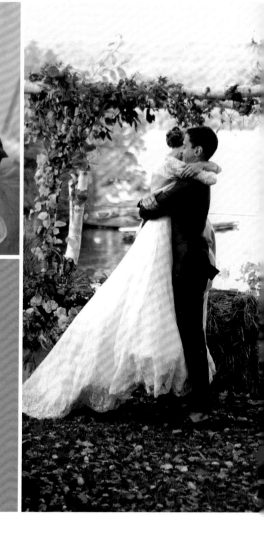

Jackie knew she wanted to use her two favorite colors, yellow and navy, as a starting point for her fall nuptials to Jono on the shore of Lake Champlain. They added deep orange accents and incorporated crab apples and acorns for a seasonal touch. But it was Vermont's gorgeous natural foliage that really brought their day to life.

TIP

Having a pet serve as the ring bearer or furry flower girl? Cute! Make sure someone has treats and a leash on hand during the ceremony just in case.

clockwise from opposite: Crab apples topped the simple ivory wedding cake. ■ The same fall staple even made an appearance in the bridal bouquet, adding color and texture. ■ Jono's family golden retriever, Marley, was their ring bearer. ■ A white birch arbor served as the backdrop for their interfaith ceremony. ■ The reception tables were named after ski mountains in Vermont. ■ The groomsmen accessorized their navy suits with yellow bow ties.

For the full fall effect, Jackie and Jono left their grassy aisle covered in colorful autumn leaves.

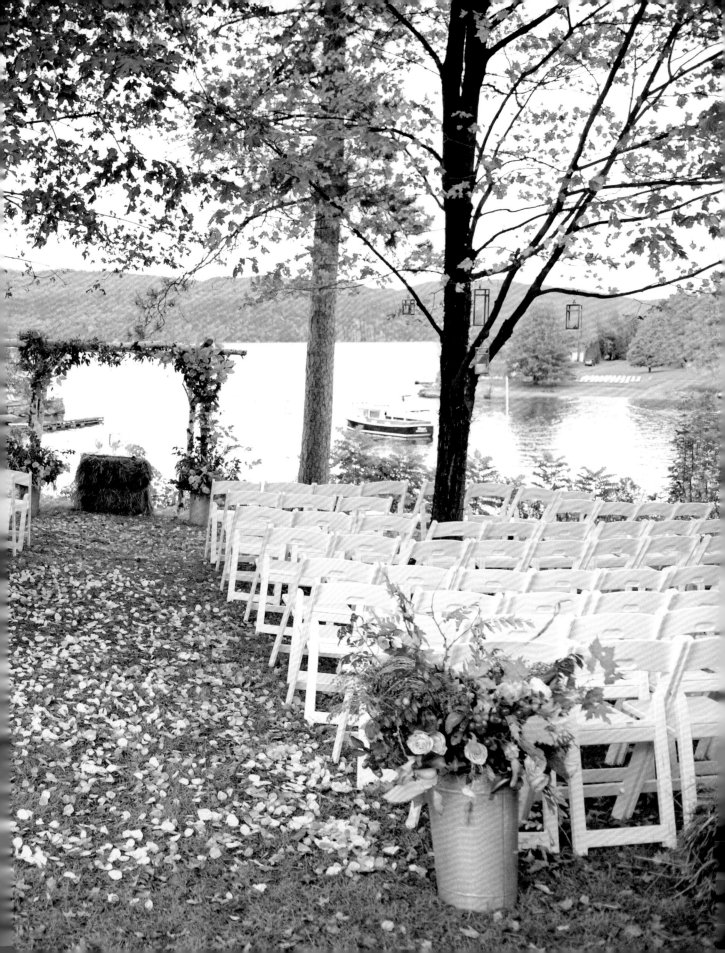

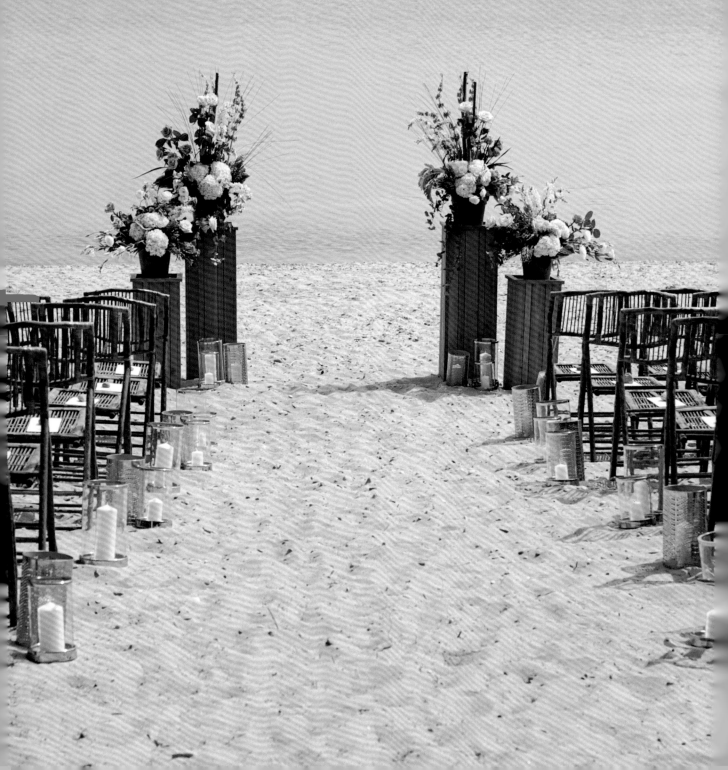

lake-house luxe

K im and Mark literally didn't have to look any farther than their own backyard for the perfect place to get married: her parents' summer home on Suttons Bay in Michigan. Rustic wood details added an outdoor element to the tented backyard reception, which felt anything but simple.

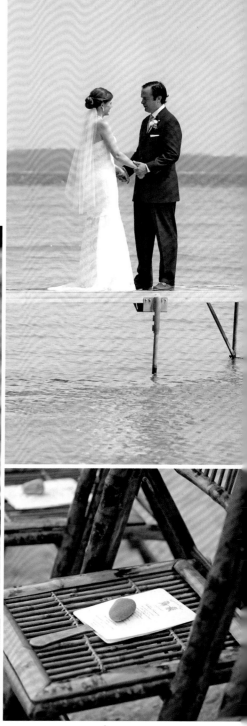

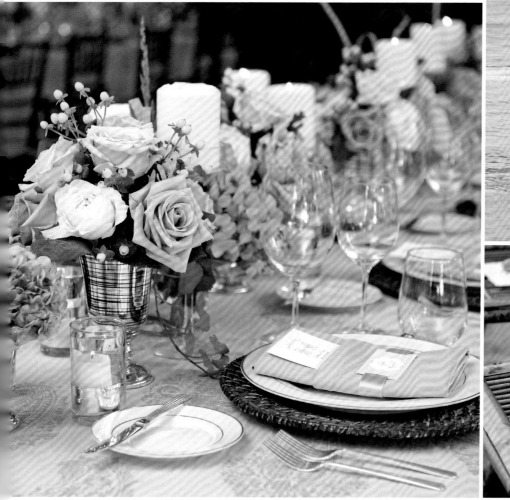

clockwise from opposite: Ceremony backdrops don't get much prettier than a sparkling blue bay. ▪ Kim and Mark made use of a nearby dock for photo ops. ▪ Sticking to details found on the shore itself made the event feel unified from start to finish. One example: The stones used to weigh down the programs had washed up on the very same beach. ▪ Even the colors of the tablescapes reflected the subtle hues of the waterfront setting.

Sea-green paisley
tablecloths picked up
the colors of the bay.

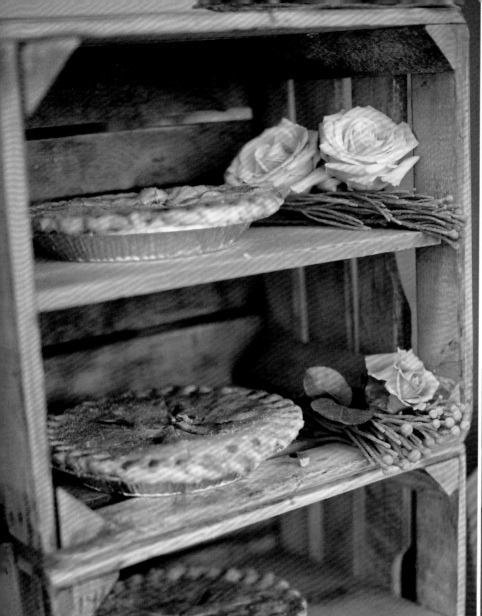

clockwise from left:
Instead of a traditional wedding cake, Kim and Mark served stacks of delicious homemade pies. ▪ All-white bunches were a perfect contrast to the royal-blue bridesmaid dresses. ▪ Even the smallest details, such as a wreath in the day's color palette, went a long way. ▪ A lounge pillow got a personal touch thanks to a painted portrait of the couple's pup.

TIP
Don't feel obligated to serve wedding cake—especially if you don't like it! Homemade pies are just as delicious and fit in well with a lake-house vibe.

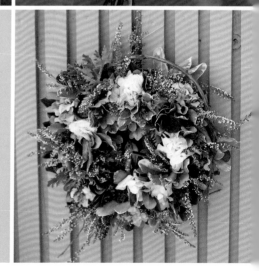

fresh and far-flung

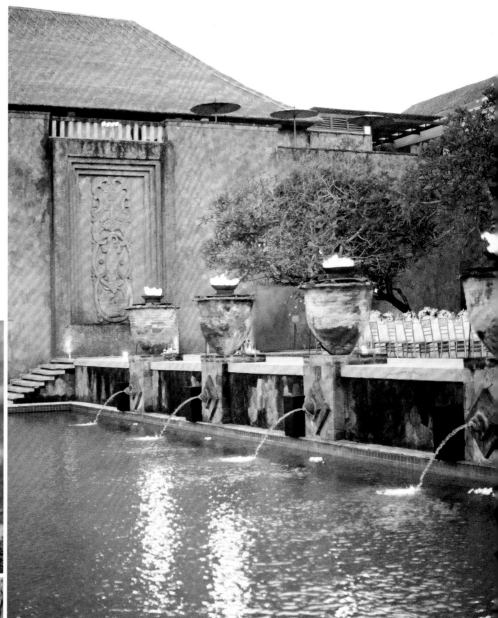

clockwise from opposite:
Garlands of tiny petals were strewn over the newlyweds' chairs. ■ Who could resist the allure of a poolside reception when it is as incredible as this one? ■ While the reception was more exotic, Sherry and Benjamin went with classic day-of looks—a black suit and an embellished ball gown. ■ An ethnic-inspired pattern gave the stationery a subtle local flavor.

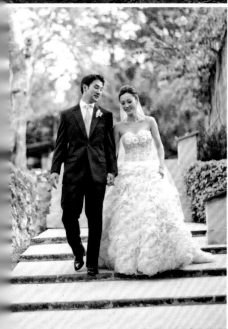

Sherry and Benjamin didn't want their Bali wedding to feel predictable in any way. That meant avoiding the vibrant colors that are so popular with weddings on the remote island. Instead, they took a more subtle approach, using understated ocean elements and a neutral color scheme of white, cream, and beige to transform the luxury beach resort.

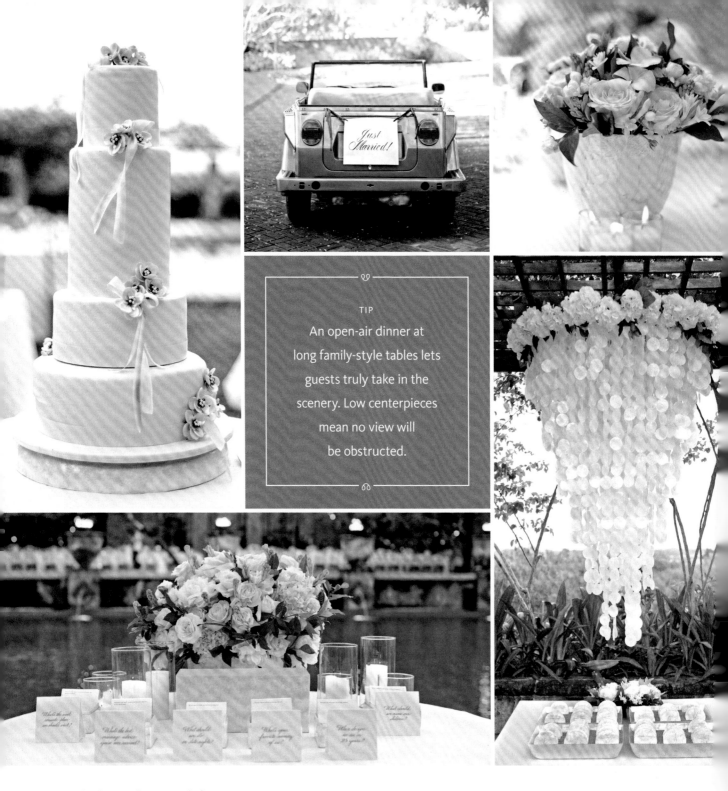

TIP

An open-air dinner at
long family-style tables lets
guests truly take in the
scenery. Low centerpieces
mean no view will
be obstructed.

clockwise from top left: Different-size tiers made
the couple's simple cake more special. ■ While the sign on
the getaway car was pretty standard, the ride (a Volkswagen
Thing) was exceptional. ■ Even the smallest votives up the
romance. ■ This escort-card table was taken to grand status
thanks to a stunning fixture of opalescent shells overhead. ■
During cocktail hour, guests answered fun questions from the
bride and groom, such as "What should we name our children?"

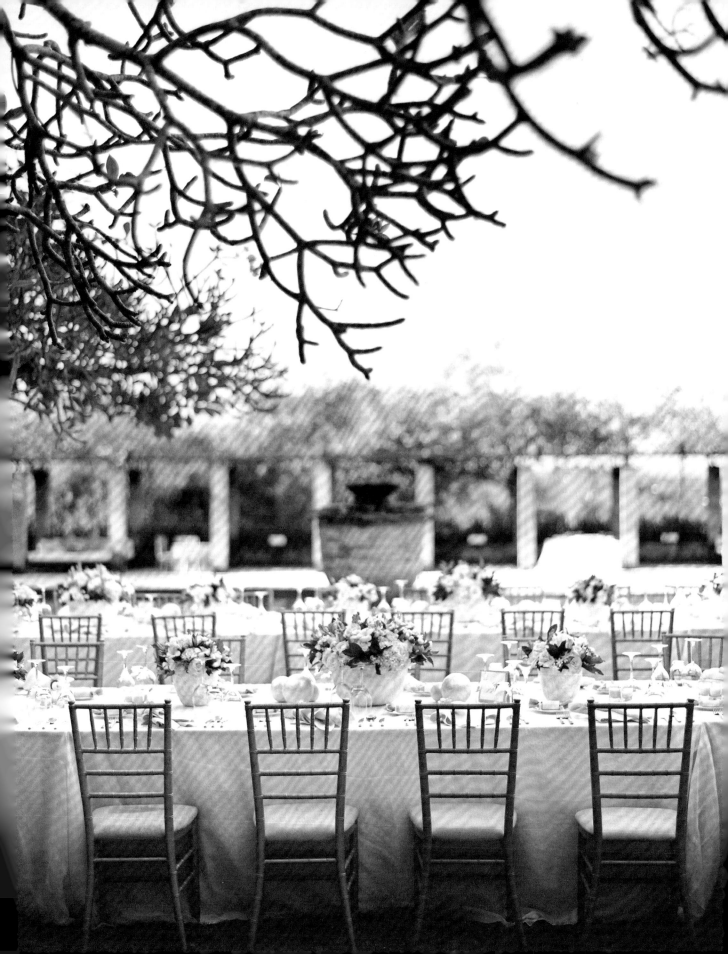

FLOWERS

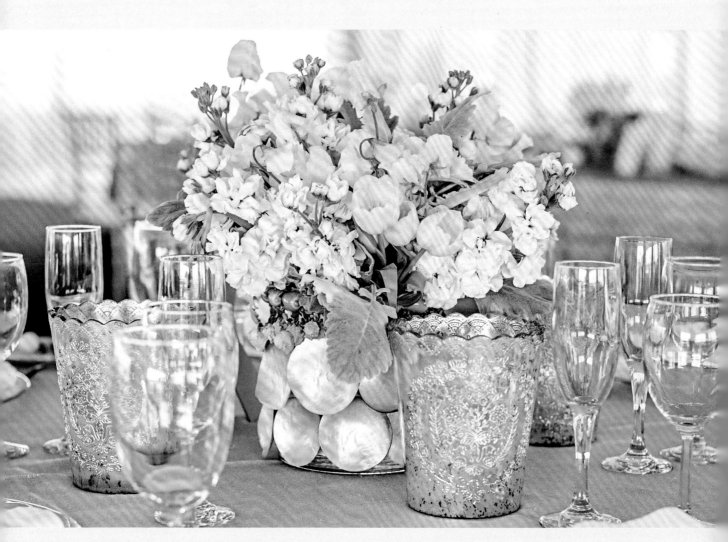

A SETTING BY THE BAY, ON THE BEACH, OR AT THE LAKE IS GROUNDS FOR SO MUCH INSPIRATION. LOOK TO THE ELEMENTS ALL AROUND YOU, SUCH AS THE CLIMATE OF THE LOCATION AND THE SEASON, FOR IDEAS.

clockwise from above: A vase encrusted with pearly shells appears both glamorous and organic, and offers a sophisticated reminder of the watery setting. ■ Switch up your floral arrangements by leaving a few of the vessels empty. Bonus: The vases' shapes are reminiscent of seashells. ■ Thistle and berries add texture to a bouquet—and they're wilt-proof! ■ A minimalist birch huppah lets the sandy beach take center stage at an oceanside ceremony. Sheer white linens blow dreamily in the wind. ■ Let your centerpieces run a little wild! A mix of natural blooms, including dusty miller, and an unstructured shape give this arrangement a loose and windblown appeal that's totally beachy.

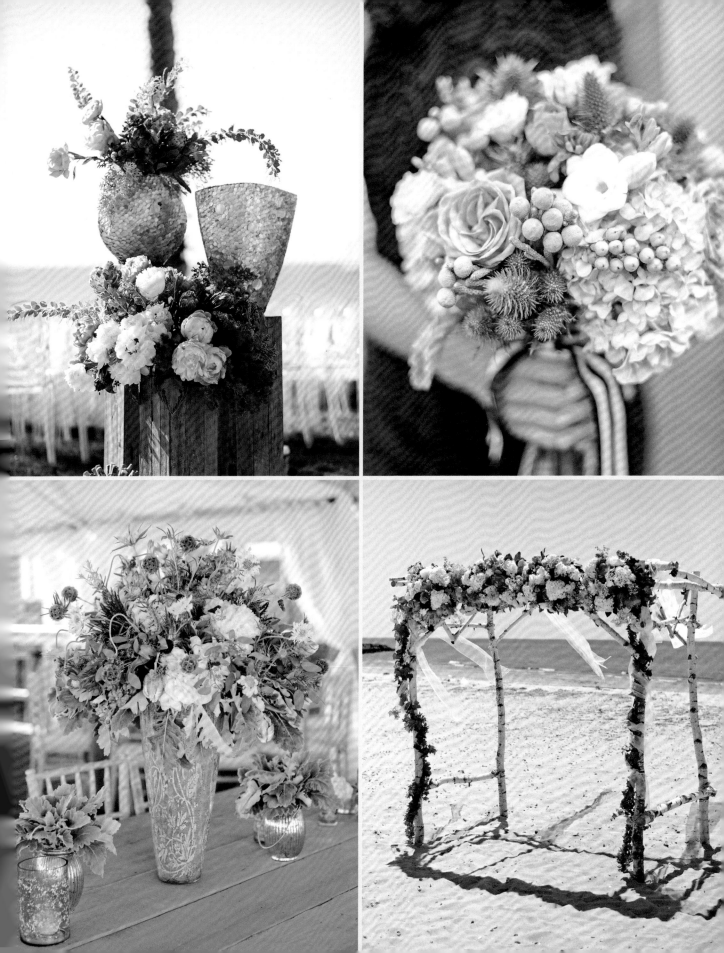

crisp and coastal

clockwise from opposite:
A bouquet doesn't get much
more textured than fiddlehead
ferns, succulents, and thistle.
■ Jennifer's simple dress
silhouette echoed the day's
aesthetic. ■ Succulents even
made an appearance in the
flower girls' crowns. ■ A red
life preserver looked perfectly
placed behind a basket filled
with towels for a late-night swim.
■ The reception tables felt like an
extension of the sea itself, thanks
to muted place settings, simple
centerpieces, and wooden chairs.

Pops of deep red gave Jennifer and Caleb's nautical
wedding on San Francisco Bay a fun twist. The unex-
pected accent color was also an homage to Jennifer's
Chinese heritage (it conveniently happened to be the club's
signature hue as well).

JAMIE & RYAN ▪ SEPTEMBER 1

positively preppy

By combining formal, indoor elements with their open-air lakeside locale, Jamie and Ryan created an elegant-yet-relaxed beach reception. Textured linens, feminine florals, natural wood, and glam pops of gold paired with a color palette of white, navy, and peach bring the day to life.

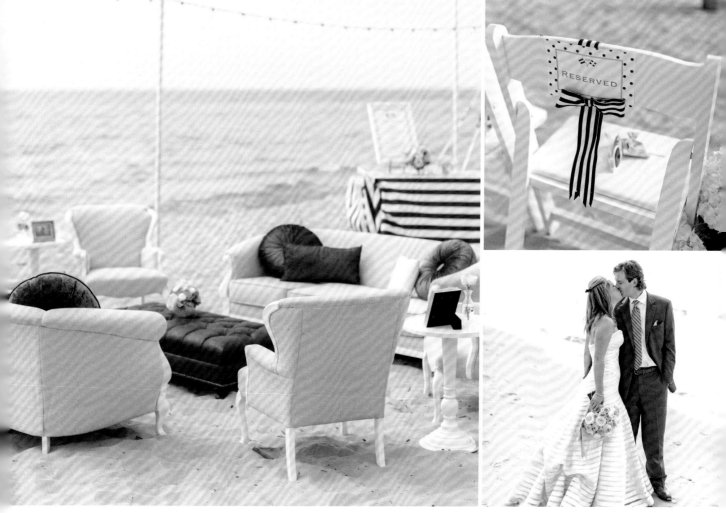

clockwise from opposite: The sides of the tent were left open for views of Lake Michigan. ▪ Attention to detail, like using driftwood for escort cards, added a unique spin. ▪ Preppy stripes, polka dots, and monograms created a Kate Spade–inspired look that freshened up the nautical theme. ▪ Stripes were everywhere—even in the bride's and groom's day-of looks. ▪ Jamie loved the contrast of the casual beach with formal décor, such as the lounge that sat steps from the water.

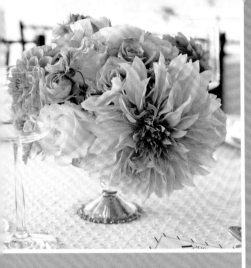

TIP

Hardwood flooring in an outdoor tent is the ultimate luxe touch. An added bonus: Your guests won't have to worry about mucking up their shoes!

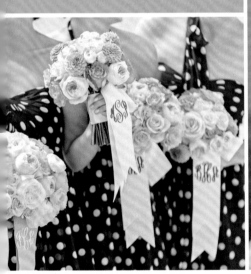

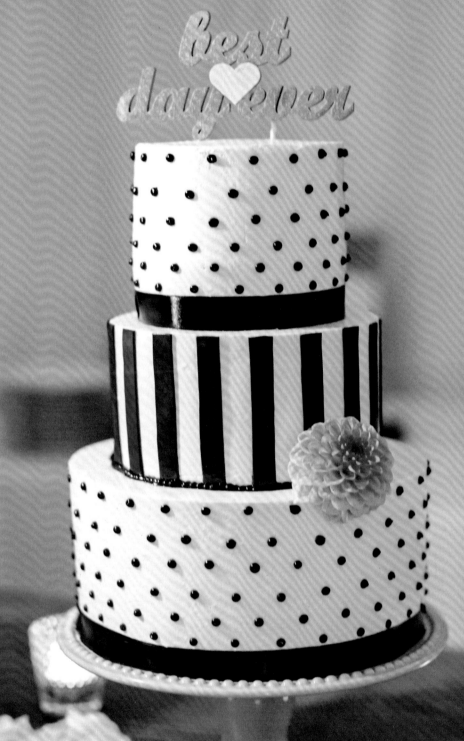

clockwise from top left: Small arrangements of soft pink flowers in gold-footed vessels topped the long reception tables. ■ Everything about Jamie and Ryan's cake—from the stripes and polka dots all the way to the fun topper—felt playful. ■ The bridesmaids carried bouquets of garden roses, dahlias, peonies, and other blooms in shades of white and peach. White ribbons with navy monograms of each bridesmaid's initials were tied around the exposed stems.

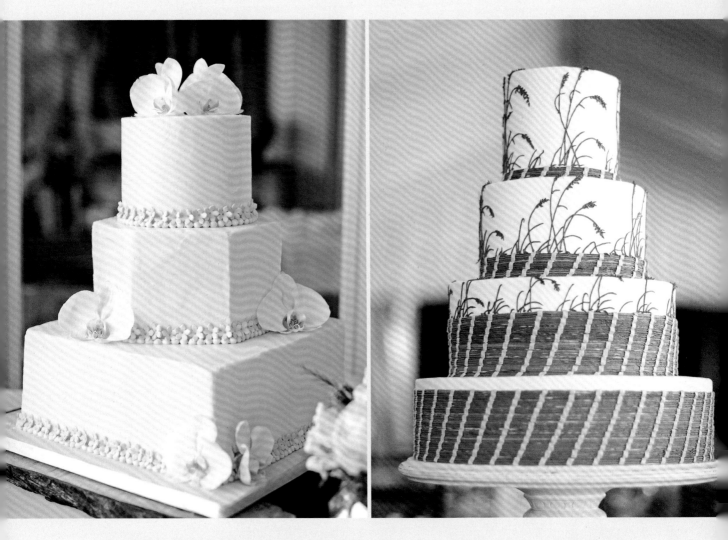

HAVING A WEDDING BY THE WATER IS A PERFECT OPPORTUNITY TO PLAY OFF THE SETTING WITH A CREATIVE THEMED CAKE THAT INCORPORATES DETAILS YOU WOULD FIND AROUND YOU.

clockwise from above left: Don't be afraid to step outside the box when it comes to your cake. Here, each tier takes on a different shape, giving it subtle dimension. For the final flourish, delicate orchids lend some tropical flavor to this white fondant confection. ▪ The embellishments on this four-tier cake resemble tall beach grass peeking over dune fencing—iconic shore imagery. ▪ A vintage-looking topper featuring a sailor is the perfect finishing touch on a cake for a boat lover and his first mate. ▪ Tiny flags have a beachy feel. Thick strips of fondant ruffles look simultaneously rustic and feminine. ▪ A watercolor effect on this painterly dessert's bottom layer sets a seaside tone, while a single gilded sugar flower feels decidedly chic. ▪ This nautical cake looks ready to hit the seas thanks to preppy stripes, a loose skein of fondant ropes, and glittery gold anchors.

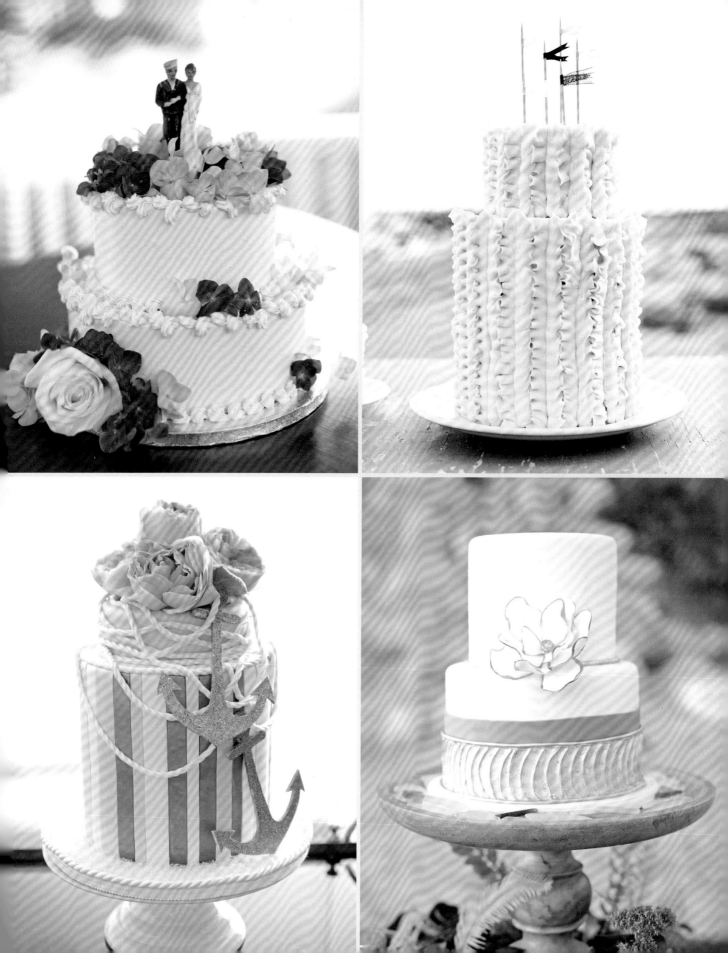

SUSI & BRIAN ▪ AUGUST 27

modern rustic

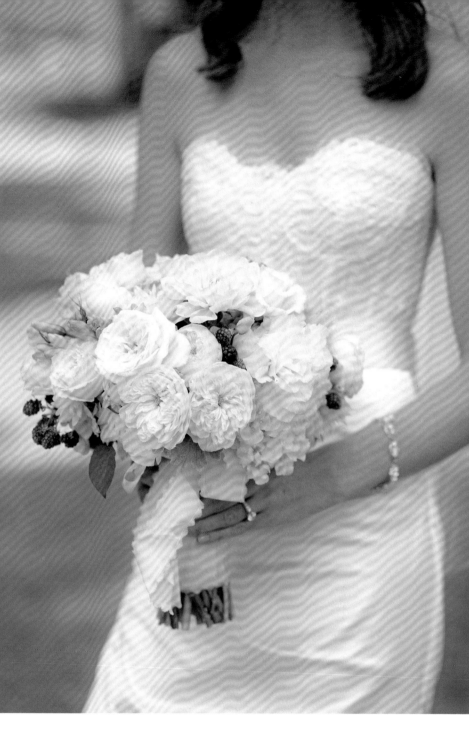

clockwise from opposite:
Bright blooms in containers of various shapes, colors, and sizes made for modern, whimsical centerpieces. ▪ A hand-tied bouquet full of ruffly white flowers echoed the texture of the lace bodice on Susi's gown. ▪ Ceremony programs using a mix of colors and fonts lightened the mood. ▪ Wood boxes of wheatgrass were a perfect organic addition to the tablescapes.

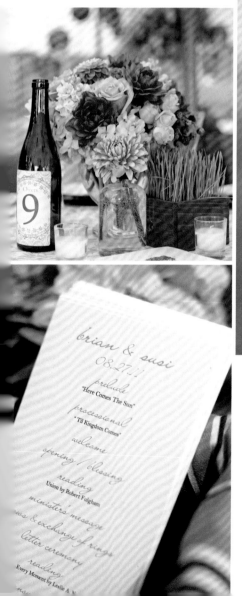

Susi and Brian did something unexpected for their Lake Tahoe, California, wedding. Instead of defaulting to an earthy color palette, they went in the opposite direction with bright orange, raspberry, and turquoise for an effect that felt special, but not too fancy. Subtle rustic accents, such as their mason jar motif, were right at home in the woodsy setting.

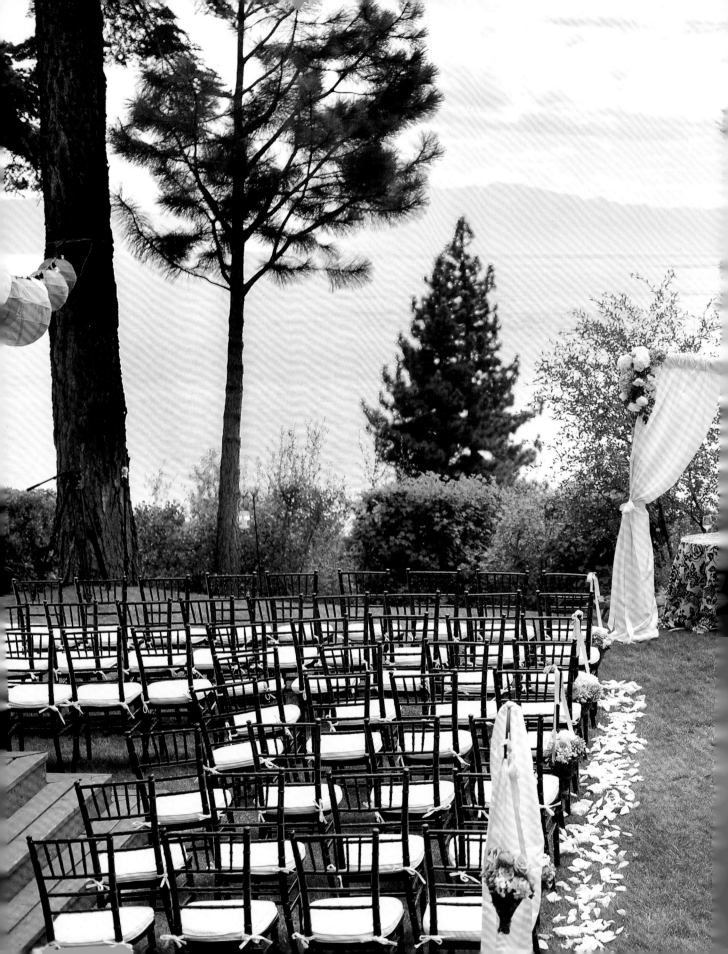

Colorful paper lanterns
and an olive tree livened
up the reception tent.

TIP

Paper lanterns lend an air of celebration and style to any space; not to mention, they're also an affordable décor option.

menu

— amuse bouche —

chilled summer corn soup with cra

clockwise from above left: Overlooking the lake, a rustic bench made with tree stumps was softened with a few color-coordinated pillows. Flower-filled lanterns were accented with ribbons. ■ Even the escort cards reinforced the theme. Guests' names and seating assignments were handwritten in white ink on leaf-shaped tags. ■ A mason jar and firefly illustration added some outdoorsy flavor to the menu cards.

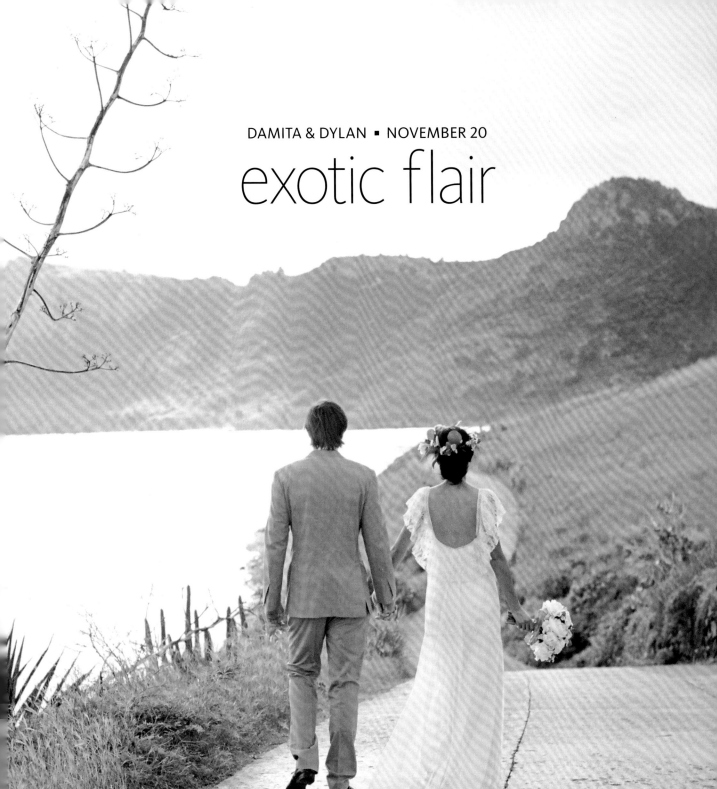

DAMITA & DYLAN ▪ NOVEMBER 20

exotic flair

Damita and Dylan worked with the existing colors and aesthetic of their St. Barts venue for their wedding. Picking up on the bright shades of yellow, red, and green in the surrounding foliage and the earthy prints of the hotel's rustic furniture, they crafted a vibrant, laid-back day worthy of their Caribbean locale.

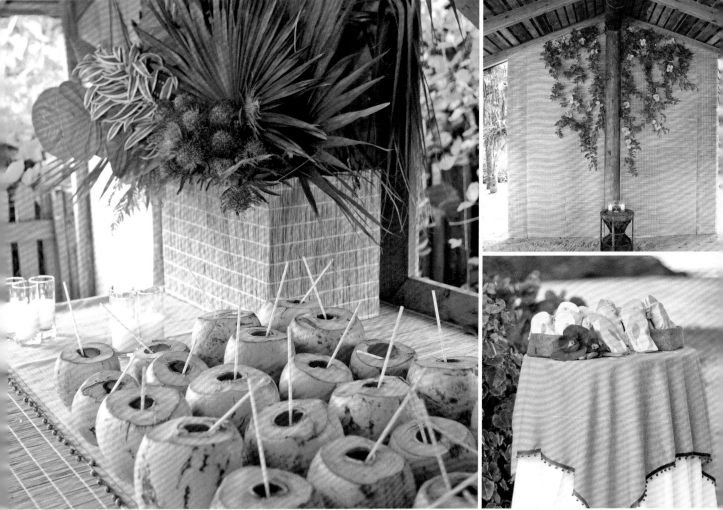

clockwise from opposite: Damita matched the relaxed feel of their island setting in a flowy gown and whimsical flower crown. ■ Small arrangements of rosettes made from tropical leaves and fabric blooms were a pretty detail. ■ Crawling ivy transformed the ceremony space. ■ Guests were given flip-flops for the sandy terrain. ■ A coconut rum cocktail served directly from coconut shells definitely reinforced the Caribbean vibe.

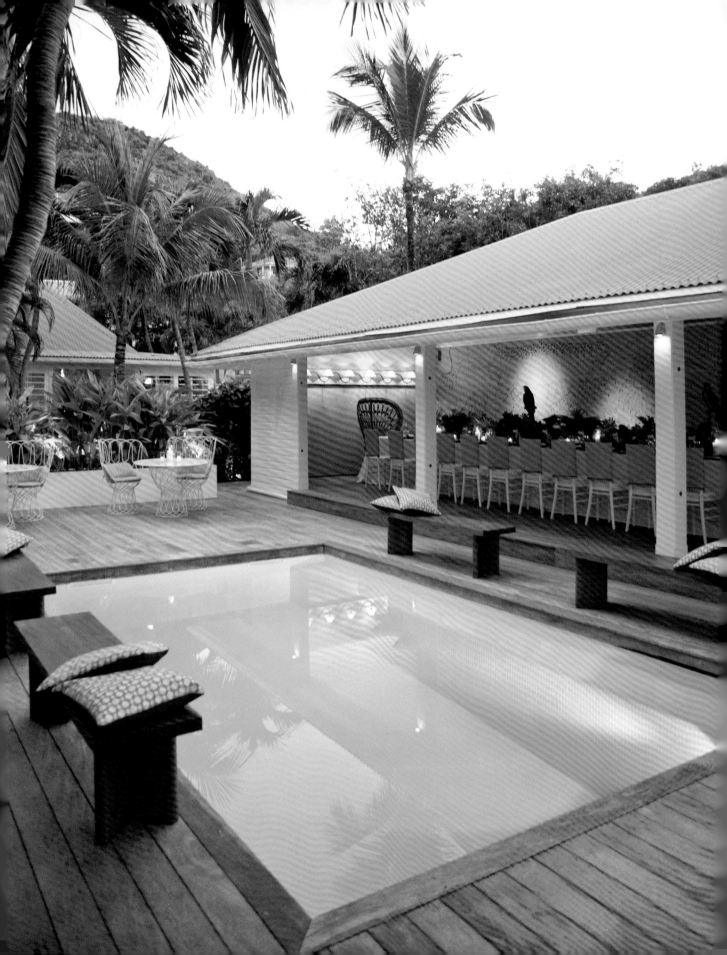

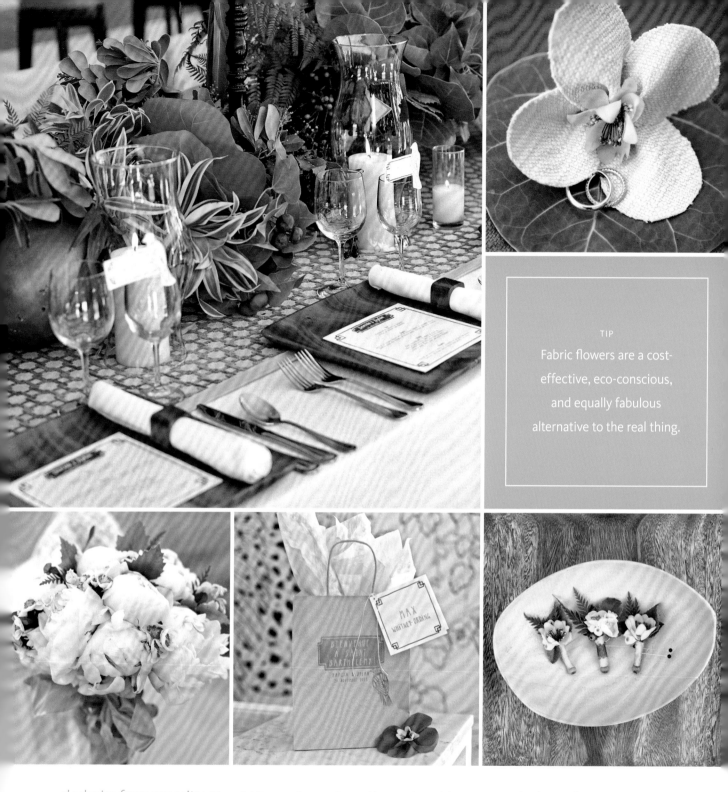

Fabric flowers are a cost-effective, eco-conscious, and equally fabulous alternative to the real thing.

clockwise from opposite: Warm lighting set the mood during the poolside cocktail hour. ▪ Indigenous elements, from foliage to coconuts, played up the exotic locale. ▪ Silk flowers switched up the look of the décor. ▪ Vintage silk blooms adorned the groomsmen lapels as well. ▪ Guests were greeted with welcome bags of local goodies for a taste of the region. ▪ Damita's bouquet was a mix of cream-colored flowers and native greenery.

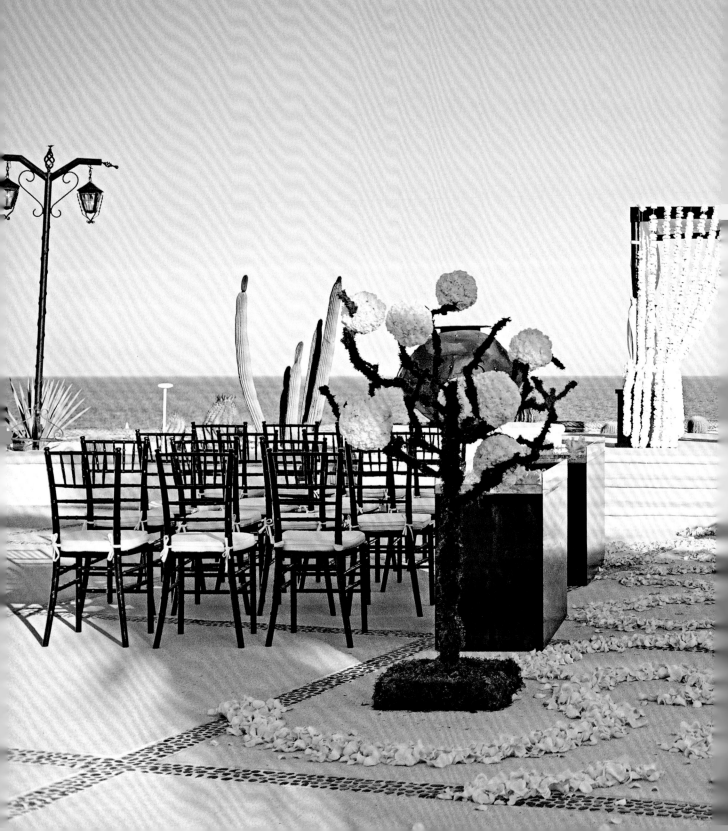

bright beach

Chicago locals Meka and Shon wanted to share their favorite escape, Los Cabos, Mexico, with their guests on their wedding day. Succulents, burlap, and grapewood branches added texture to their stylish fiesta.

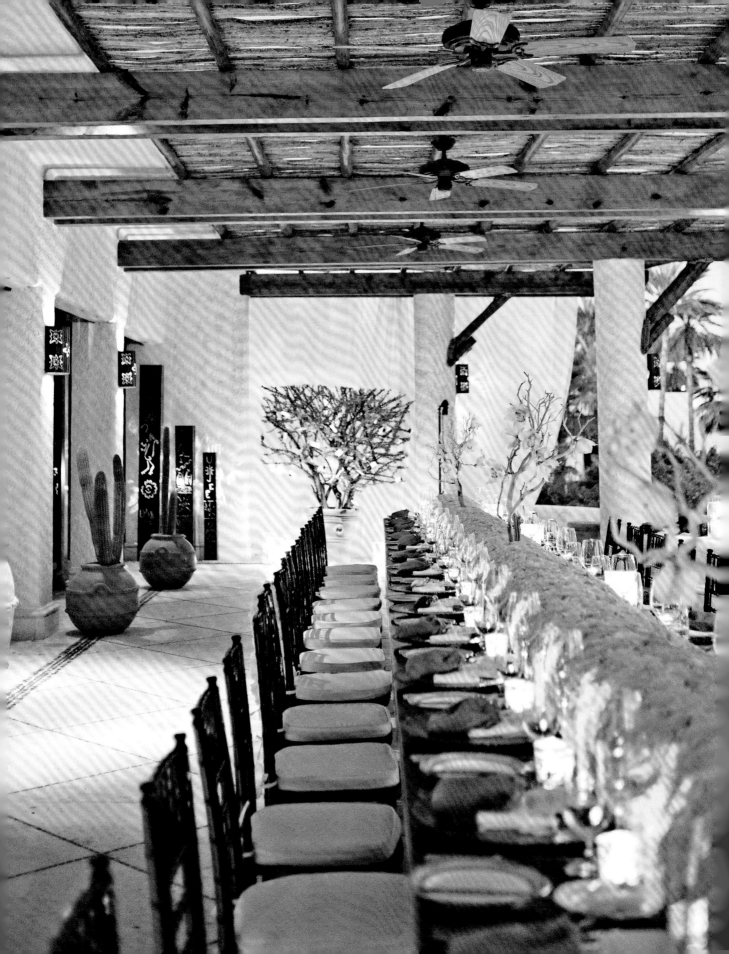

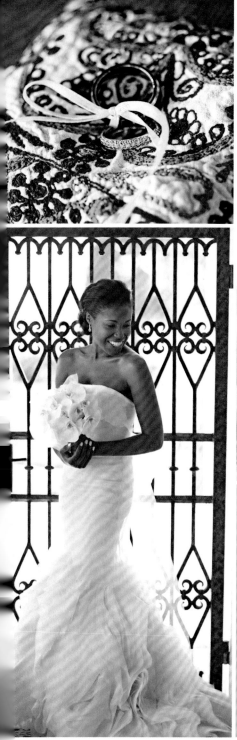

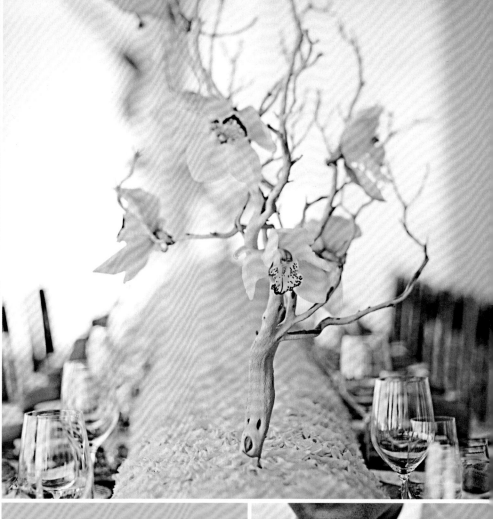

TIP

Don't be afraid to go bold!
A vibrant accent color is
an easy way to spice up
your décor and inject some
personality into the day.

clockwise from opposite: A table runner of yellow roses amped up the drama at the reception. ▪ The ring bearer pillow was made from a vintage Mexican wedding dress, a nod to the locale. ▪ Single manzanita branches with yellow blooms almost appeared to grow straight up out of the flower runner. ▪ Shon looked beach ready sans tie. A fun craspedia boutonniere continued the laid-back vibe. ▪ White orchids echoed the petal-like folds of Meka's dress.

ceremony seating

CIRCULAR ARRANGEMENTS, ANTIQUE COUCHES, A SPIRAL FORMATION—YOU CAN GET AS
CREATIVE AS YOU WISH WITH YOUR CHAIRS, AS LONG AS GUESTS CAN SEE THE ALTAR.

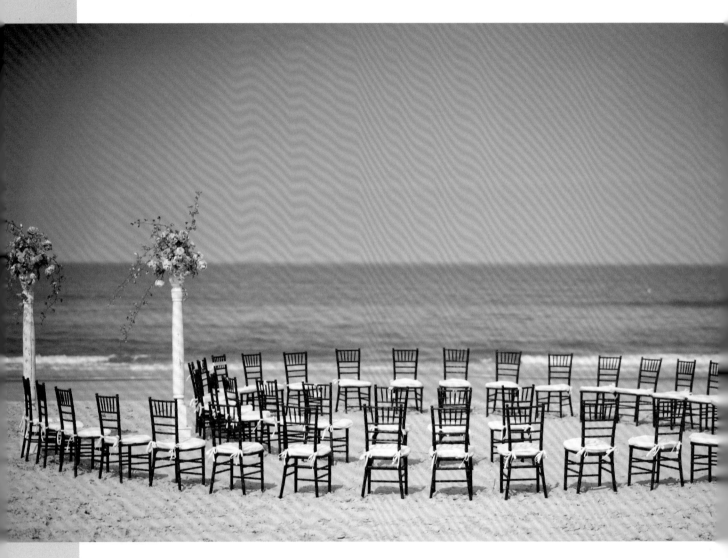

spiral

FOR A CEREMONY
WITH A TWIST

Setting up your chairs in a spiral lets everyone feel close to the action.
Not to mention, the bride and groom will be able to gaze upon every guest.
This type of seating style throws the typical two-side arrangement out the
window and encourages people to mix and mingle, regardless of whether
they're a guest of the bride or the groom. But keep in mind that a spiral
formation will make your walk down the aisle a winding one.

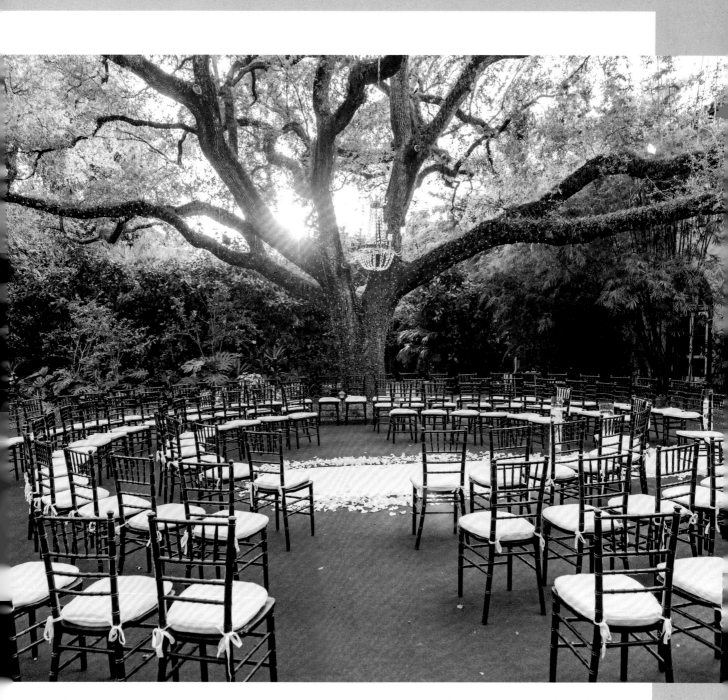

circle

YOU'LL BE THE CENTER OF
ATTENTION, LITERALLY

An intimate option, chairs in a circle (a symbol of everlasting love) allow all guests to feel closer to the ceremony. At smaller weddings, everyone gets a front-row seat, but even a large group will feel like they're embracing the couple in two or three rows. Arrange two to four entrances into the circle so guests can easily get in and out. To make a dramatic entrance, parents, bridesmaids, and the bride can all walk down different aisles.

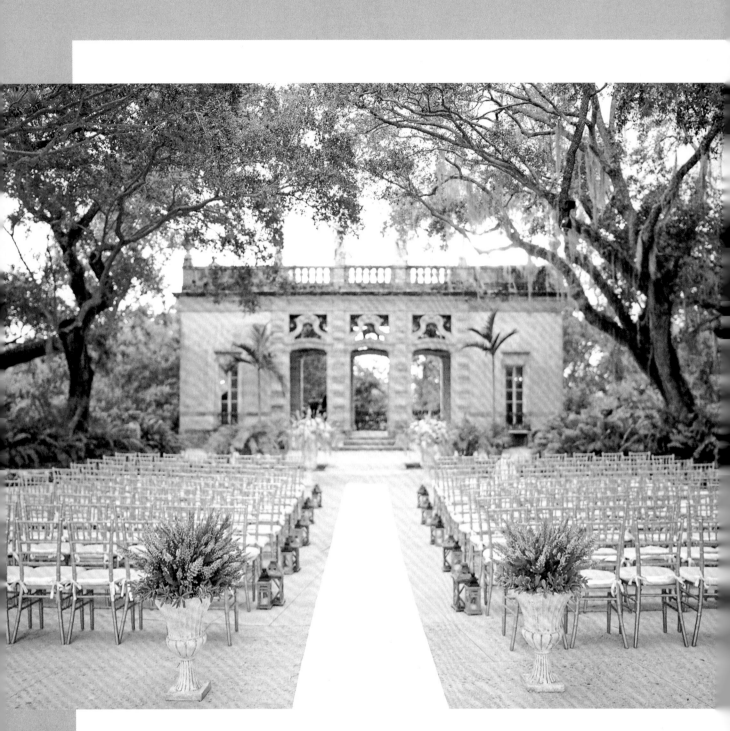

traditional

TRIED-
AND-TRUE

The most classic of ceremony seating arrangements involves two groups of straight rows divided by a center aisle. Traditionally, the bride's family and friends sit on one side and the groom's on the other (in Christian ceremonies, the bride is on the left and the groom is on the right; Jewish ceremonies do the reverse). Or allow guests to simply pick a seat, not a side.

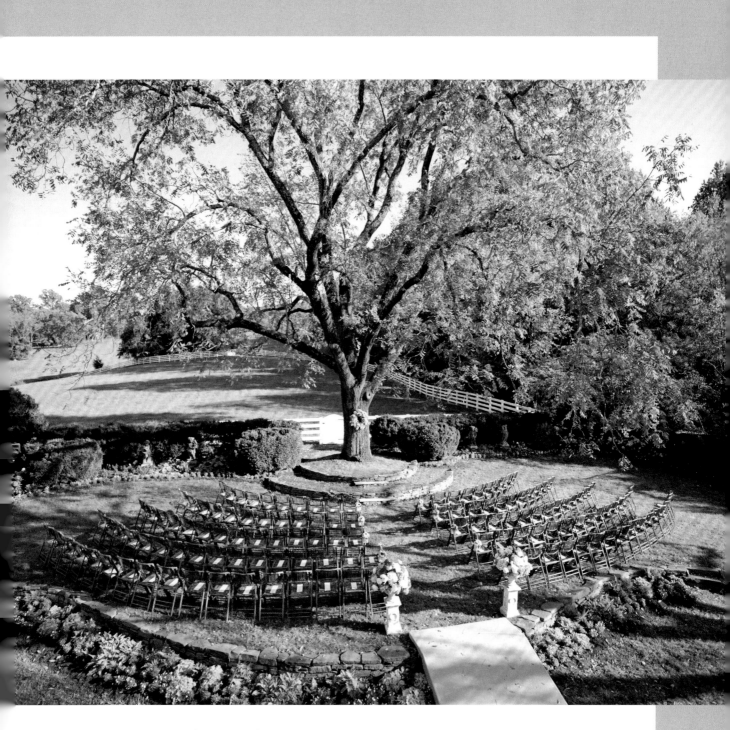

semicircle

A COMFORTABLE
VIEWING OPTION

Rows form a semicircle instead of a straight line. Each row is slightly angled, anchored by a center aisle. As with seating in the round, you still have the feeling that everyone's curving around you. Plus, you'll be able to have fewer rows, as the setup allows for them to get longer (and accommodate more chairs) toward the back of the layout.

waterside wedding basics

Whether you've chosen an exotic beach or a tree-lined lake, here's what you need to know for the ultimate waterfront event.

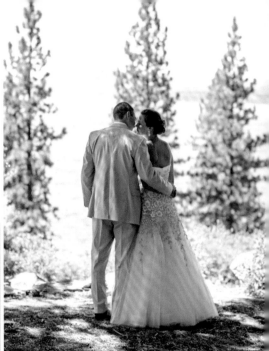

colors

Sea-inspired shades, such as aqua, navy, and turquoise, are traditional for celebrations on the water, but use them in unexpected ways, such as serving signature cocktails inspired by the colors of the ocean or encouraging guests to dress in aquatic hues. To enhance the look, add chic neutral colors to tables and mix in natural elements, like burlap or coral, along with floral centerpieces. Nothing says relaxed beach elegance like putting your personal stamp on the day.

try these color combos

turquoise & blue

aqua & taupe

navy blue & coral

stationery

Hint at your wedding's nautical setting by incorporating a marine design into the invitations and carrying it through the rest of the wedding papers. Shells, anchors, and sand dollars are fun motifs, but you can also branch out beyond the expected with more abstract ones—think: watercolor waves, compasses, seagulls, and so on. For a yacht club wedding, give guests a glimpse of what they can expect with preppy stripes, polka dots, and a Vineyard Vines–inspired whale motif. Saying "I do" on a remote stretch of coastline? Work an illustration of the rustic setting into the stationery, complete with sand and sun.

attire

Wear whatever you feel best in, but keep in mind that some dresses can be heavy and extremely hot in the sun (tip: no heavily beaded ball gowns on the beach!). Most beach brides opt for flowy, ethereal fabrics that are breathable and lightweight, such as chiffon, tulle, and organza. For bridesmaids, tea- or knee-length dresses work well and are much easier to walk in, which is especially important when you're heading down the aisle. Guys can nix the idea of tuxes in favor of breathable khakis or linen pants and a linen shirt. Clue guests in on the attire via the invitation or wedding website (use words such as *beach chic* to explain the dress code). After all, you don't want an attendee trudging through the sand in five-inch heels.

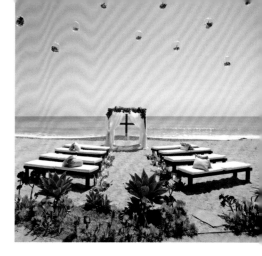

menu

Warm weather can take a toll on guests' appetites, so opt for beachy fare that is less affected by heat, and serve small bites attendees can easily eat while standing. Keep the food light and fresh with a focus on citrus fruits or local produce. Work with your caterer to create a menu that celebrates the local seafood. Clam bakes and lobster rolls are delicious (and traditional) choices for New England affairs, for example. Finally, when it comes to the desserts, stay away from fillings such as mousse, custard, or anything made with eggs, and stick with seasonal warm-weather flavors, like mango or lemon.

favors

Treat your guests to favors that will remind them of your fabulous beach bash every time they use them. Monogrammed totes, coolers, or flip-flops in your wedding colors are practical gifts guests can use on their own beach adventures for years to come. For edible takeaways, consider sending guests home with saltwater taffy, starfish-shaped chocolates, or boardwalk popcorn. On the other end of the spectrum, a donation to an organization dedicated to protecting the ocean, like Oceana or the Safina Center, is a thoughtful alternative to traditional favors. Think of your donations as a way of thanking Mother Nature for letting you use one of her masterpieces for your day.

other considerations

Crossing your fingers and hoping for sun is not enough to guarantee a gorgeous day. Despite how serene a waterfront wedding sounds, weather can change quickly. A backup plan should include an alternate site for the ceremony and reception, and a way to notify guests and wedding pros quickly about any new plan. When booking a beachfront hotel or similar venue, for peace of mind, put a deposit on an indoor room where the party can be moved should inclement weather pop up. Also keep in mind that the majority of accessible beaches are public, so you'll have little control over who is there to sneak a peek. And many public beaches require a permit for a ceremony to take place. You'll also need to check with the town's park service for local codes and noise ordinances. If your wedding is at a popular spot, find out if you can arrive early in the day to stake your claim and set up chairs, a huppah, arches, or whatever else is needed.

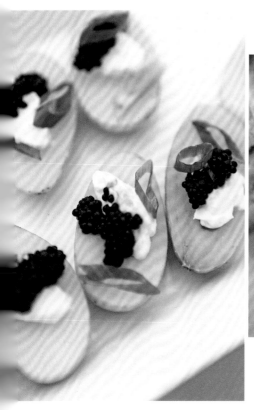

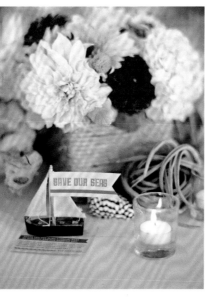

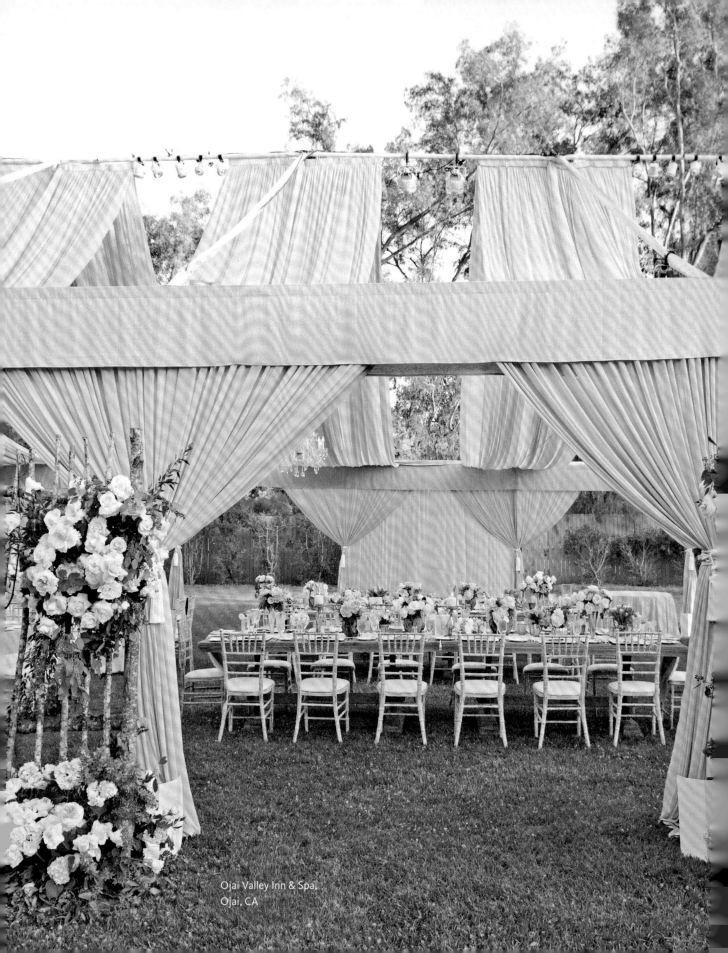

Ojai Valley Inn & Spa,
Ojai, CA

3
GARDEN

A lush garden is like a décor jackpot: free, stunning flowers all around. Whether your location has vibrant blooms, towering trees, or rich foliage, these surroundings will take center stage, and your guests will love exploring the grounds. But there is still so much room for creativity. Making the most of the spectacular surroundings is a no-brainer, so you'll likely want to have both your ceremony and reception outside—that way you can maximize your location. You could have your ceremony under the shade of giant oaks or on an open lawn with green grass stretching for miles. A fountain or sculpture garden on-site would serve as a beautiful backdrop too. Another idea: Opt for a clear tent or pergola to highlight the scenery but still protect guests from the elements. If you do decide to go open-air, many botanical gardens have indoor facilities, such as greenhouses, so you'll have a built-in backup plan.

 With so much to look at, you'll want to enhance rather than compete with the natural stage. The season in which you decide to marry will play a huge role, so look to the colors of the garden and the flowers, foliage, and trees for ideas. If it is spring and the cherry blossoms are in bloom, pink will automatcially become a prominent hue in your palette. You may repeat the flowers in the garden on your reception tables or infuse the feel of the location itself into the overall vibe. For instance, if you're having the celebration in an Asian garden, you could have curly bamboo-stem centerpieces and paper lanterns hanging overhead. Let nature be your guide and allow your imagination to take over completely.

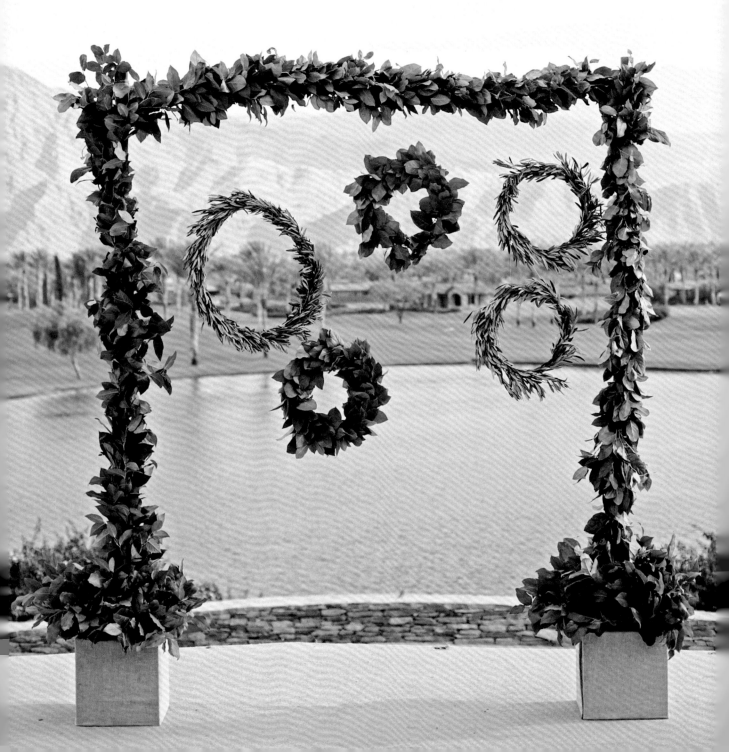

touch of tuscany

nspired by the Italian architecture of their venue in Indian Wells, California, Kendrick and Aron decided they wanted their guests to feel like they had been transported all the way to Tuscany. While the space and the gorgeous mountain landscape did the heavy lifting, décor details, such as the color palette (navy, nude, and pink), crystal chandeliers, and leafy garlands, did the rest.

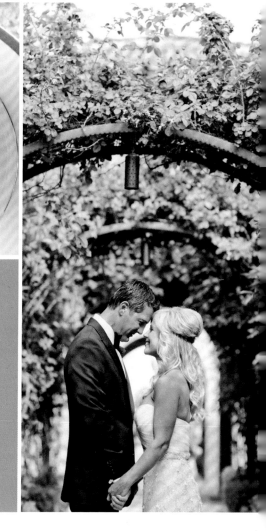

TIP
Don't overdo your color scheme. Flowers are a subtle (and easy) way to incorporate bold hues into your décor.

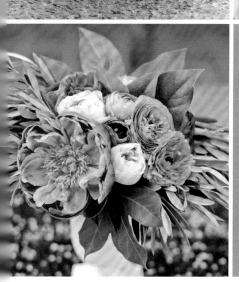

clockwise from opposite: The types of greens in Kendrick and Aron's wedding, including olive leaves, really played up the Mediterranean vibe. ■ They served a traditional Italian cream cake adorned with olive leaves—a more than fitting dessert choice. ■ A scallop design on the menu cards added an old-world touch. ■ Arches and arches of lush greens created a grovelike backdrop for photos. ■ The one pop of color the couple added came through the flowers.

Rustic wood chairs and
café lights were outdoorsy
additions to the linen-
draped tent.

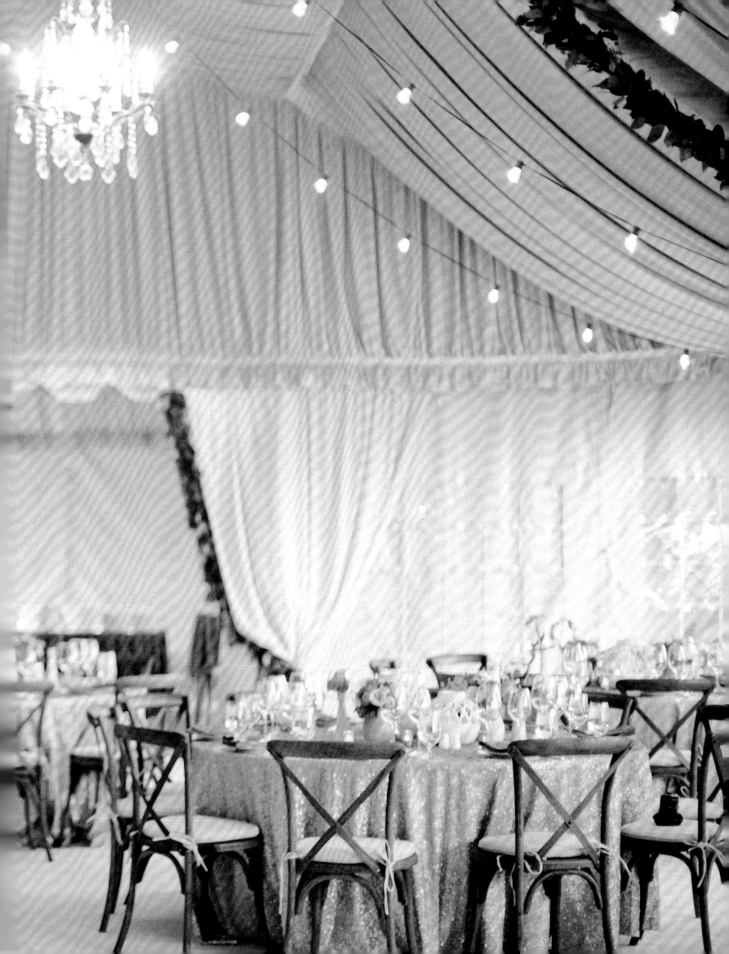

BROOKE & PAUL ▪ SEPTEMBER 29

simple and sweet

Careful not to upstage their venue's natural beauty, Brooke and Paul used a rich, yet subtle, aesthetic to complement the fall foliage. After all, Napa's Meadowbrook Farm was a very personal pick for the couple—it is owned by Brooke's grandparents. A primary color palette of gray and blush, with pops of pink and harvest reds and greens, brought their vision to life.

clockwise from opposite: Vineyards may be all about the grapes, but Brooke and Paul didn't miss a chance to bring in lush florals. ■ Bouquets of garden roses, astilbe, calla lilies, and dusty miller played up the day's sweet color palette. ■ Shabby-chic chairs, tables, and couches in neutral tones created a distinctive lounge space. ■ Brooke styled her hair in loose waves—a fuss-free hairstyle perfect for an outdoor affair with an organic edge. ■ Letterpressed invites set a sophisticated tone for the day. ■ Escort cards in beds of hydrangeas looked totally simple yet chic.

- ♡ -

TIP

A family-owned venue is often
an easy (and sentimental)
choice for a wedding, but be
prepared for loved ones
to have plenty of opinions
on how to use it.

- ∞ -

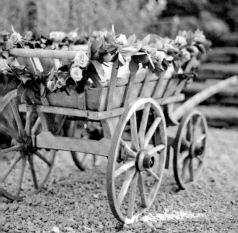

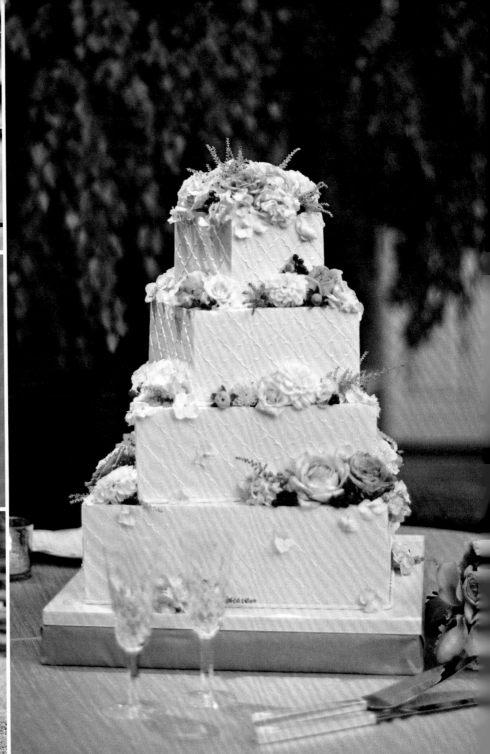

clockwise from top left: No décor opportunity was wasted. An iron gate was spiffed up with a wreath of pale garden roses and dusty miller. ■ Fresh flowers added color to their wedding cake while a subtle quatrefoil design gave it texture. ■ Clean wood tables and low centerpieces looked effortless and highlighted the natural beauty of the property. ■ Festive touches, such as a wagon decorated with a flower garland, played up the charm of the outdoor venue.

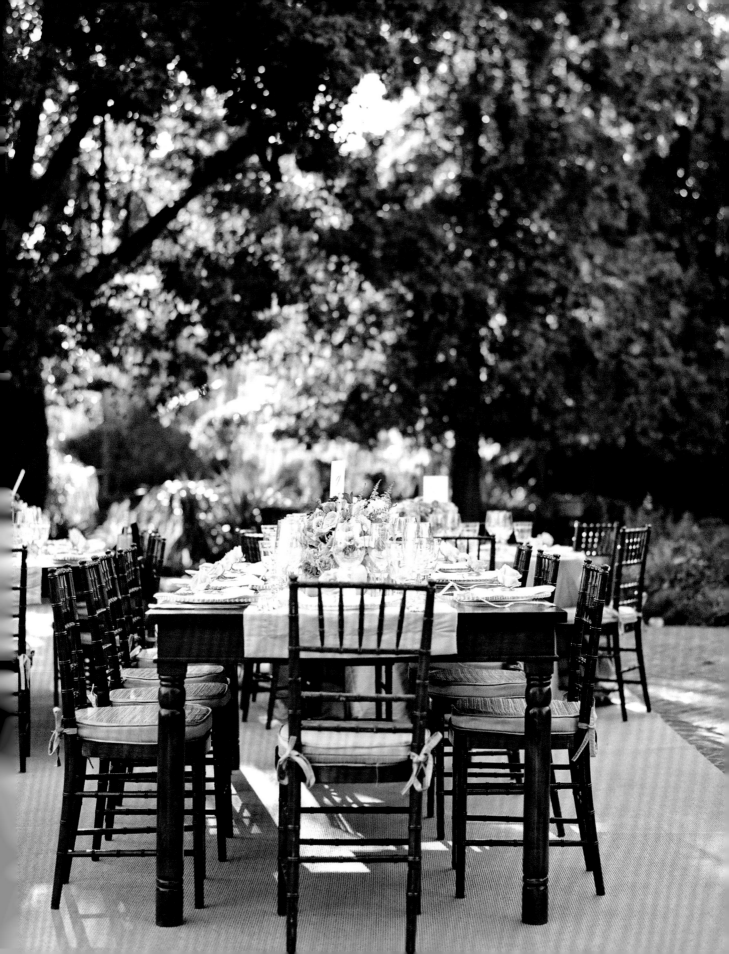

FLOWERS

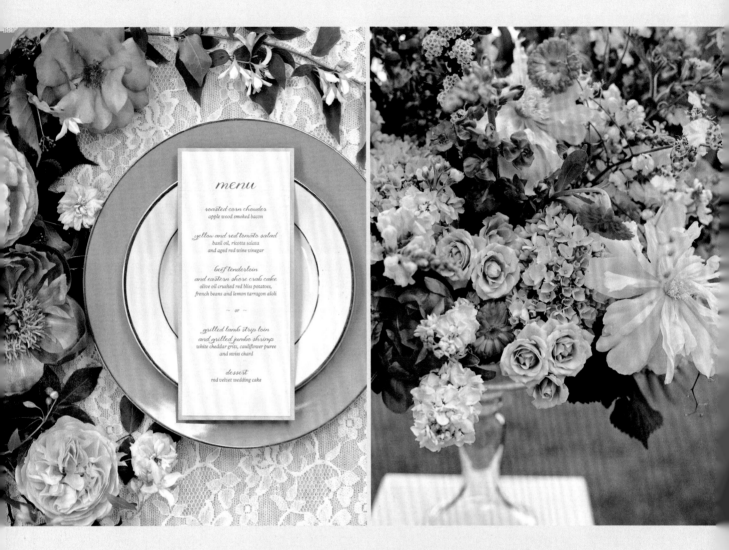

menu

roasted corn chowder
apple wood smoked bacon

yellow and red tomato salad
basil oil, ricotta salata
and aged red wine vinegar

*beef tenderloin
and eastern shore crab cake*
olive oil crushed red bliss potatoes,
french beans and lemon tarragon aïoli

~ or ~

*grilled lamb strip loin
and grilled jumbo shrimp*
white cheddar grits, cauliflower puree
and swiss chard

dessert
red velvet wedding cake

A GORGEOUS GARDEN SETTING IS NATURALLY ABUNDANT IN FLOWERS AND FOLIAGE; LET YOUR SURROUNDINGS LEAD THE WAY TO THE BLOOMS YOU CARRY, SO THEY WON'T COMPETE.

clockwise from above left: You don't have to confine your flowers to a vase or vessel. Instead, let them spill out over the table for a relaxed, undone feel. ■ Nothing says garden quite like an arrangement bursting with color and texture. Mix florals and hues for the ultimate just-picked look. ■ Even the freshest antique roses have just the right amount of vintage flair. ■ Don't forget the chairs—after all, they're the part of your day your guests will be most intimate with! Here, lemon leaves and white lilac look almost too pretty to sit on. ■ Pincushion proteas and dahlias in a footed gold bowl and gilded pomegranates give tablescapes an exotic touch, ideal for a tropical garden. ■ Hanging lanterns take your ceremony décor to new heights. Blush and cream roses and natural greens are timeless accents for a garden affair.

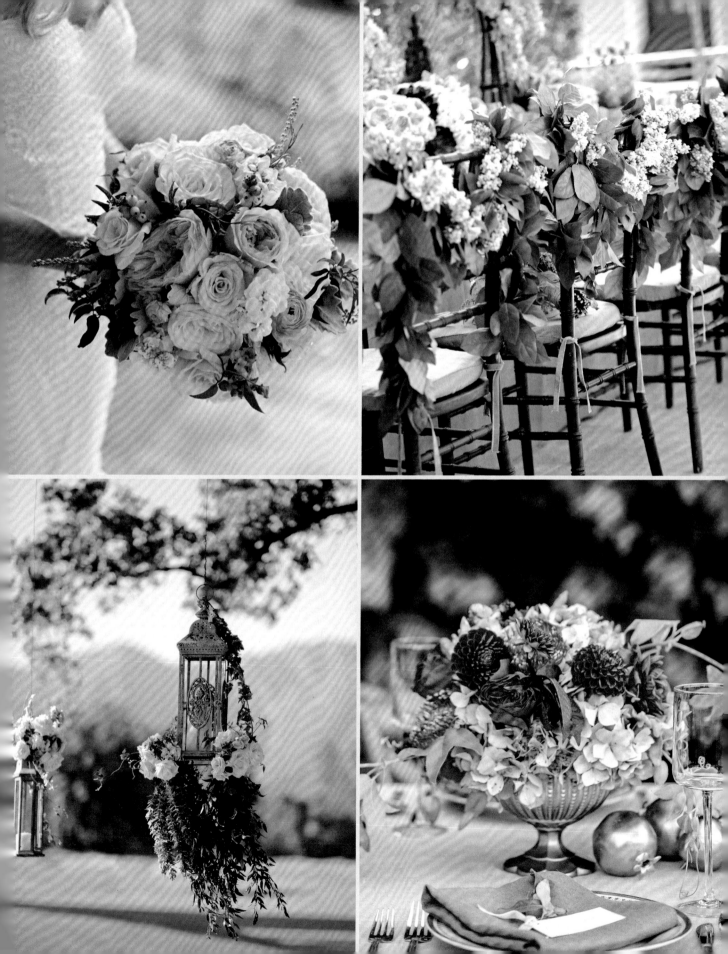

STEPHANIE & SEAN ▪ OCTOBER 7

organic
sophistication

A ceramic teapot made for a creative centerpiece. ■ Instead of traditional paper seating cards, galvanized rounds filled with moss went perfectly with the earthy theme. ■ No detail was overlooked—even the couple's Westie was ready to party in a green-and-white floral collar. ■ Sean's ranunculus boutonniere looked as if it came straight from the garden, but his suit was a formal three piece.

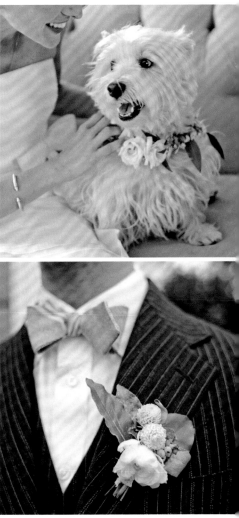

Thanks to a soft color scheme of green, white, and gray, heaps of lush greenery, and towering treelike installations, Stephanie and Sean's indoor reception felt like a natural extension of their garden ceremony. And it wasn't just the color palette; earthy and formal elements combined to blur the line between outdoors and in.

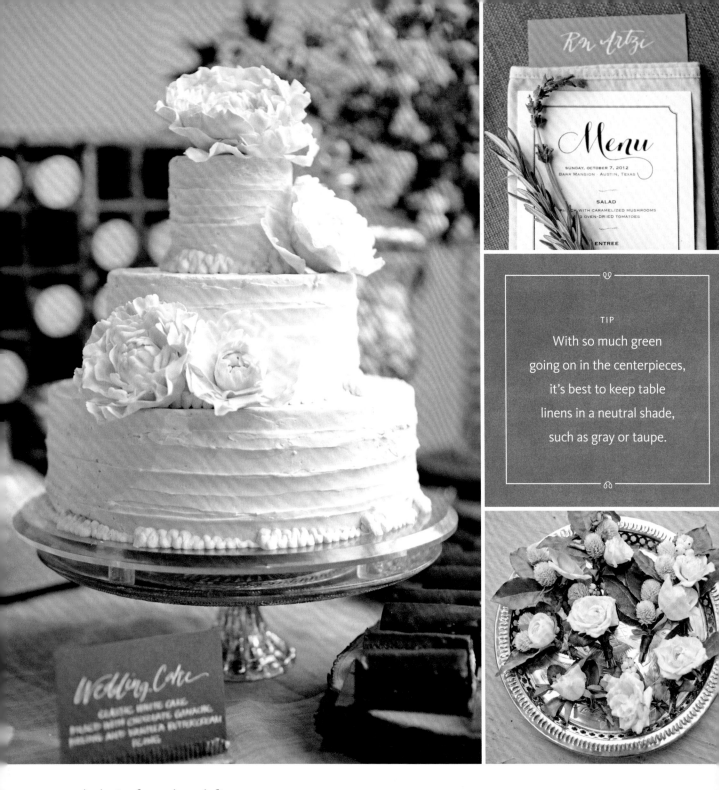

clockwise from above left: Pale-pink sugar peonies added a formal touch to the otherwise homespun feel of the buttercream cake. ■ Small details like sprigs of lavender and rosemary ramped up the garden theme. ■ White ranunculus and silver brunia boutonnieres matched the day's color scheme and sophisticated garden vibe.

Flowers aren't always the most dramatic choice for a centerpiece. Lush tree branches provided an indoor garden effect.

KIMBERLY & CJ ▪ MAY 7

eclectic charm

The inspiration for Kimberly and CJ's wedding was bright, bold hues. Fancy décor and whimsical details, such as chandeliers and antiques, transformed the casual garden setting in Santa Barbara, California, into a totally distinctive reception space—eclectic yet grounded in tradition. Their married name, Gallo, which means "rooster" in Italian, inspired the artwork on the welcome bags and stationery.

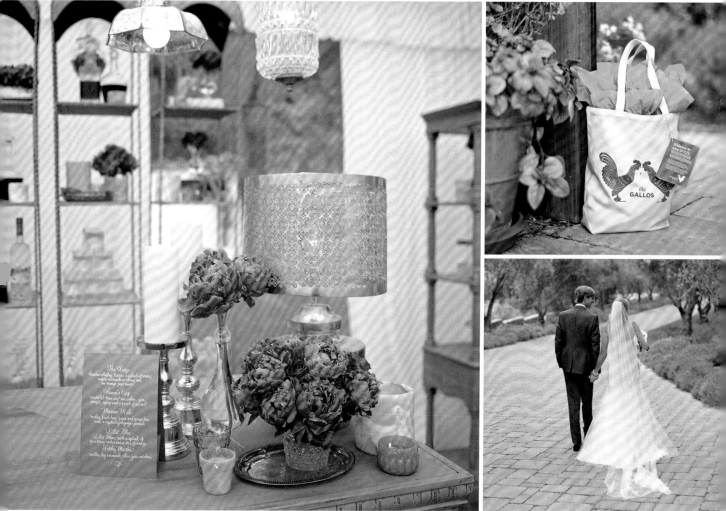

clockwise from opposite: Instead of traditional lanterns, tall wire baskets with pillar candles lined the ceremony aisle. ■ Blue-and-white baker's twine was a whimsical addition to their ceremony programs. ■ Welcome bags filled with goodies and a schedule of events greeted guests in their hotel rooms. ■ Kimberly's dramatic cathedral-length veil complemented her trumpet gown. ■ Lush peonies, aqua votives, and silver candleholders accented the bar.

Playful accents, such as
strands of yellow beads,
were unexpected and fun.

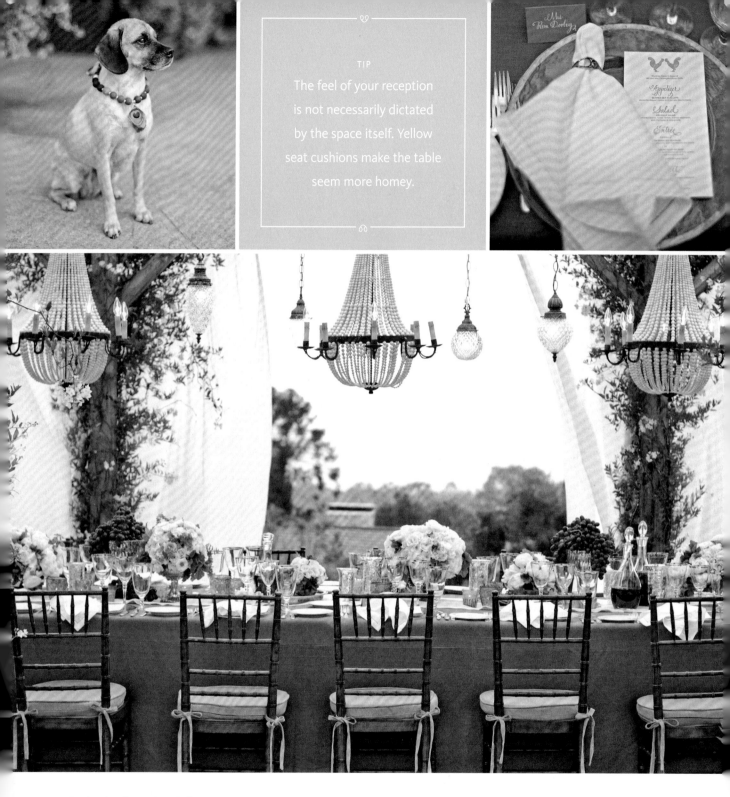

TIP

The feel of your reception is not necessarily dictated by the space itself. Yellow seat cushions make the table seem more homey.

clockwise from top left: Even the couple's dog, Blu, was decked out with a customized collar in the wedding colors. ■ Gold-rimmed glass chargers popped against the slate-gray table linens. ■ Dramatic chandeliers and billowy white fabric upped the formality in this outdoor setting. The crystal stemware, cream-colored blooms, and candlelight created a feel that was more ballroom, yet the wood chairs still maintained the earthiness. The result: a perfect combo.

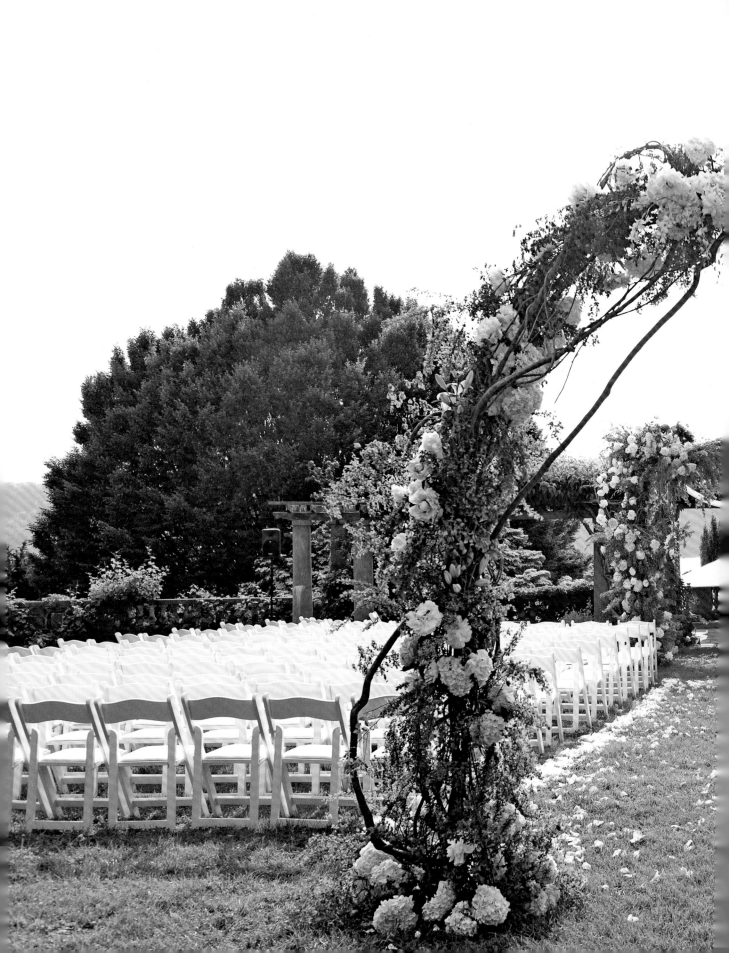

victorian splendor

Gabby and Weston channeled the feel of a classic ballroom for their day but still managed to play up their garden setting along the Hudson River in New York. The trick was finding just the right color palette—white, gold, silver, light blue, and pink—luxe touches, and flowers . . . lots and lots of flowers.

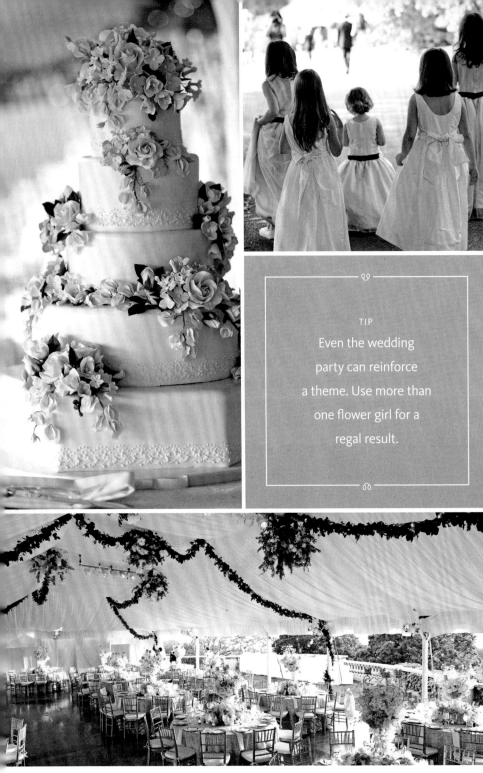

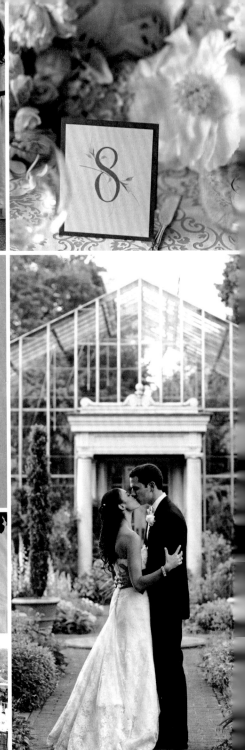

> **TIP**
>
> Even the wedding party can reinforce a theme. Use more than one flower girl for a regal result.

clockwise from top left: A sugar-flower garland was a romantic touch on the wedding cake and a perfect way to show off their wedding colors. ■ Multiple flower girls gave an old-world English effect. ■ Simple table numbers were both elegant and effective—and didn't overshadow the flowers. ■ A glass conservatory is the ideal plan B in case the weather turns foul. Fortunately, Gabby and Weston didn't need it. ■ Lush linen draping transformed the reception tent.

A candelabra covered in blooms added a dreamy touch to the tablescape.

timeless fantasy

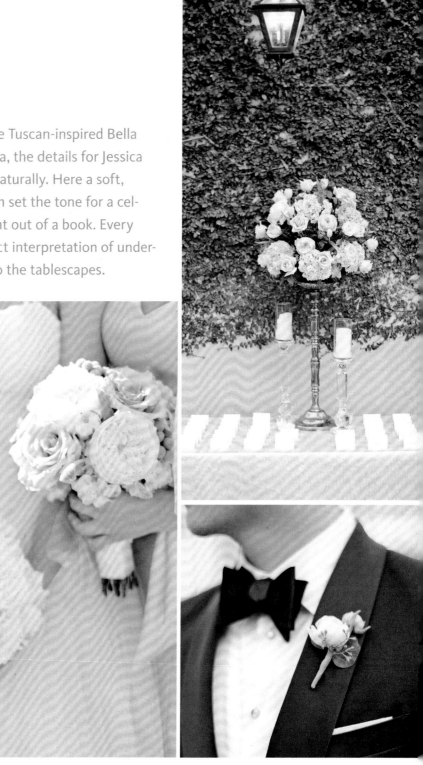

With a gorgeous venue like the Tuscan-inspired Bella Collina in Montverde, Florida, the details for Jessica and Ben's wedding flowed naturally. Here a soft, dreamy color palette of blush and cream set the tone for a celebration that looked like it came straight out of a book. Every piece of the couple's day was the perfect interpretation of understated elegance, from the flower girls to the tablescapes.

clockwise from opposite: Dresses with tulle overlay and floral crowns gave the adorable flower girls even more of an angelic look. ■ A tall arrangement of creamy blooms infused the otherwise minimal escort-card table with romance. ■ The timeless black tux called for an equally classic white boutonniere. ■ The bride and bridesmaids carried bunches of blooms—roses and peonies—in the pale pink and cream colors used throughout the event.

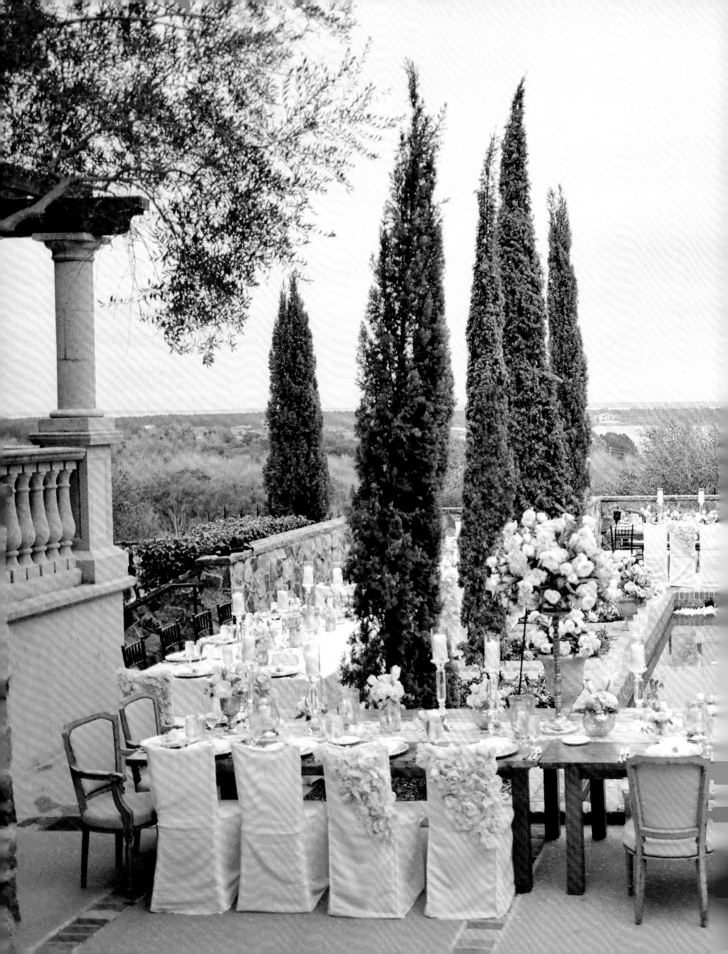

The reflecting pool created a natural focal point for the reception, and the cypress trees and lush flowers made it even more picturesque.

Delicate white embellish-
ments gave the cake an
ornate yet unfussy feel.

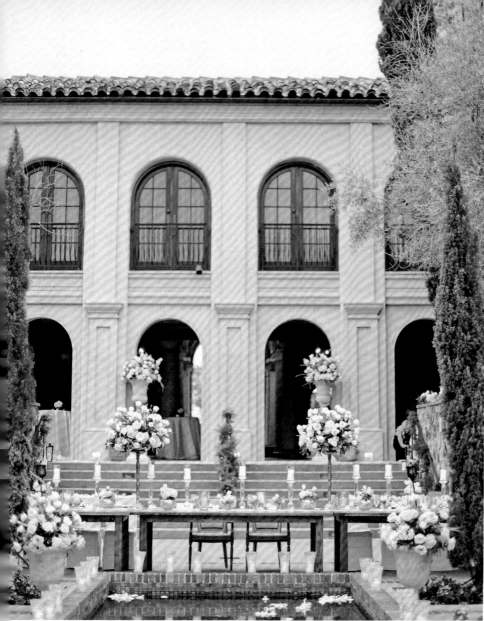

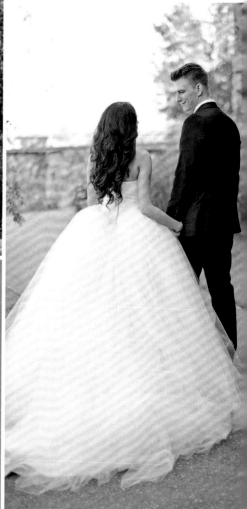

clockwise from left:
Bunches of white florals took
on a starring role in tall vases,
dressing up the formality of the
space. ■ This kind of classic
wedding made a white ball
gown and tux a definite must.
■ Jewel accents on the shoes
were a pretty detail.

TIP

If your venue has a pool,
use it to its best advantage:
as a setting for dinner,
a romantic spot for cocktails,
or even as a base for a clear
dance-floor surface.

CAKES

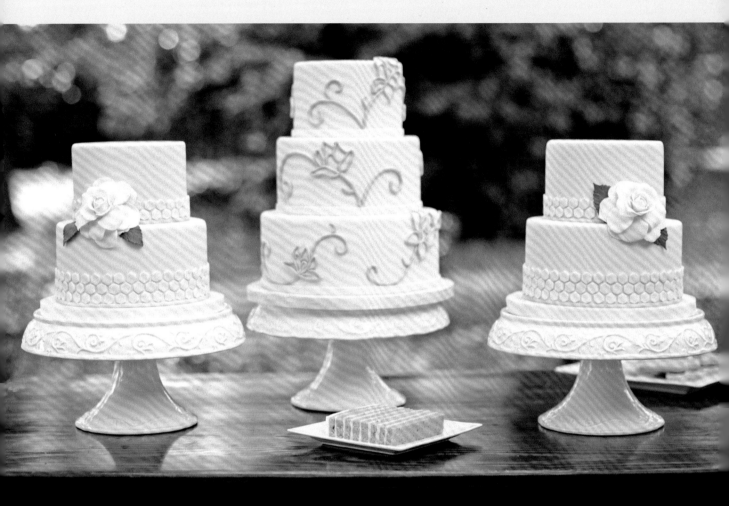

A GARDEN SETTING CALLS FOR A CAKE DECORATED WITH FLOWERS, WHETHER IT'S
FRESH BLOOMS, EXACT LIKENESSES DONE IN SUGAR, OR ARTISTIC INTERPRETATIONS.

clockwise from above: A trio of smaller cakes is a whimsical alternative to the classic single confection. A shared theme—flowers—keeps your sweets looking cohesive. ■ Cascading sugar flower petals and a single pink peony add some feminine flavor to a chic gilded cake. ■ An abstract pattern is a fun, modern take on traditional floral embellishments. And that pink fondant bow is a showstopper! ■ Simple has never looked better. And white on white will never go out of style. Ask your florist about matching the flowers on your cake with your bouquet. ■ Fresh flowers are a timeless, cost-effective way to finish a wedding cake—not to mention a perfect fit for a garden setting. Fondant flowers, while stunning, are more expensive; each one must be molded and painted by hand.

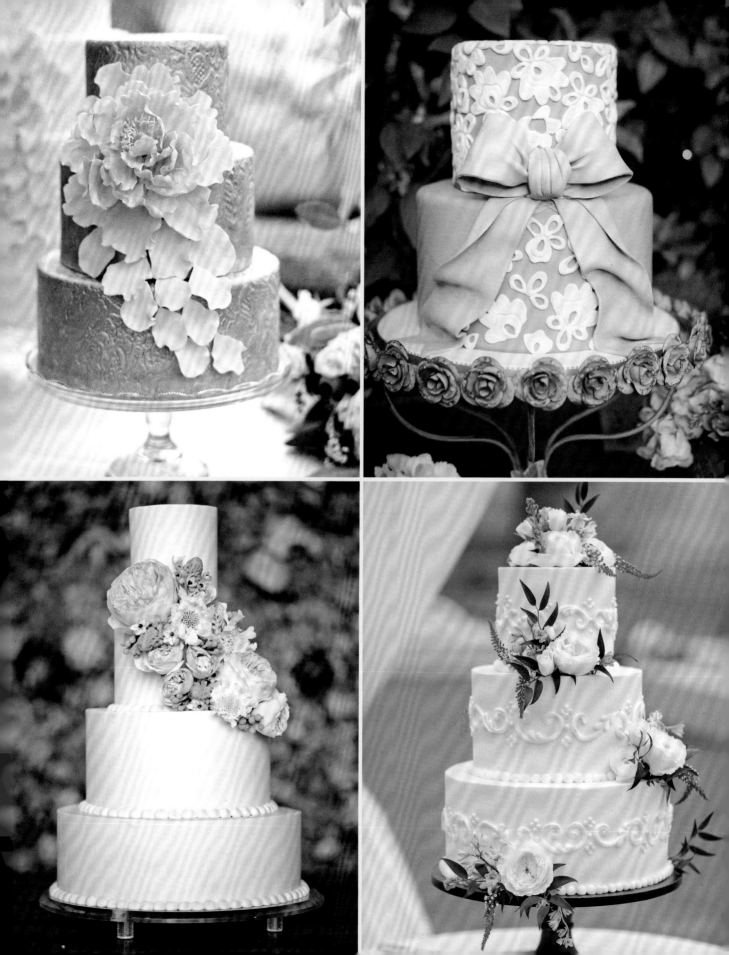

STELLA & TIM ▪ JULY 8

undone glamour

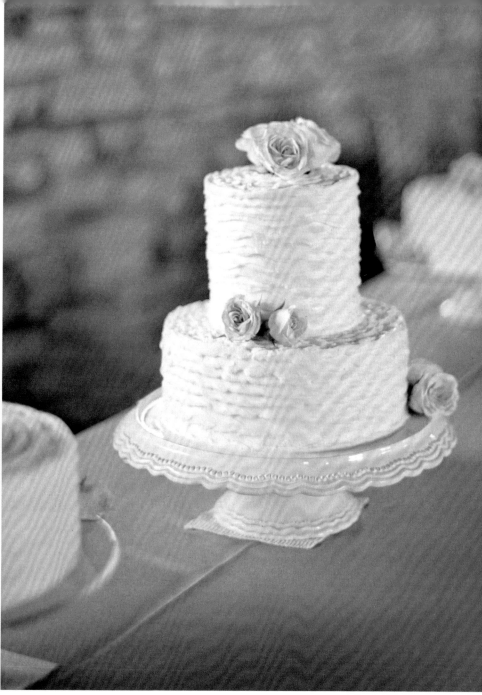

clockwise from opposite:
Stella and Tim loved how the stone ceilings of Mayowood Stone Barn resembled an Italian villa. ■ Multiple cakes are always better than one. Varying shapes and sizes created the ultimate unfussy look. ■ The bridesmaids echoed the lustrous color scheme in pale-gold dresses. ■ Petite arrangements in gilded vases punctuated the space.

With lush garden blooms and rustic wooden details, Stella and Tim's celebration mastered the art of undone glamour. An antique-gold color palette and vintage gilded accents set a tone that was in keeping with the historic venue in Rochester, Minnesota.

TIP

Providing paper parasols may seem like a minor detail, but even a small gesture like this shows guests you care about their comfort.

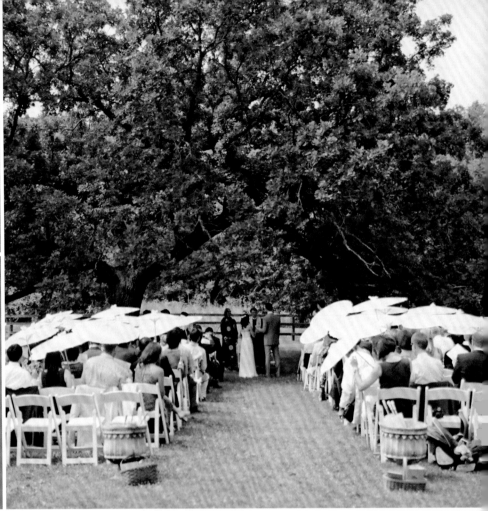

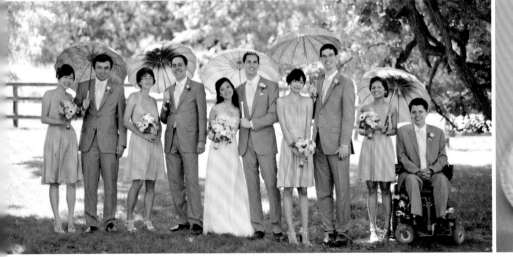

clockwise from top left: Instead of a tux, Tim wore a gray suit and a simple rose boutonniere. ■ The couple married under a lush canopy of trees. ■ Pimm's Cup cocktails were a fun (and summery) addition to the usual water, wine, or beer. ■ Paper parasols blocked the sun and looked incredibly charming in photo ops too.

It wasn't the types of flowers—
garden roses, budding freesia,
and anemones—that were so
perfect (though they were!) but
how they came together.

LOUNGES

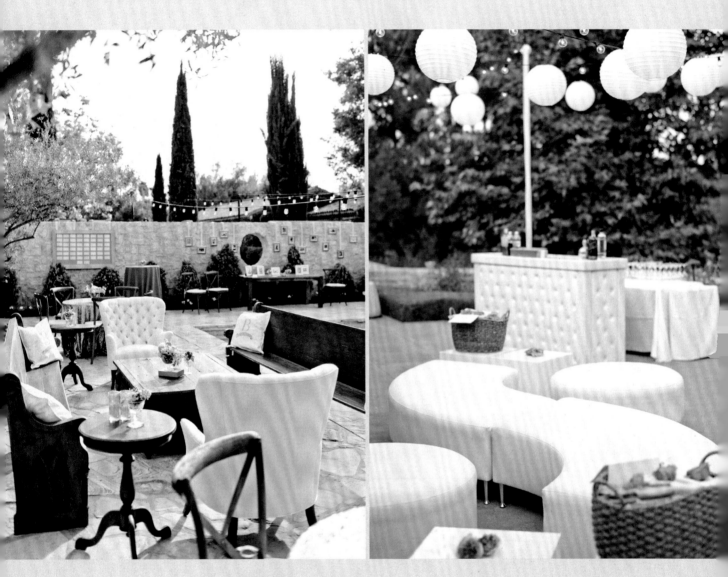

A SPACE FOR GUESTS TO RELAX AND REST THEIR FEET
IS YET ANOTHER OPPORTUNITY TO SHOWCASE YOUR STYLE.

clockwise from above left: A mix of antique church pews (softened with throw pillows) and comfy armchairs allow bigger groups to gather. Add end tables, so guests have a spot to put their drinks. ■ White furnishings with clean, sleek lines set a mod vibe. ■ Black-and-white lounge décor is a foolproof combination for a contemporary look. ■ Colorful pillows, vases, and flowers warm up the all-white pieces. ■ An outdoor wedding is an opportunity to build an inspired space, since you're essentially designing a living room. Here, a vintage-style sofa and tiered table are accessorized with flea-market finds. ■ A low daybed, twinkle lights, and sheer draping are exotic touches in a shady lounge.

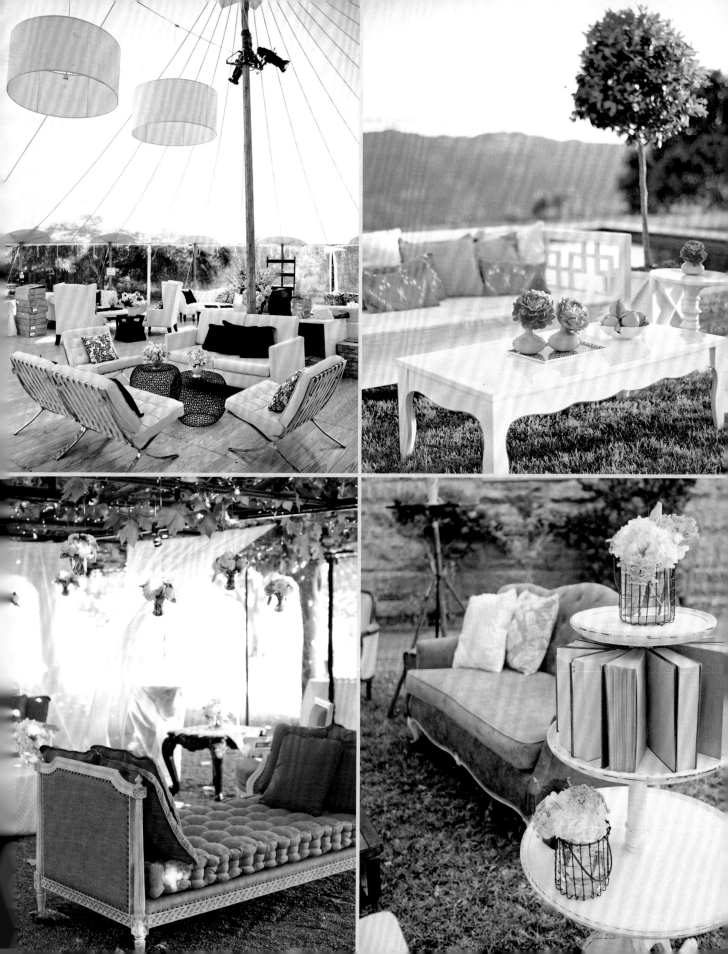

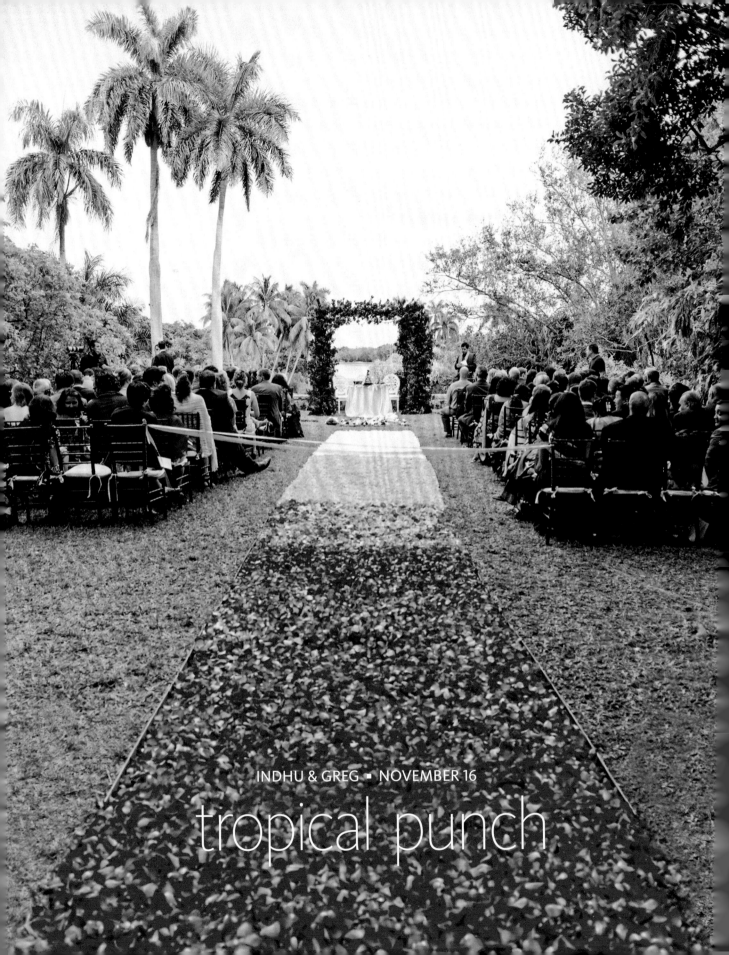

INDHU & GREG ■ NOVEMBER 16

tropical punch

I t's no surprise that Indhu and Greg's wedding was such a vibrant, personal affair. Once the Washington, DC–based pair settled on a botanical garden in Coral Gables, Florida, they set about including pieces of his American and her Indian heritage and infusing every last detail with bold hues. "We equated bright colors with love," Indhu says. The result: a 100 percent original affair. The ceremony was held in Sanskrit inside a *mandap*, a traditional Indian structure, but the couple wore Western attire. And for dinner, they served both an Indian and American buffet to their lucky guests—yum!

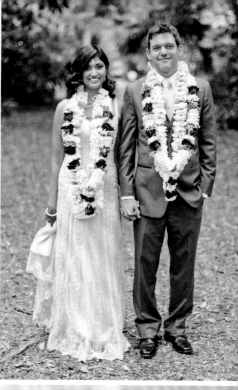

clockwise from opposite: Multihued rose petals created an ombré effect, which made for one knockout aisle! ▪ The couple wore floral garlands (an Indian tradition). For the reception, Indhu changed into a sari designed by her aunt's friend. ▪ Guests were able to customize their drinks at the champagne bar. ▪ Clear vessels lifted centerpieces of purple orchids and tealights high above the tables.

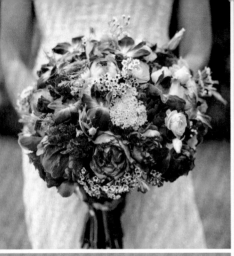

TIP

Don't be afraid to tweak traditions and combine the parts of your heritages that speak to both of you.

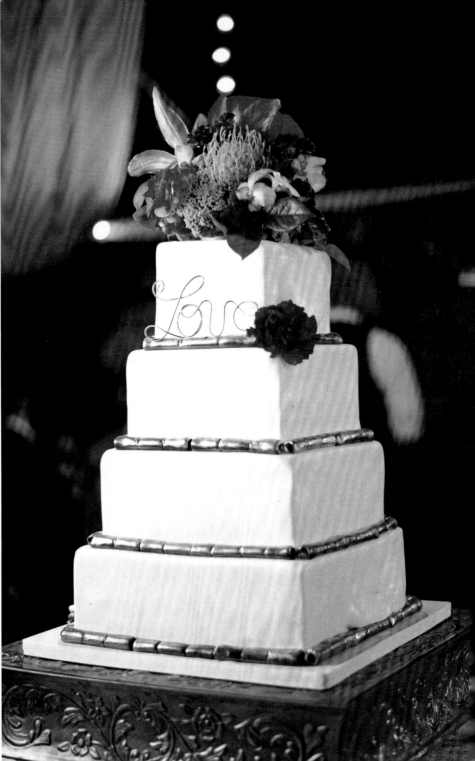

clockwise from bottom left: Table numbers were fashioned out of wire and framed. ■ The bride's bouquet comprised a mix of colorful flowers, including hot-pink peonies, yellow ranunculus, blue orchids, purple lisianthus, and pink and yellow spray roses. ■ Tropical blooms crowned the white cake, which was accented with beads of gold fondant. ■ Low, dense arrangements of bright blooms in wood boxes popped against the sparkly table linens.

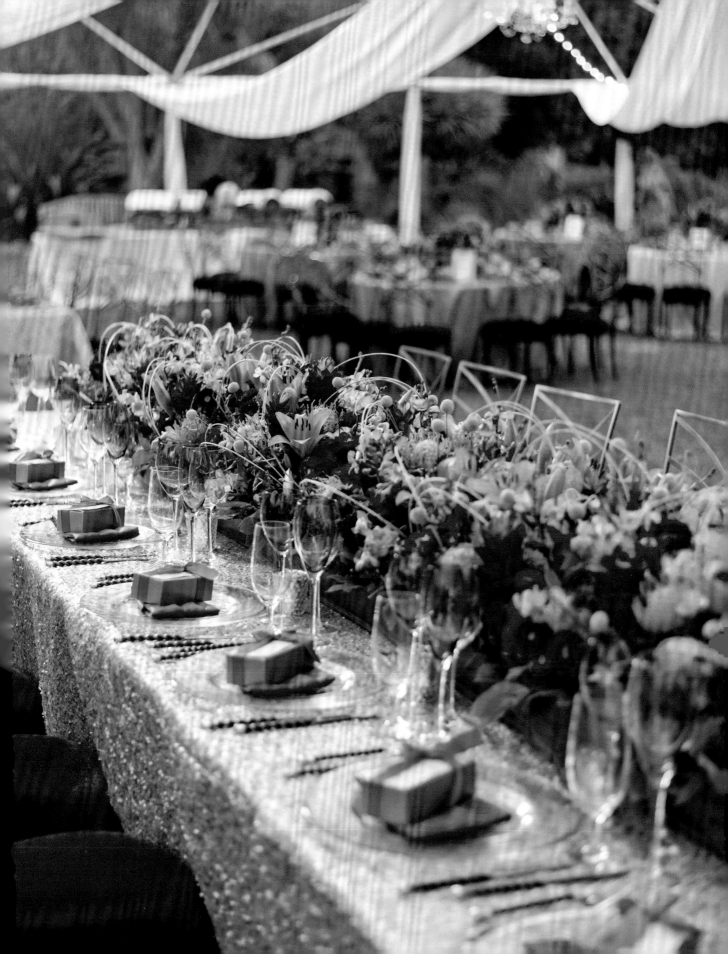

reception tents

NOT ALL TENTS ARE CREATED EQUAL. THEY COME IN A MULTITUDE OF SIZES, SHAPES, FABRICS, AND COLORS.

Frame tents are often flexible in where they can be placed—adjacent to buildings, on hard surfaces, or on properties where the deep stakes of a pole tent cannot be used.

It is best to have a clear-top tent in cooler months, when the temperature is below 75 degrees. Tents act like greenhouses, so even on a day that is not particularly hot, heat will build in a clear-top tent.

When the weather is very hot, remember not only to get fans for the main tent but also for the kitchen and staff tents.

Don't forget to have sidewalls available for your tent on-site, in case a storm blows through. Discuss options for pulling tent sides open or closed during unexpected weather, and make sure you have the ability to add heaters or air conditioners if necessary.

You will need enough lighting for your photographer to get the best shots, but not too much light to remove the intimacy from the event. Depending on the size of the tent and number of poles, consider hanging a few large light fixtures over bars and sconces around the perimeter of the tent.

In addition to the reception tent, you will need a staging tent and a tent for your band, if you're having one. Most bands require, by contract, a separate space to rest and gather, so a 10-square-foot or 10-by-15-foot tent would be ideal. All of your wedding pros will need a place to put their things, so having a 10-square-foot tent to accommodate them is a good idea. Tuck these small tents behind a solid sidewall or a draped wall of the main tent to hide them from your guests.

Your pros will need time to set up, and tear down, the site—and all that goes with it. Consider reserving the site for your wedding day and the morning after, if possible. (Find out if the venue offers a package deal or how much each additional hour will cost.)

Make sure your catering company has experience running tented events. They will not only provide all the right supplies (saving you the hassle of having to rent them) and set up and clean up, but they will also know to have enough waitstaff on hand to look after all of your guests.

Don't rely solely on your tent. Even the sturdiest tents can't withstand heavy rains and fierce winds. Your best bet is to have an indoor backup plan at a nearby reception space or restaurant.

If there aren't any restrooms nearby, you should consider renting them. The general rule of thumb is to have one bathroom or stall for every 35 guests. This way, guests will spend less time standing in line and more time partying on the dance floor. These days, you can find luxury portable restrooms with lots of amenities like in-room music, granite countertops, and air-conditioning or heat, depending on the season.

open-air

OVERHEAD CROSSBEAMS
ARE LEFT UNCOVERED FOR
AN AIRY LOOK.

A picturesque option for outdoor receptions, this kind of tent features a perimeter of pillars that support uncovered crossbeams. Although this leaves your party open to the elements, the result is a feeling of shelter while offering a view of the sky and landscape. Turn to page 104 for another example.

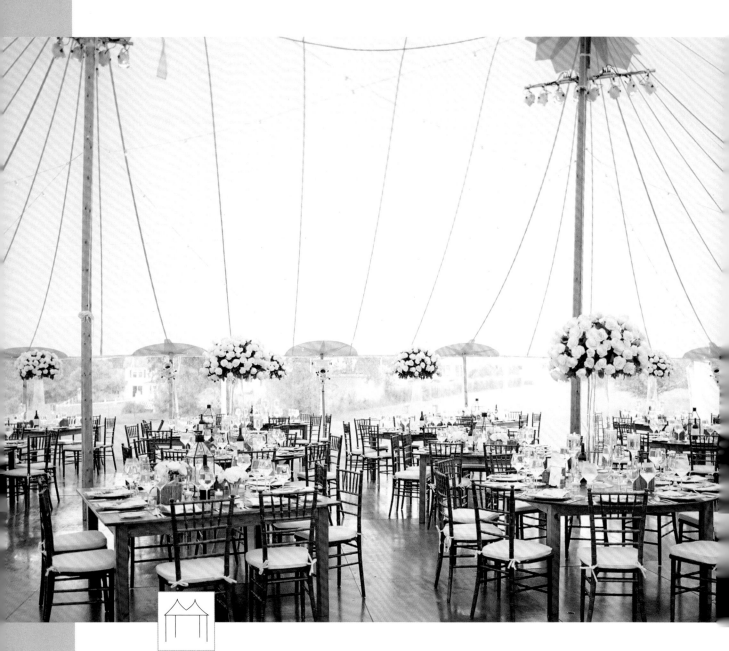

pole tent

THE FORMAL DESIGN HAS A
CENTER PEAK, INTERIOR POLES,
AND A LOFTED SHAPE.

This is a popular option, also seen on page 30, that works for many types of weddings. There are new types of pole tents constructed from sailcloth with support poles made of wood; the natural feel is ideal for a rustic-inspired look. If you're concerned about the weather from the get-go, consider a marketplace tent since they are usually completely enclosed. The roofline on these tents peaks in the middle and supports sloped panels extending from either side.

frame tent

THIS HAS NO INTERIOR POLES,
BUT THE FRAME IS VISIBLE
FROM THE OUTSIDE.

Another common choice, the top of this type of tent is secured to the frame, which is supported by legs around its perimeter. The absence of interior poles creates an open, unobstructed feeling in this traditional tent. Find another example on page 37.

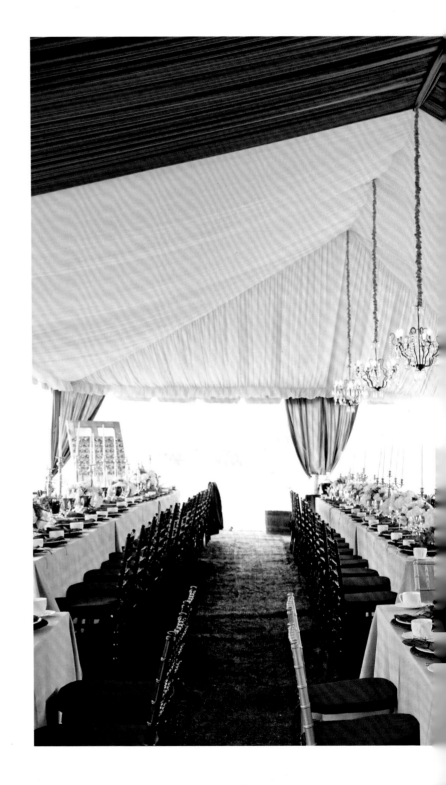

gable-end tent

A FANCIER VERSION OF A FRAME TENT, THIS KIND HAS FABRIC PANELS WITH A SCALLOPED EDGE THAT CAP EACH END.

The design of a gable tent, also seen on page 108, lends itself to a more formal reception. Aside from the fabric of the tent, you can add dramatic draping to the ceiling so the feel is even more elaborate. Work with the rental company to figure out what size is best and where to place it on the property.

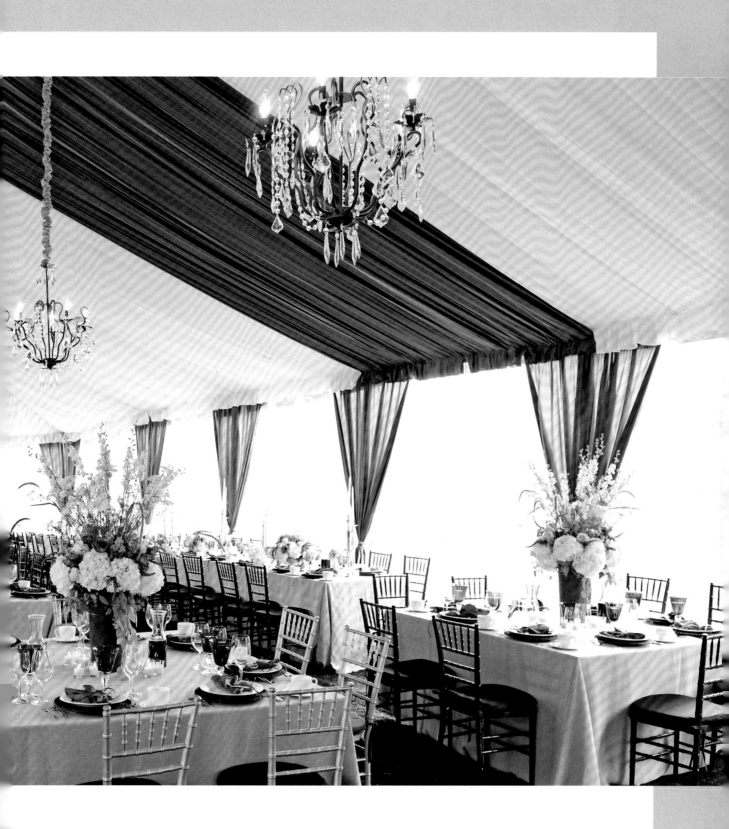

garden wedding basics

From the big details to the little ones, find out the secrets to pulling off the garden wedding of your dreams.

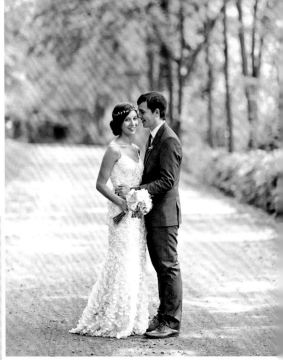

colors

The last thing you want is to overwhelm your gorgeous venue with your color scheme—you chose to get married in a garden for a reason! Let the grounds take center stage with a neutral color palette of organic hues. Use subtle shades of white, blush, brown, green, and blue as your base, and accentuate it with brighter colors, such as red, purple, and hot pink. Also, find out what is blooming and try not to compete with the colors and feel of that time of year.

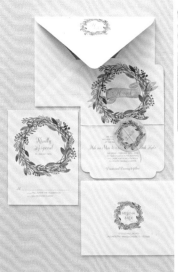

attire

Lace gowns are a classic choice for garden weddings, but don't feel like you're married to that option (sorry, we couldn't resist). You may want to skip the long train and cathedral-length veil—these will end up dragging and getting dirty. As for your groom, he might look a bit out of place (not to mention, sweaty) in a traditional black tuxedo. Instead, encourage him to try a more "undone" look. Think: brown, blue, or gray, or a vest versus a jacket.

try these
color combos

cream & light blue

green & taupe

blush & brown

stationery

From the invites to the escort cards, stationery plays an important role in every part of your day. Hint at your garden setting by using a floral motif in the invitations and carrying it throughout the rest of the wedding papers. Saying "I do" in a rose garden? Give guests a glimpse of what's to come with a border of roses on the invites, menu cards, and save-the-dates. Getting married in a gazebo? Work an illustration of it into the invitation suite and programs for a meaningful touch. Kraft paper is another great way to infuse some "garden" into the stationery.

menu

Your food should complement your natural setting. Work with your caterer to come up with a menu based on locally sourced, in-season ingredients. This will whittle down your options (read: make your choices easier) and save you money. For an extra-special touch—and if they're available—inquire about incorporating ingredients grown right there at your venue into the meal. Also, consider avoiding foods that spoil quickly in the sun, like fruit and cheese in particular. If you have a tent, position the food beneath fans. The circulating air will keep it a bit more temperate and shield the platters from flies and other bugs.

favors

Send guests packing with favors that echo your day's romantic garden setting. Gift them with small potted flowers or seed packets and encourage them to plant them at home. Bonus: Your guests will think of your wedding every time they water them! There are websites that will customize the packets for you, or you can make it into a fun DIY project for you and your bridal party. For a garden party with Victorian flair, consider loose-leaf tea packaged with a sweet thank-you note. Small jars of honey are another good idea; after all, a garden would be nothing without some hardworking bees.

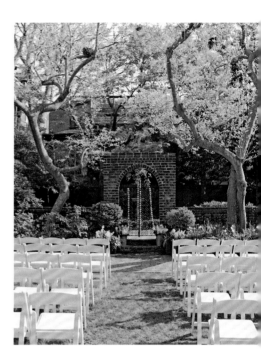

other considerations

Wind can become a challenge when setting up your event. If you are using paper escort cards, think about how they will stay put. Attached to ribbon, made of rocks, tucked into grass, nestled in shutters, tied to branches—there are dozens of pretty ways to display the cards that will keep them grounded. Have linen clips for your tables to keep tablecloths from blowing off. Battery-operated candles or LED votives are a good option as well. And then there's the issue of bugs. Consider having your site sprayed by an exterminator two days before the wedding to guard against insects. Placing citronella candles throughout the space will also help to keep any bugs away.

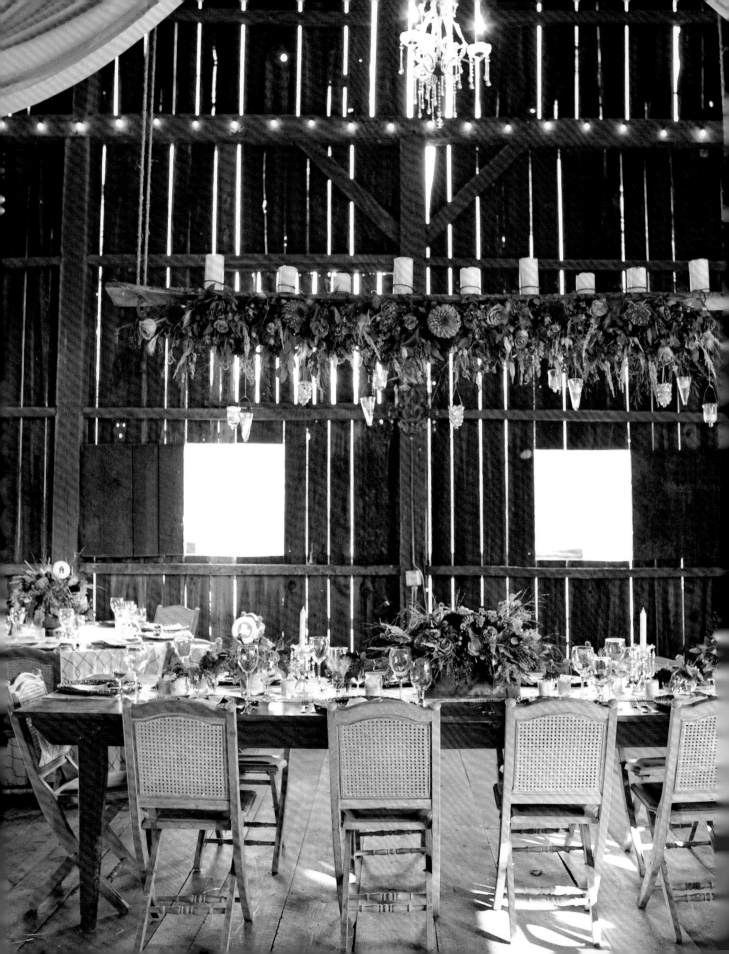

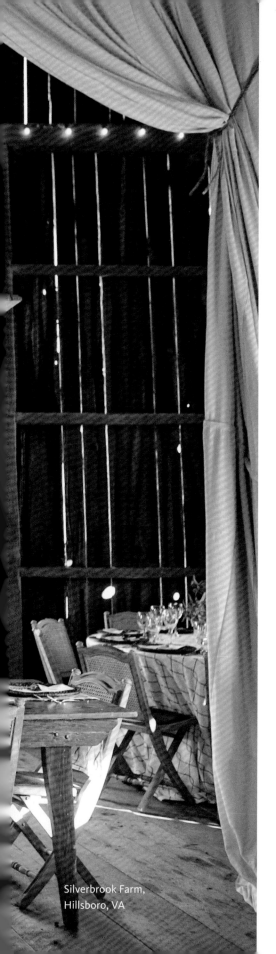

Silverbrook Farm,
Hillsboro, VA

4

RANCH

A rugged setting is paradise found for nature lovers and anyone who can appreciate amazing scenery. The right awe-inspiring spot—a working ranch, an open range, or the foothills of a mountain—is just waiting to be claimed for your wedding. And when you have majestic peaks, valleys, or vast fields as your setting, there's little need for fancy décor. You'll most likely want to have an open-air ceremony to take advantage of the glorious backdrop—think of the photos! (Just keep in mind that many national and public parks require a permit, but luckily, it's usually free.) But when it comes time for dinner and dancing, a barn or a tent can provide shelter and foster an intimate feeling while staying connected to the alfresco setting.

A wedding in the great outdoors naturally lends itself to a country feel (think: wood accents and earthy tones), yet you can make it more formal by dressing up the venue (like a barn, for example) with crystal chandeliers and silver. You'll want to work within the setting, so you don't end up detracting from it. Nature provides the best décor imaginable: Line an aisle with pinecones, use birch rounds as chargers, or have painted wood signs lead the way around your wedding site. A rustic spot can take so many shapes. Use your individual style to achieve the look you're after—be it country, shabby chic, or glamorous. The scenery itself will take care of the rest.

rocky mountain romance

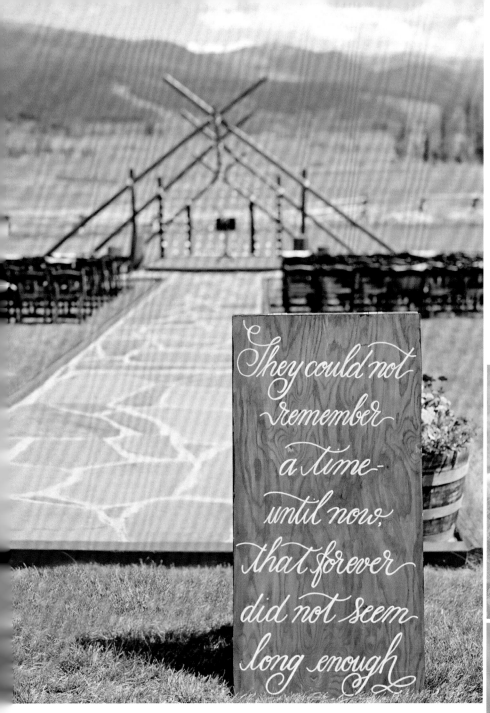

clockwise from opposite: Jessica and Greg fell in love with the views at Devil's Thumb Ranch in Tabernash, Colorado—making it an easy choice for their wedding day. ▪ A bare wood arbor didn't obstruct the scenery behind the couple as they said their vows. ▪ A sentimental detail: The front of the ring bearer pillow was printed with the pair's wedding invitation. ▪ Drink stirrers with little "Cheers" flags made the cocktails even more spirited.

Jessica and Greg added romance to the Colorado ranch's no-frills look with a sweet color palette of pink, peach, and neutral tones. Blue skies, grassy knolls, and a sprawling landscape provided an amazing backdrop for a wedding in the shadow of the Rockies.

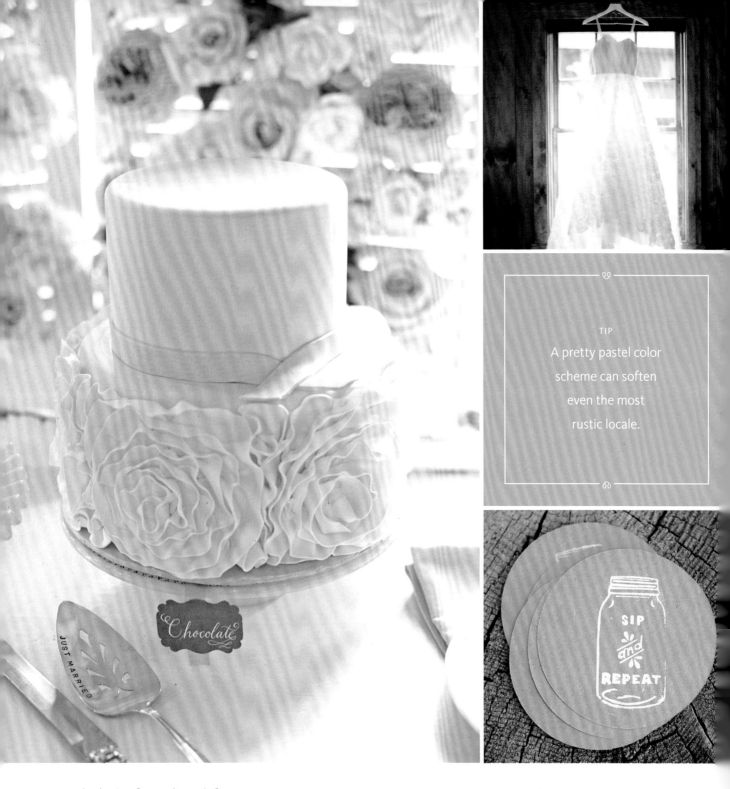

TIP A pretty pastel color scheme can soften even the most rustic locale.

SIP and **REPEAT**

Chocolate

JUST MARRIED

clockwise from above left: The two-tier fondant cake had pink ribbon and rosettes that mirrored the details on Jessica's gown. ■ Rosettes added unexpected femininity (for a ranch!) to the skirt of her dress. ■ Long reception tables were topped with small arrangements of scabiosa pods, hydrangeas, garden roses, and dahlias that looked like they could have been plucked from a nearby meadow. ■ Custom drink coasters were a lighthearted addition to the cocktail hour.

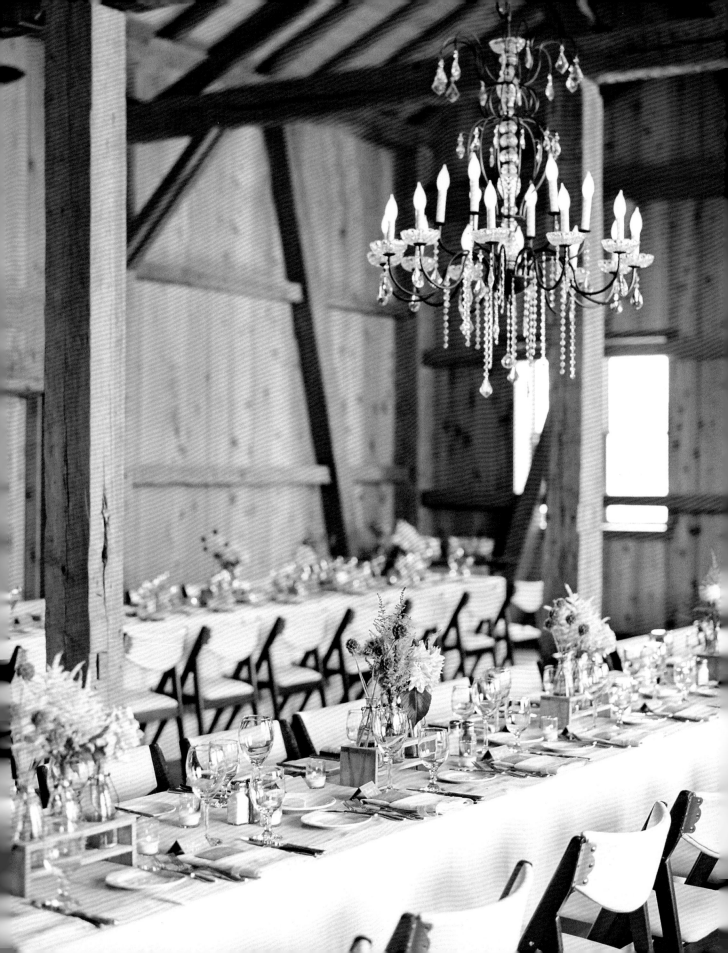

you are my sunshine

MERYL & JON ▪ SEPTEMBER 15

wooded
whimsy

After eight years together, Meryl and Jon were married on the gorgeous California ranch where her family had been vacationing for more than 25 years. With so much nostalgia surrounding the setting, it was important to them to maintain its aesthetic by letting it dictate the day's rustic décor. Buoyant oranges and silver accents brightened up the woodsy details.

clockwise from opposite: Sycamore trees were a striking backdrop for the ceremony space. At the end of the grassy aisle, a vintage Spanish carved wood table served as a unique altar. ■ Textured arrangements received a polished touch by way of ornate vases. ■ A little oak leaf, a nod to the venue, was packaged with each individual invitation. ■ Guests hitched a ride to the wedding reception in a wagon—naturally!

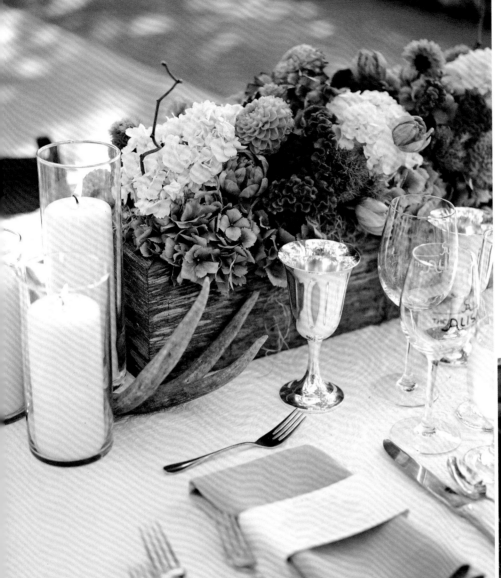

clockwise from left:
Weathered window boxes were a homespun take on centerpieces. ■ The rings were held in a dish engraved with the wedding date and "You are my sunshine"—a saying they wove throughout the day. ■ Meryl carried a mix of dahlias, dusty miller, cabbage roses, and peonies. ■ The flower girls wore woodland-inspired crowns.

> **TIP**
> Look to the season to help dictate what flowers you choose. Autumn, for example, is a perfect time to use orange blooms.

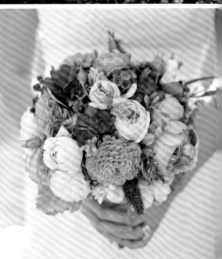

An open-rectangle setup meant nobody missed out on any of the action during the reception.

FLOWERS

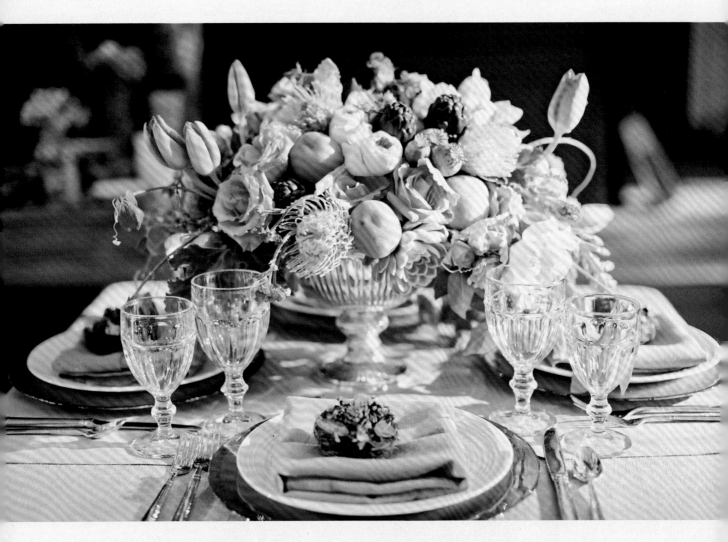

A RUSTIC VENUE IS FAR FROM FUSSY, SO SHOULDN'T YOUR FLOWERS FOLLOW SUIT?
SKIP THE STRUCTURED STUFF IN LIEU OF SOMETHING A BIT MORE WILD, TEXTURED, AND FREE.

clockwise from above: Give centerpieces a modern spin by incorporating local, seasonal produce, like artichokes and peaches. It's a nice way to pay homage to your location and bring interesting texture to the arrangement. ■ An eclectic mix of flowers and foliage, such as gold zinnias, red dahlias, cream roses, scabiosa pods, seeded eucalyptus, and hypericum berries, hits just the right note in a loose bouquet.

■ Flanking the ceremony aisle with natural wood planter boxes filled with a variety of greenery and branches helps set the tone. ■ A handful of tall centerpieces can look out of balance on long farmhouse-style tables. Instead, set out lots of small, low arrangements in a row. ■ If it's rustic romance you're after, try a cluster of glowing lanterns and a canopy with cascading drapery and leaves.

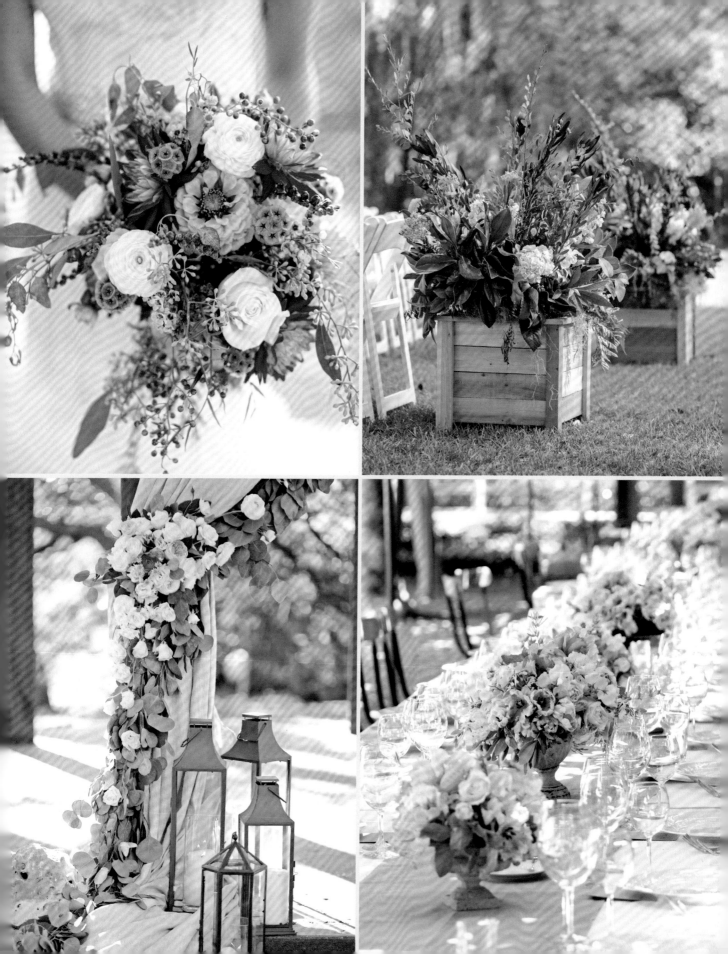

KRISTA & BRICE ▪ MARCH 30

hill country vintage

Krista and Brice
SATURDAY, THE THIRTIETH OF MARCH
two thousand thirteen

BABY SPINACH SALAD
fresh baby spinach, feta cheese, sugared strawberries, candied
pecans, mandarins, granny smith apples, topped with a homemade
raspberry vinaigrette

HEAVENLY STUFFED CHICKEN
breast of chicken stuffed with goat cheese, cream cheese, and black
forest ham, then breaded and sautéed and topped with poblano
cream sauce

ROSEMARY ROASTED NEW POTATOES

CHARGRILLED ASPARAGUS

YEAST ROLLS

DESSERT
Wedding Cake

With Krista's family's incredible Texas ranch (it dates to the Civil War!) as their backdrop, she and Brice put together a romantic affair full of sweet vintage touches and plenty of her favorite color, purple. From the antique church pews at the ceremony to the mismatched china at the reception, the magic was truly in the details.

JUST MARRIED

TIP
Instead of taking a literal approach to your color scheme, pick your main color and play around with it in different shades. This keeps everything from looking too uniform.

clockwise from opposite: Krista's nieces looked adorable in wildflower crowns and purple sashes. ■ Letterpressed menu cards were propped up with wood stands made by the bride's brother. ■ The lace pattern on the wedding cake echoed the detailing on Krista's gown. ■ The newlyweds arrived at the reception in farm fashion in a friend's horse-drawn carriage. ■ Long farmhouse-style tables paired with mismatched chairs added to the vintage, down-home feel.

Hanging rose pomanders
added a sweet pop of color
to the ceremony site.

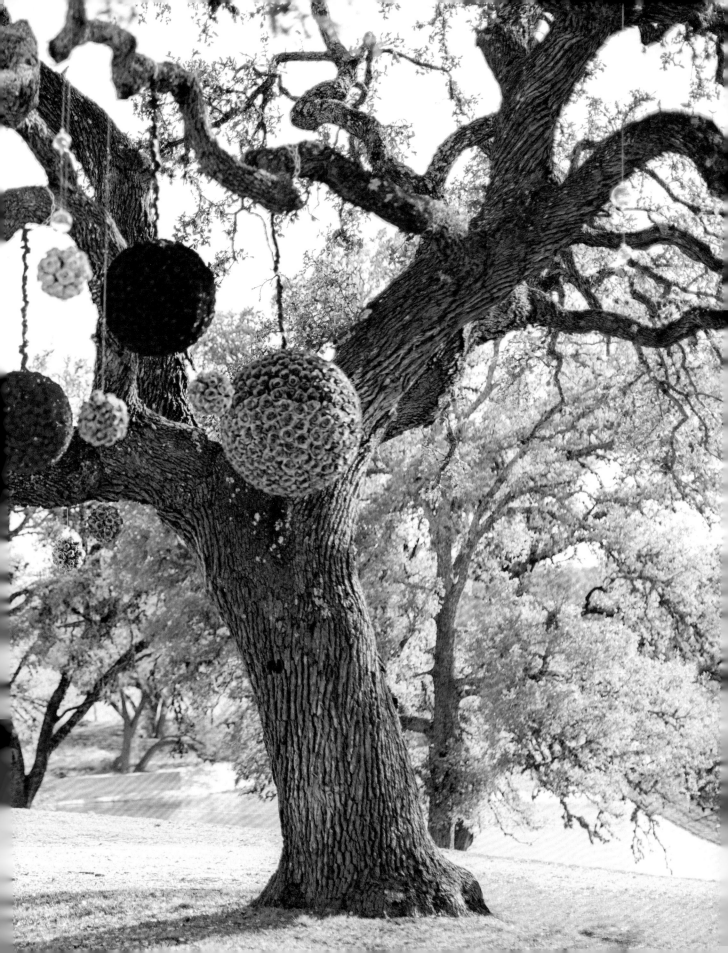

MATTHEW & PETER ▪ SEPTEMBER 8

majestic minimalism

S an Francisco couple Matthew (opposite, left) and Peter had their hearts set on an open-air, mountain setting for their wedding—and ultimately fulfilled that vision with a romantic sunset ceremony in Utah. Splashes of green, tangerine, and charcoal complemented their all-white reception décor and reflected the pair's modern, sophisticated taste.

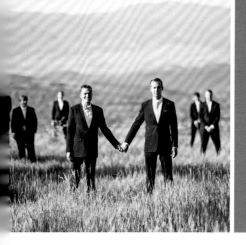

TIP

Same-sex couples should coordinate but still show off their individual styles: Matthew wore a more casual necktie and cuffed his pants, while Peter donned a bow tie.

clockwise from opposite: All 11 groomsmen wore their own black suits with shirts and ties to coordinate with the grooms. ■ A wood sign led the way to the ceremony. ■ Slate boxes filled with orange orchids, manzanita branches, and greenery decorated the white tables at the Main & Sky. ■ Custom ceremony programs (designed by Matthew!) featured silhouetted evergreens. ■ Since Peter's family has a house in Park City, the location was extra-meaningful to the couple.

patterned and posh

clockwise from opposite:
A giant protea burst from Anne's untamed bouquet. ▪ No ranch wedding is complete without horseshoe drink stirrers. ▪ A ranch-ready pair of cowboy boots was a must-have for Anne. ▪ The black, white, and kraft-paper stationery suite mixed patterns and materials for a cohesive look. ▪ A fabric tepee provided the littlest attendants with a quirky clubhouse.

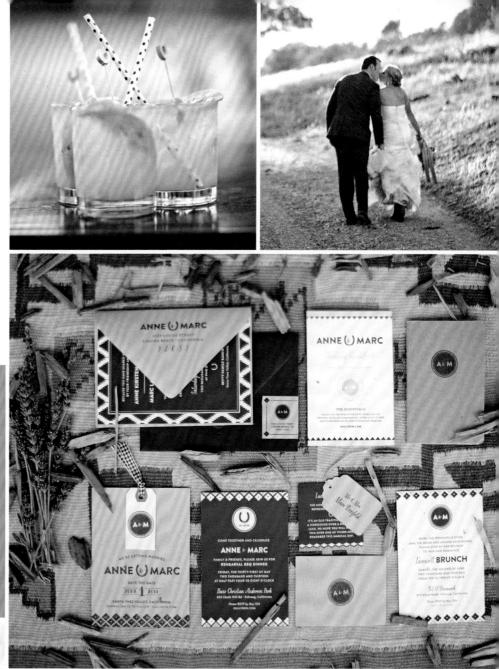

TIP

Inviting kids to your wedding? A separate space for them to hang out and a little entertainment can go a long way toward keeping them happy and occupied. Priceless!

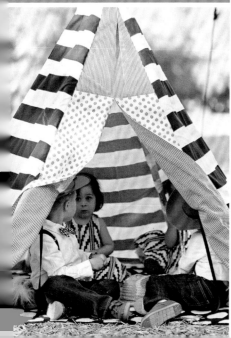

When Anne and Marc decided to host their wedding at Anne's family's 800-acre ranch, which has no running water or electricity, they quickly realized they would need to build a small city. The couple updated the raw space with a contemporary black-and-white color palette and mixed Western motifs for a bohemian aesthetic that was completely their own.

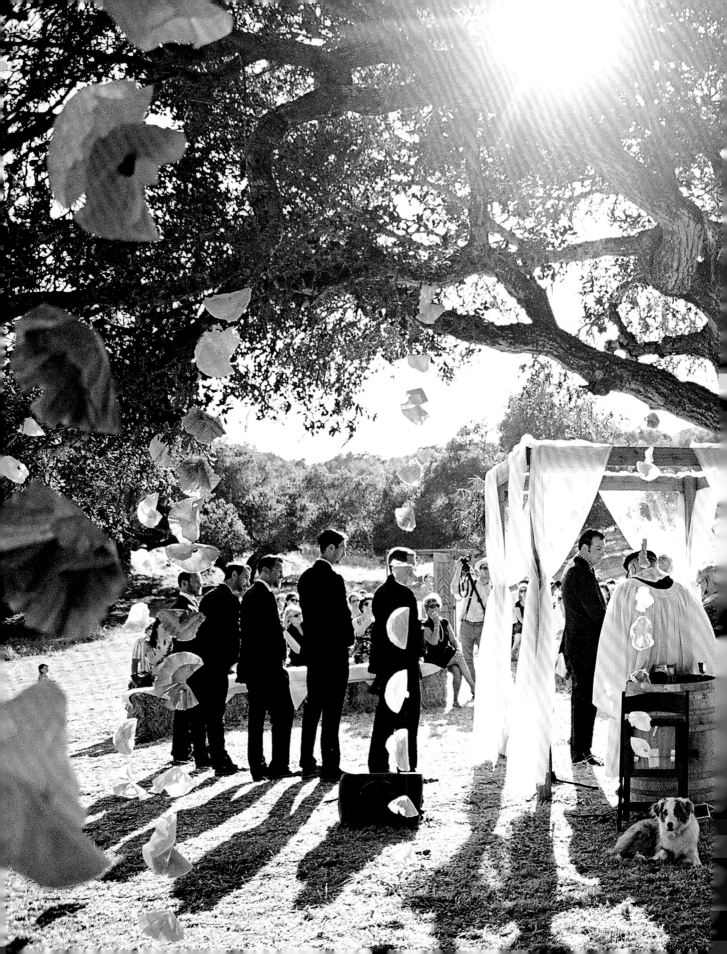

A draped huppah was the focal point of Anne and Marc's interfaith (Jewish and Christian) ceremony.

CAKES

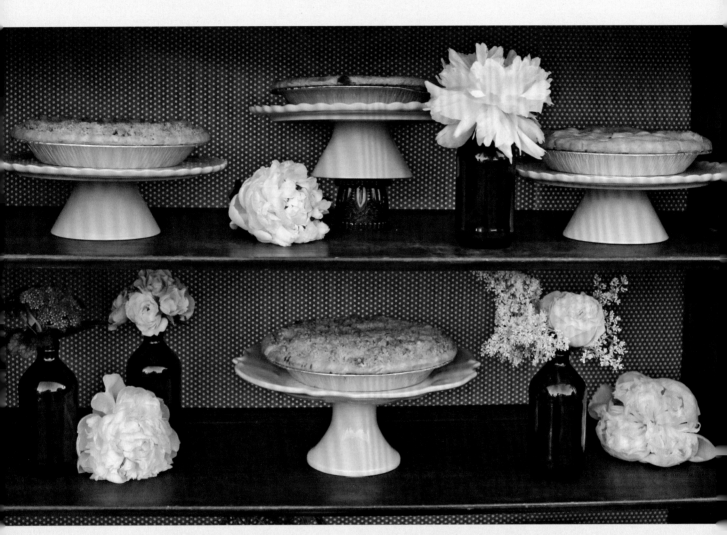

INJECT A SHOT OF FEMININE FLAVOR INTO YOUR DAY WITH SWEET-LOOKING CAKES (OR PIES!). PASTEL COLORS AND DELICATE DETAILS HELP BALANCE OUT THE RUGGED VIBE OF A BARN OR RANCH.

clockwise from above: Nothing beats a selection of farm-stand-fresh pies for a country-chic wedding. Fill them with seasonal fruits and then sweeten things up even more with a pretty display of pastel cake stands. ▪ If you thought ruffles were just for wedding gowns, think again. For a seriously elegant look, opt for a tier of light and airy frills topped off with a few fresh blooms. ▪ Metallics are a natural match for the woodsy surroundings of a barn or ranch, so go for the glam with a gilded cake. Use texture and lines to play up the *faux bois* feel. ▪ A soft pink cake with delicate lace details and a crown of girly blooms is a lovely contrast to rural backdrops. ▪ There's no need for fussy formality when you are down on the farm. Whimsical loopy lines lend themselves well to a more playful, laid-back vibe and subtly hint at lassos.

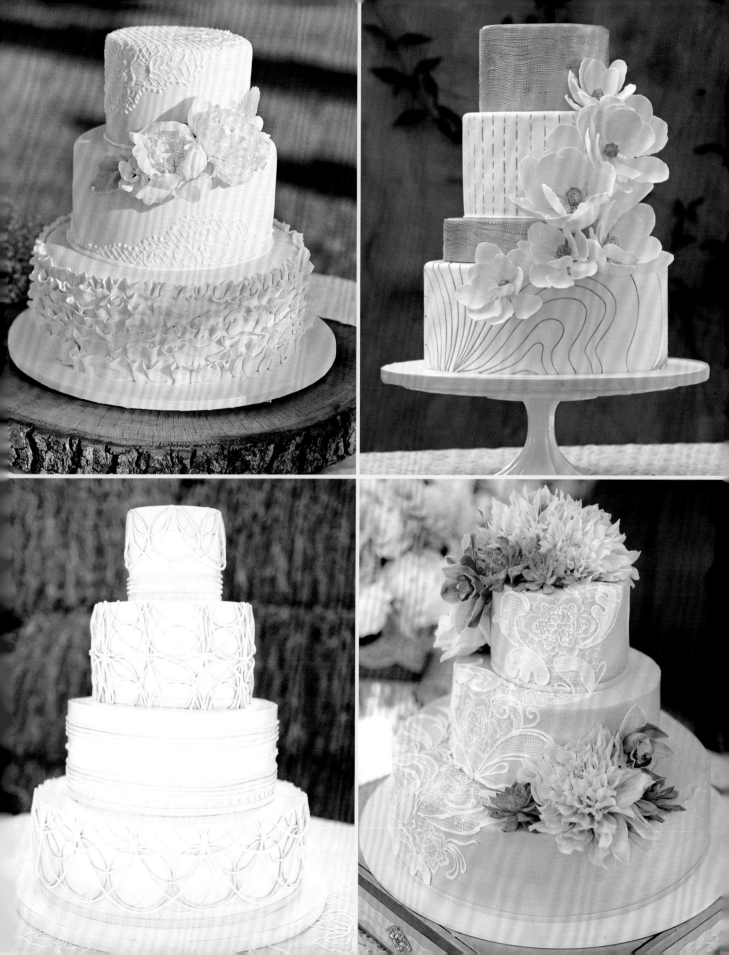

ANNA & ALEX ▪ AUGUST 10

country cool

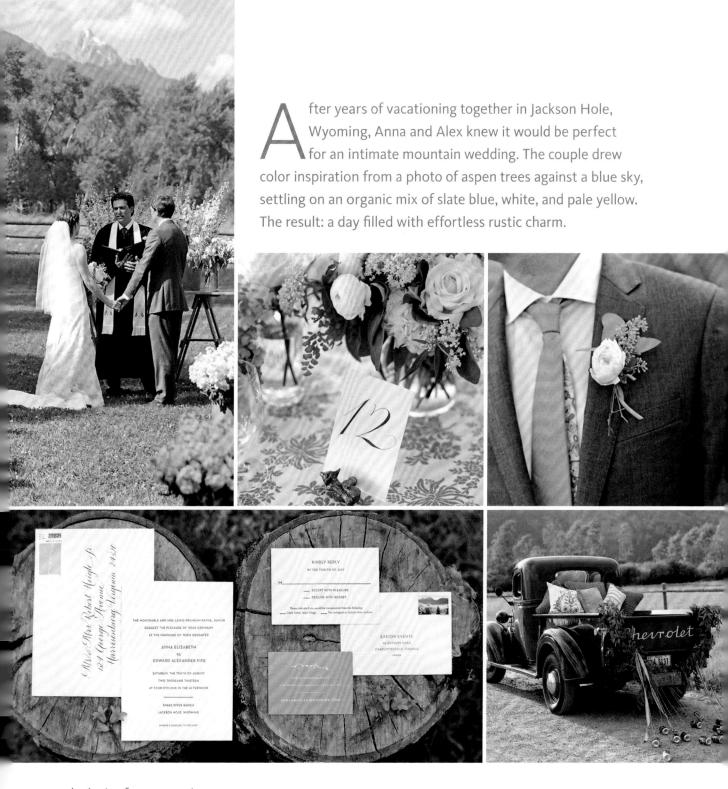

After years of vacationing together in Jackson Hole, Wyoming, Anna and Alex knew it would be perfect for an intimate mountain wedding. The couple drew color inspiration from a photo of aspen trees against a blue sky, settling on an organic mix of slate blue, white, and pale yellow. The result: a day filled with effortless rustic charm.

clockwise from opposite: A wood sawhorse with large bunches of white delphinium and clematis served as a primitive altar. ■ The late-afternoon ceremony was set against the backdrop of the Tetons. ■ Bronze animal figurines held up the calligraphed table numbers. ■ Alex's white boutonniere combined soft and textured elements for a dynamic look. ■ A vintage pickup whisked the newlyweds away. ■ A silhouette of the Tetons was woven throughout the stationery.

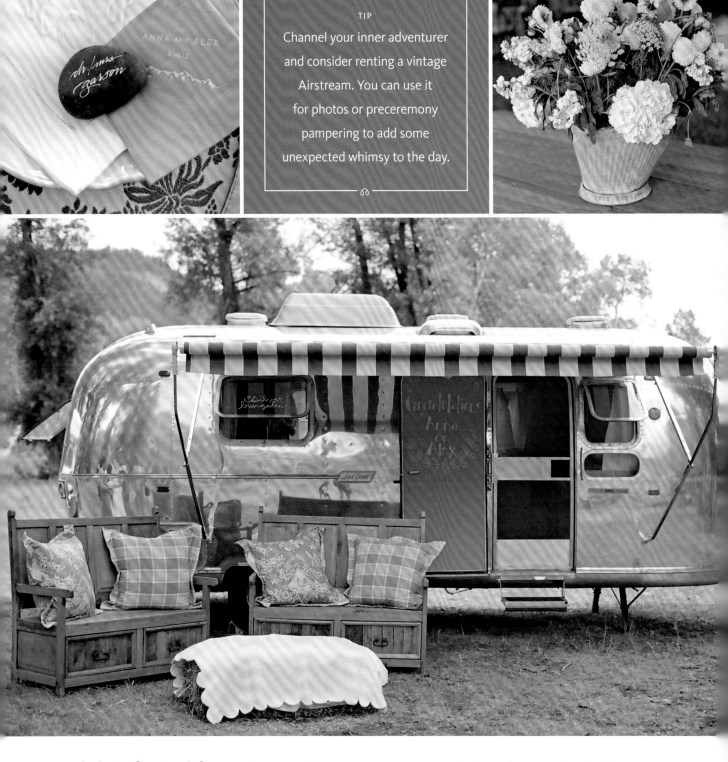

Channel your inner adventurer and consider renting a vintage Airstream. You can use it for photos or preceremony pampering to add some unexpected whimsy to the day.

clockwise from top left: River rocks were hand-calligraphed with guests' names and table assignments. After the reception, guests made wishes and threw them into a nearby creek. ■ Cream and white roses in rustic metal vases were mixed with snapdragons and local wildflowers in natural shades of white and cream. ■ Anna and her bridesmaids relaxed in style in a vintage silver Airstream before the ceremony.

Wood cross-back chairs added a low-key look to the patterned table linens.

ELEANOR & KEVIN ▪ MAY 4

bohemian
barn

clockwise from opposite: Bright floral arrangements both in macramé hangers and on the tables brought the barn to life. ■ The couple dressed to reflect their individual styles. He donned a bright blue suit; she chose a loose-fitting gown and went barefoot. ■ In place of menu cards, each guest received a custom crossword puzzle to complete. ■ Eleanor topped her low-key fishtail braid with a pretty floral crown.

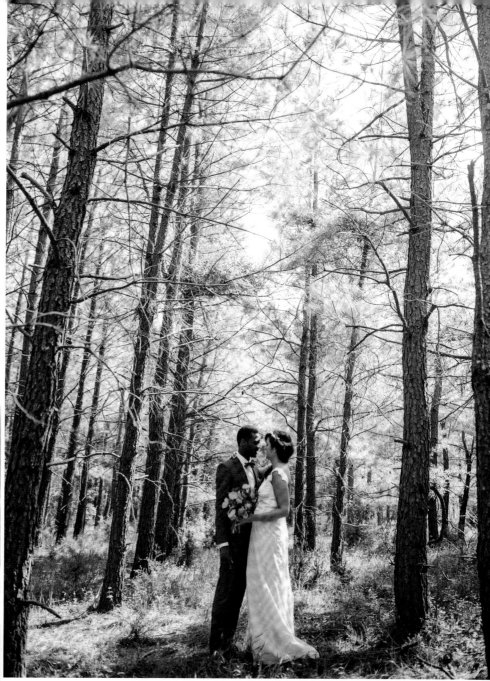

ELEANOR + KEVIN
MAY 4, 2013

It was love at first (virtual) sight for this Scotland-based pair and their venue. After seeing a video of Murray Hill—a rural Leesburg, Virginia, estate overlooking both a river and mountains—Eleanor and Kevin immediately booked it. With the help of a local planner and wedding pros, the couple created a truly joyful and vibrant day full of unique details that reflected their laid-back, whimsical vibe.

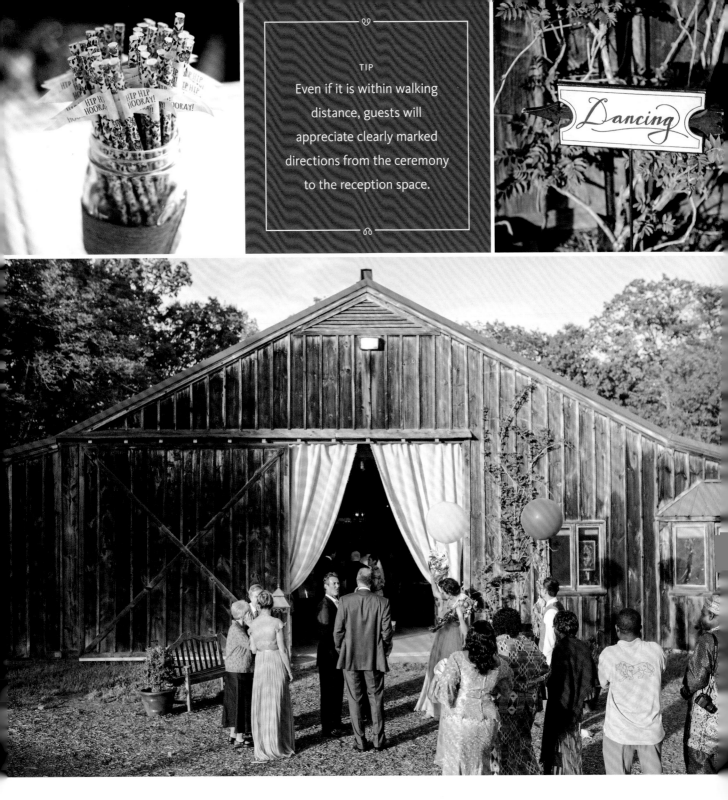

TIP

Even if it is within walking distance, guests will appreciate clearly marked directions from the ceremony to the reception space.

Dancing

clockwise from top left: Cheery pennants accented pretty floral paper straws. ▪ A sign points the way to the dance floor, where the DJ played a mix of classic wedding hits and African songs that reminded the couple of their time abroad. ▪ The maid of honor and best man each carried a huge, colorful balloon and led the guests through the woods from the ceremony to the barn reception. "It was a lively walk and definitely got everyone excited!" says Eleanor.

With the exception of potted florals lining the aisle, the ceremony décor was minimal to allow the stunning tree-dotted backdrop to shine.

SIGNS

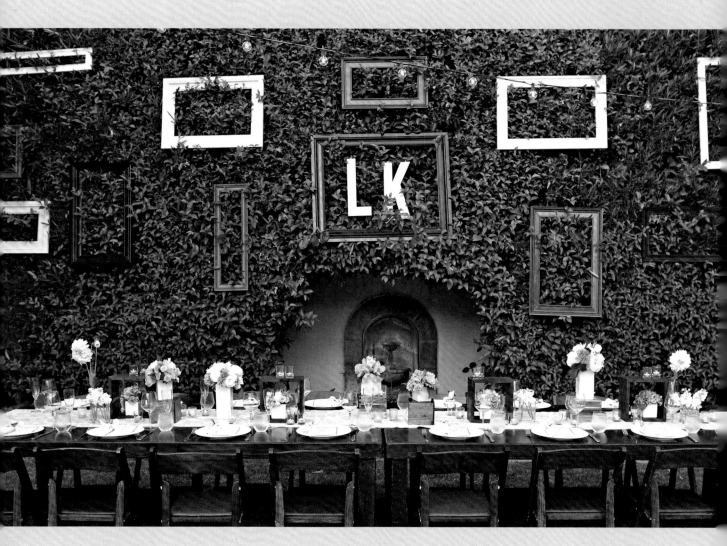

SIGNS ARE AN IMPORTANT PART OF ANY WEDDING RECEPTION. THEY CAN HELP GUIDE YOUR GUESTS OR JUST INSPIRE THEM. HERE ARE FIVE CREATIVE WAYS TO GET THE WORD OUT.

clockwise from above: Bring the indoors out by crafting a cheeky gallery display from empty frames and a boxwood wall. Then, let your initials take center stage. ■ This charming pup proves that a die-cut silhouette is the fastest (and cutest!) way to get your signs noticed. It's also a fun opportunity to infuse another pop of personality into your day, so have one custom made into your favorite shape. ■ Screen printing words onto a pillow is a witty way to display them. And it makes the perfect accent for an outdoor lounge. ■ Never underestimate the power of fonts! And with a seemingly endless amount of options—from elegant calligraphy to quirky bubble letters—you can find just the right one to fit your wedding vibe. ■ Signs can do double-duty, giving your guests directions and serving as a sweet sentiment. These distressed, beachy ones would look equally at home at a vineyard, a farm, or a campground.

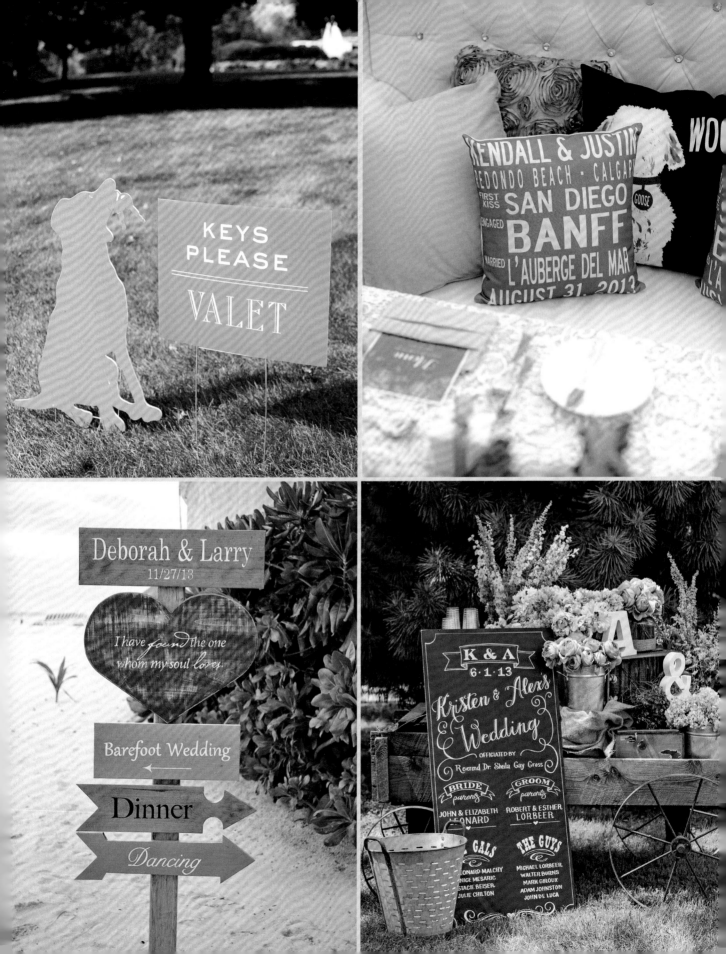

KEYS PLEASE
— VALET —

KENDALL & JUSTIN
REDONDO BEACH · CALGARY
FIRST KISS
SAN DIEGO
ENGAGED
BANFF
MARRIED
L'AUBERGE DEL MAR
AUGUST 31, 2013

WOO

GOOSE

Deborah & Larry
11/27/13

I have found the one whom my soul loves.

Barefoot Wedding ←

Dinner →

Dancing →

K & A
6 · 1 · 13
Kristen & Alexs
Wedding
OFFICIATED BY
Reverend Dr. Sheila Gay Gross

BRIDE parents
JOHN & ELIZABETH
LEONARD

GROOM parents
ROBERT & ESTHER
LORBEER

GALS
LEONARD · MALCHY
NICE MESARIC
STACIE BEISER
JULIE CHILTON

THE GUYS
MICHAEL LORBEER
WALTER BURNS
MARK GIROUX
ADAM JOHNSTON
JOHN DE LUCA

A
&

KATIE & CHRIS • SEPTEMBER 2

totally tahoe

clockwise from opposite:
Chalkboard plaques on the back of the bride's and groom's chairs were among the day's many playful touches. ▪ The escort cards were displayed in tiny tree-trunk rounds on a wonderfully woodsy table decked out with pinecones, antlers, and weathered metal lanterns. ▪ A festive wood sign led guests to the celebration. ▪ Petite bunches of white garden roses and greenery dotted the tables.

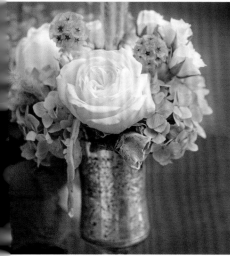

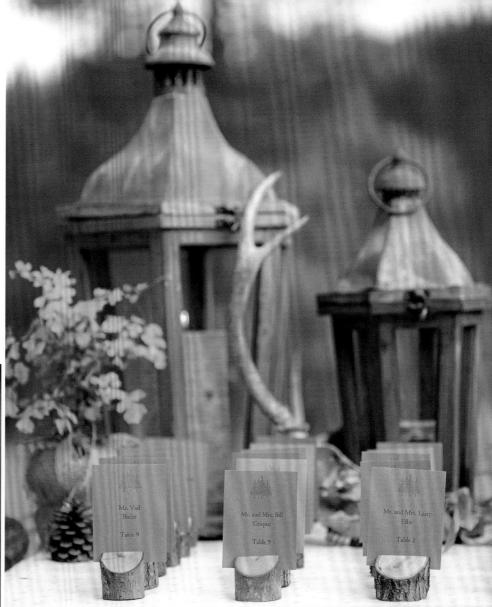

Katie and Chris planned an elegant tented wedding in the thick of the Lake Tahoe forest in California. Quirky natural wood décor and homespun signs spoke to the unfussy locale, while a color palette of organic browns, greens, and shades of white provided a decidedly sophisticated air to the day.

TIP

Small details can make
a big overall impact.
Little wood signs
are a cute touch and so
fitting to the setting.

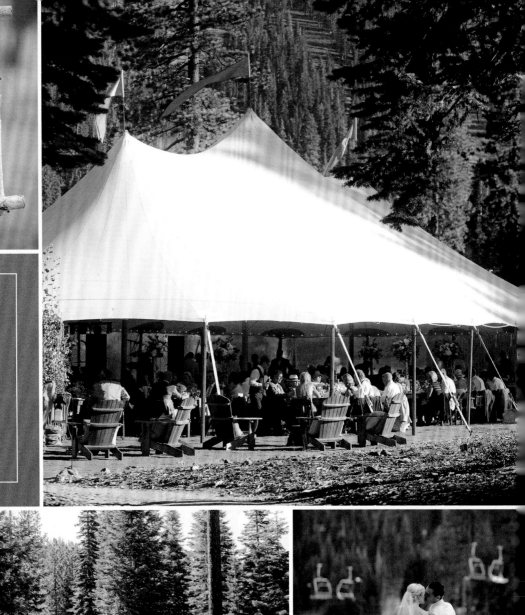

clockwise from top left: Chalkboard signs with handwritten messages were scattered across the grounds for a folksy feel. ■ A sailcloth tent with stark wood poles resembled Tahoe's tall trees. ■ Katie and Chris explored the grounds of the Ritz-Carlton, Lake Tahoe for some striking postceremony pics. ■ Among a sea of pine trees, a grassy patch was perfect for the couple's open-air ceremony.

Candles and lanterns added mood lighting to the tablescapes.

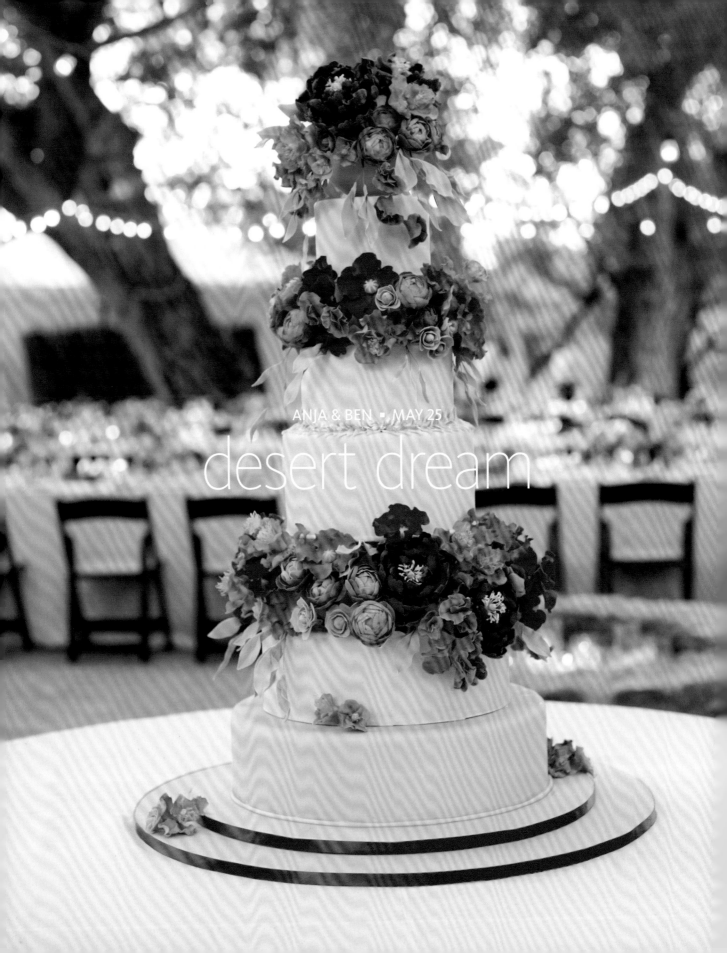

ANJA & BEN ▪ MAY 25

desert dream

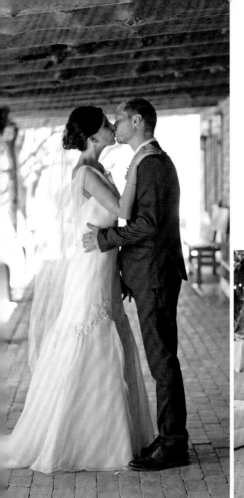

It was a far cry from their home in Brooklyn, New York, but Anja (an Arizona native) and Ben were set on getting married in the desert. For their Tucson nuptials, they used neutrals and browns with accents of turquoise, orange, and pink. An open-air ceremony and reception amid saguaro cacti set the tone for a warm and welcoming celebration.

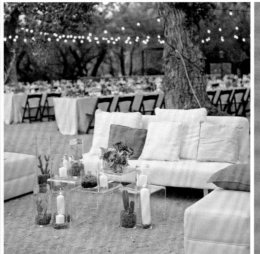

TIP
Guests are bound to feel overheated at some point beneath the desert sun. Offer nonalcoholic drinks and fans and keep the ceremony on the shorter side.

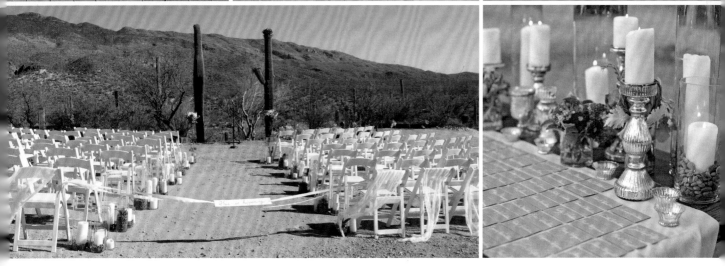

clockwise from opposite: The five-tier ivory cake was decorated with sugar flowers and desert plants. ■ Anja's light and airy gown looked (and felt) appropriate in the desert heat. ■ The lounge had white couches with punchy pillows that picked up the colors in the centerpieces. ■ White escort cards in gold envelopes were displayed on a table topped with florals and candles. ■ Two cacti created a natural place for the altar. The minimal décor included a collection of candles lining the aisle.

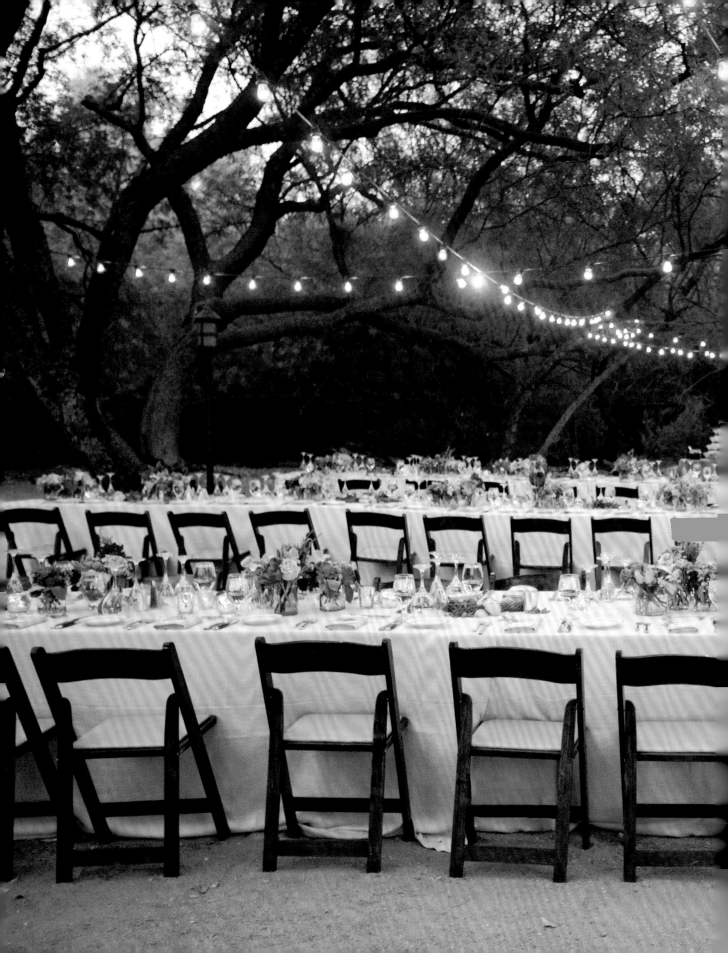

Warm twinkle lights strung between the trees set the mood for the reception as night fell.

MEAGAN & RYAN ▪ NOVEMBER 9

hippie chic

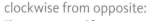

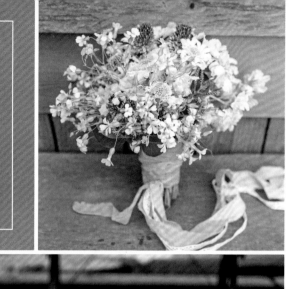

TIP

Incorporating things that
are important to you
as a couple—camping,
for example—makes
your wedding more
meaningful for both you
and your guests.

clockwise from opposite:
There was no need for
ceremony décor with a view
this spectacular. ▪ A hand-tied
bouquet of wildflowers was
the perfect fit for an outdoorsy
affair. ▪ A camping topper was
an appropriate accessory for
Meagan and Ryan's buttercream
cake. ▪ Later that night, the
couple enjoyed their very own
plush tent just feet from their
reception. ▪ Picnic tables got a
touch of glam thanks to delicate
lace linens, mismatched napkins,
and gold lanterns.

Meagan and Ryan chose El Capitan Canyon in Santa
Barbara, California, for their luxe, free-spirited affair
that—purposely—felt more like an intimate camping
trip with friends than a wedding. From mason jars of moonshine
and gilded candlesticks to the cabin guest rooms, the result was
the ultimate twist on camping.

marrying by season

HERE ARE A FEW OUTDOOR DESTINATIONS THAT ARE IDEAL IN EACH SEASON.

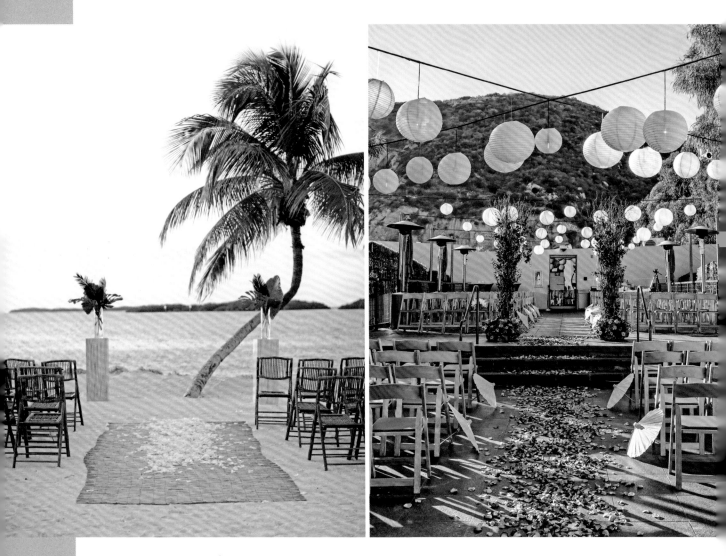

spring

THE PERFECT LOCALE IS WARM AND IN FULL
BLOOM IN APRIL AND MAY.

Islamorada, Florida ■ Big Sky, Montana
Austin, Texas ■ Washington, DC

summer

THESE SPOTS AREN'T TOO HOT AND HAVE
LOADS OF NATURAL SCENERY.

Laguna Beach, California ■ Jackson Hole, Wyoming
Nantucket, Massachusetts ■ Chicago

 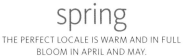

fall

THESE DESTINATIONS OFFER FOLIAGE, TEMPERATE EVENINGS,
AND FUN NEARBY ACTIVITIES FOR GUESTS.

Napa Valley, California ■ Upper Peninsula, Michigan
Charleston, South Carolina ■ New York City

winter

THESE SPOTS ARE GREAT
FOR CREATING A WINTER WONDERLAND.

Vail, Colorado ■ Stowe, Vermont
Aspen, Colorado ■ Park City, Utah

ranch wedding basics

Throw the perfect farm or ranch wedding with these helpful planning tips and tricks.

colors

Let the raw beauty of your grounds take center stage—this means sticking with a color palette that doesn't push your setting's natural décor out of the limelight. Instead, neutral, organic colors such as shades of brown and green will go a long way toward making your day feel cohesive. For some splashes of color, spice things up with bright florals. Local, in-season blooms will be easiest to come by, and they'll blend in seamlessly with the surroundings.

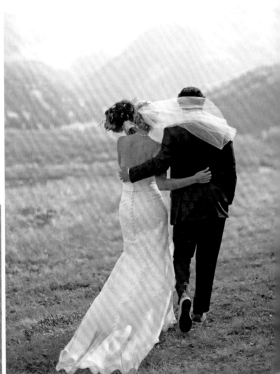

try these
color combos

green & brown

coral & taupe

hot pink & purple

stationery

There are a million ways to infuse your rustic wedding day locale into your stationery. From the paper to the font, the world is your oyster. Mountaintops, pinecones, trees, and so on are go-to motifs for alpine affairs, while horseshoes, stars, and cacti are huge for ranch nuptials. Branch out from predictable designs with more general touches that evoke the wilderness vibe of your day. For example, print your invitations on wood-grain card stock for a unique and subtle introduction to your theme. Western fonts are a good option for desert and ranch weddings.

attire

It's important that you and your bridal party are comfortable above all. Keep in mind that a big, heavy ball gown might make it hard for you to hop on a horse or frolic through the trees for photos. Similarly, your man might look just a little out of place in a full tux. As for sticking to classic rustic attire, it's up to you how literal you want to be with your theme. Beyond the tried-and-true (read: bolo ties, Stetsons, plaid, and cowboy boots), there are plenty of other subtle ways to incorporate your locale into your attire. Think: horseshoe pendant necklaces for the girls and cuff links for the guys.

menu

It's not a ranch wedding without some typical ranch grub. Offer plenty of farm-to-table options such as steak from a nearby cattle ranch and grill stations for wild game, such as deer, elk, and quail. Another fun idea is to incorporate honey and peaches from local farms into the desserts or favors. And don't forget the *queso* bar! Having a winter wedding? S'mores are always a hit when the weather gets chilly. For the ceremony, pitchers of lavender-infused lemonade and sweet tea are refreshing faves sure to please both young and old.

favors

Send guests home with a product of the land—the more unique to your setting, the better. Having your nuptials in northern New England? Treat them to some maple syrup from a nearby farm in a cute bottle. For a wedding in the mountains, wood drink coasters and granola or trail mix in mason jars make excellent favors. Wedding on a ranch? Send your guests packing with a lucky horseshoe or local sweets. Pashminas for when the sun goes down are also a popular (and considerate) takeaway for the ladies.

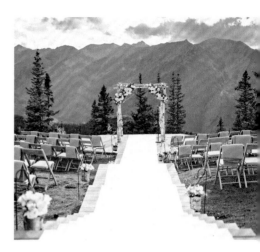

other considerations

It should go without saying, but if you're planning to wed outdoors, expect to get up close and personal with Mother Nature. In the mountains and the desert, hot days often turn chilly, and winter can bring about 75-degree heat. You'll need to be ready for any weather situation, keeping air-conditioning, heating equipment, and a backup generator on hand, no matter the time of year. And always have a plan B (read: a tent or nearby barn) in case of rain or extreme wind to get guests to cover quickly.

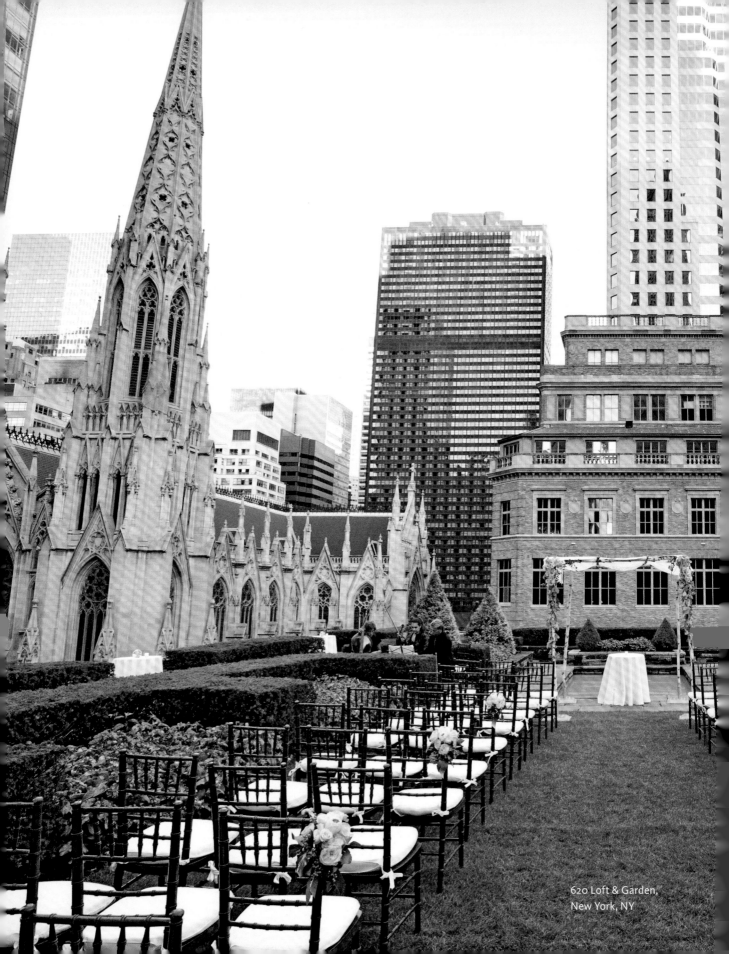

620 Loft & Garden,
New York, NY

5

CITYSCAPE

Imagine the romance of a wedding in a busy metropolis—the skyline, town square, or towering buildings all around you. It may not be the first idea that comes to mind when you think of outdoor nuptials, but with a little ingenuity, a city can actually present some of the most unique spaces for saying "I do." Maybe it is a rooftop garden with the tops of buildings creating an intimate enclave; it could be a museum's courtyard or sculpture garden, or even a spacious patio in the heart of the city square. First, figure out the city in which you want to wed. Then do your research for unexpected spots. Cities are just about as public as you can get, so remember: Most of the places you find will likely require you to meet local ordinance requirements. These might include obtaining a permit for a public park and adhering to noise policies (some areas might have a restriction on sound levels and a specific time your band or DJ will need to unplug).

When it comes to tone, it can be sleek, traditional, eclectic, or whatever you can possibly envision—a wedding among the skyscrapers is a creative juxtaposition in itself. The season that you choose will play a big part in the look of your event, especially if you have views of trees and flowers that you may want to use as a base for your color palette. You can emphasize the urban feel with modern details and a city-chic dress code, or go in the opposite direction with an ornate, romantic vibe, if that suits your style best. Either way, if you're willing to open your mind, there's something so intimate about celebrating in your own special nook, knowing the rest of the city is bustling all around you.

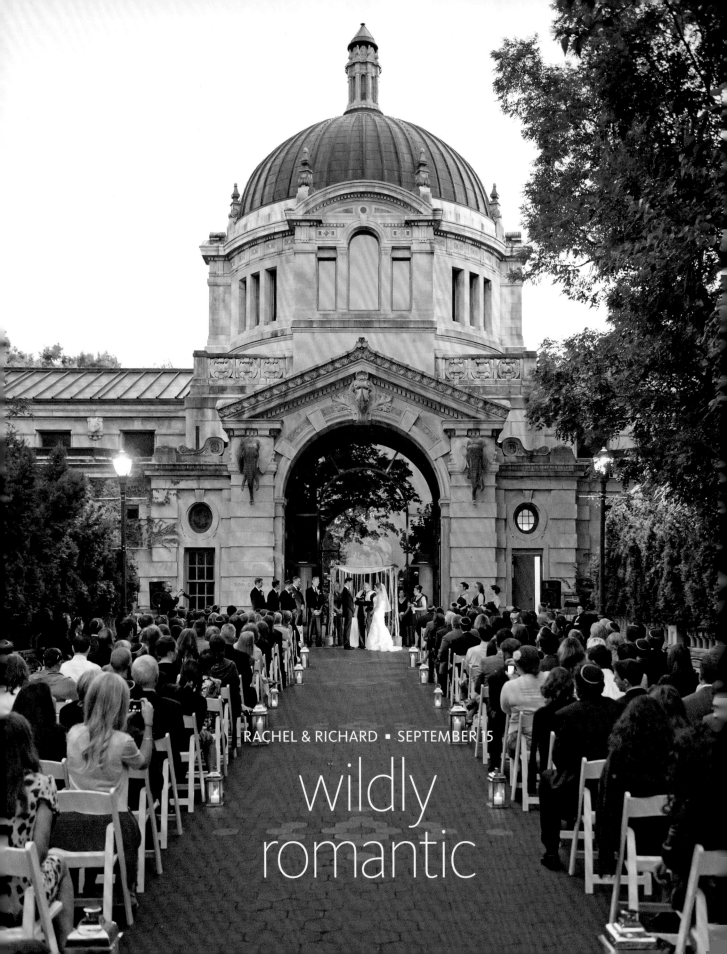

RACHEL & RICHARD · SEPTEMBER 15

wildly
romantic

When it comes to zoo venues, not too many places can top New York's Bronx Zoo. For their fall wedding at this popular landmark, Rachel and Richard carried out an elegant purple scheme (it's Rachel's favorite color) throughout the day's décor. And as a nod to their surroundings, they tied it all together with a playful yet chic animal motif.

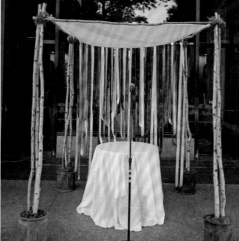

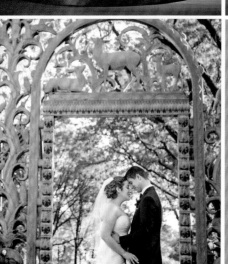

TIP

Look to your venue's architecture to find the perfect backdrop for your ceremony, like the impressive archway where Rachel and Richard said "I do."

clockwise from opposite: Candlelit lanterns of varying sizes lined the ceremony aisle, casting a warm glow on the sunset ceremony. ▪ Mercury glass vases were a pretty contrast to rich purple blooms. ▪ Bold ribbons in the day's vibrant color scheme created a focal point at the back of the huppah. ▪ For a charming touch, silver-painted animal figurines mingled playfully with centerpieces on the reception tables. ▪ Their special venue provided plenty of iconic photo ops. ▪ Fondant animal silhouettes on the cake incorporated the zoo theme without feeling too over the top.

ADRIENNE & CAMERON ▪ JUNE 22

downtown vintage

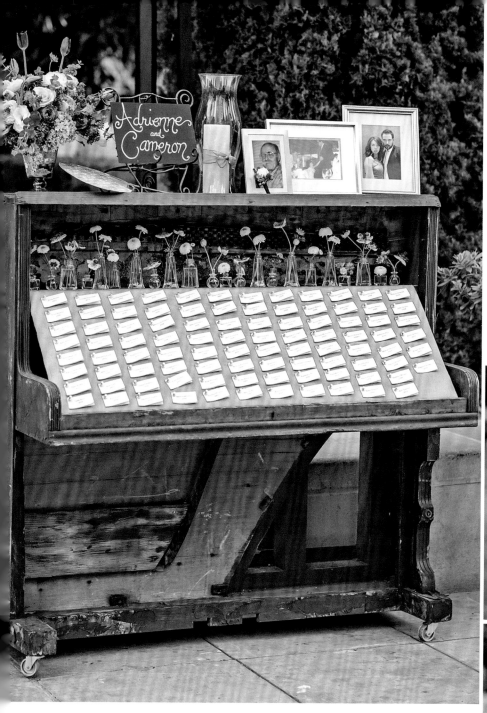

clockwise from opposite:
A wide park pathway became the perfect ceremony aisle. ■ An old, deconstructed piano was transformed into an unexpected escort-card display. ■ Another clever touch: Antique windows complete with flower boxes hung as a ceremony backdrop. ■ Pretty patterned fans kept the California heat at bay and tied in the vintage theme.

I n a beautiful park nestled in the heart of downtown Los Angeles, Adrienne, a nature lover, and Cameron, a city guy, found the ideal compromise for their wedding. After exchanging vows under the trees with the skyline soaring above them, they retreated to the patio of a nearby café for dinner and dancing under romantic twinkle lights.

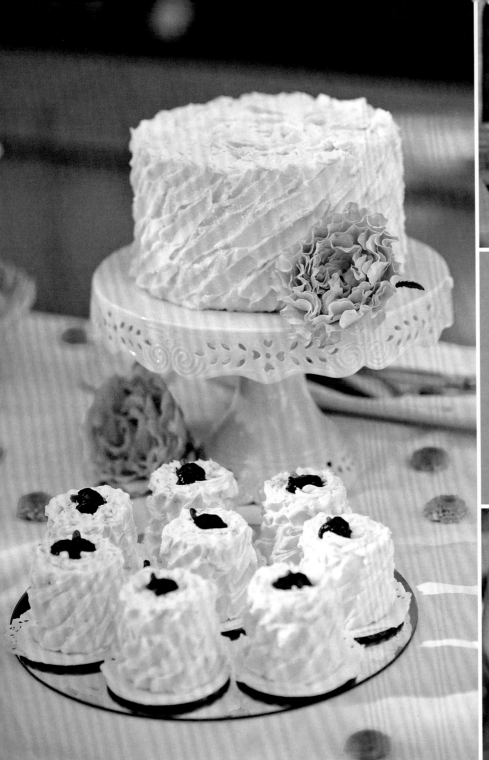

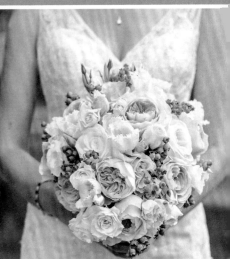

clockwise from above left: Rather than deciding on one cake, the couple opted for a variety of mini cakes in different flavors. ■ Twinkle lights upped the romance on the dance floor. ■ The tree-lined reception area treated guests to views of the Los Angeles Central Library. ■ In honor of Adrienne's late father, who was a blueberry farmer, unripened blueberries provided a special touch, as well as some texture, to her romantic bouquet.

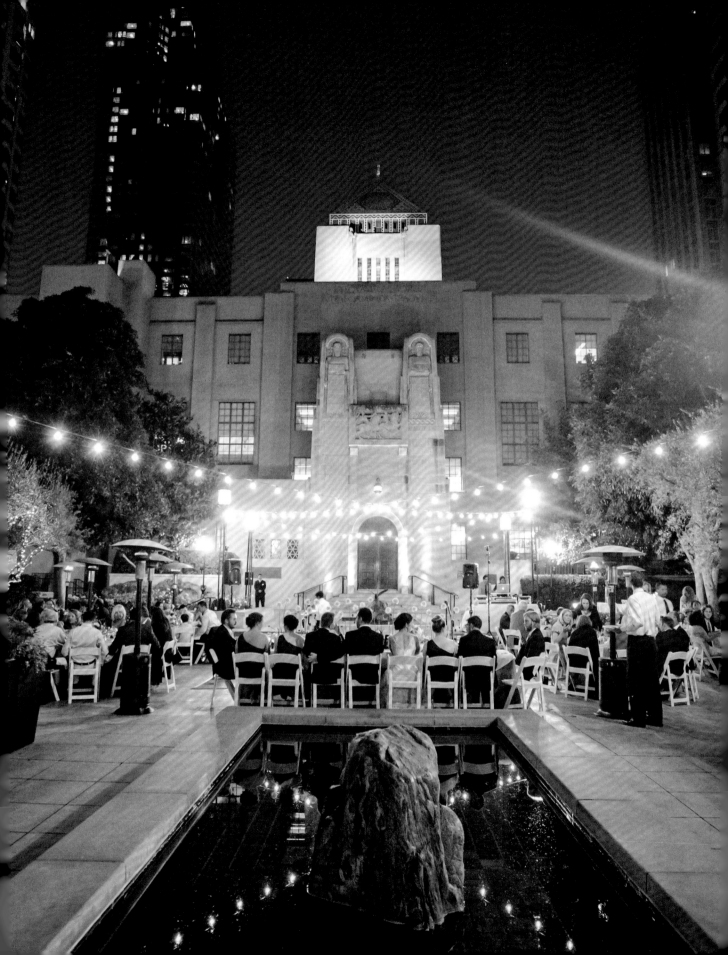

FLOWERS

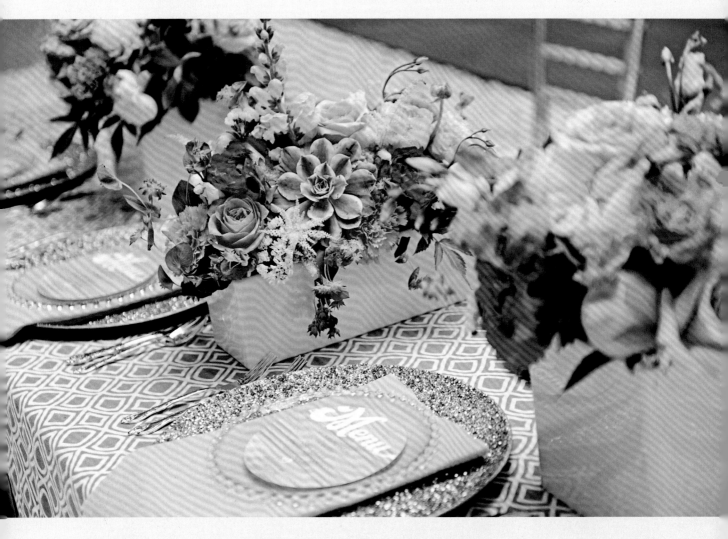

HEAT, SMOG, WIND, AND OTHER CITY WOES CAN WREAK HAVOC ON FLORAL DISPLAYS. TO AVOID A WILTED MESS, OPT FOR MORE MINIMAL ARRANGEMENTS OR, BETTER YET, CHIC ALTERNATIVES LIKE PAPER BLOOMS.

clockwise from above: Dense, low centerpieces that feature sturdy flowers like roses and carnations have serious staying power (guests can even take them home!). ▪ If you have trees near your reception tables, consider hanging simple boxes filled with fresh blooms from the branches—they can double as table numbers. ▪ Tightly secure flowers and branches to a huppah with floral wire to ensure they don't blow off during a windy rooftop ceremony. ▪ If your venue has stellar city views, make that the focus and stick to small, uncomplicated centerpieces. But remember that simple doesn't have to mean boring—try playing with interesting textures, like pairing a fluffy peony with quirky craspedia and a few succulents. ▪ This artful arrangement is a totally cool take on the terrarium trend. Plus, since it's primarily made up of moss, leaves, and a twisting branch, it's a sturdier, yet still statement-making, alternative to a big, billowy centerpiece.

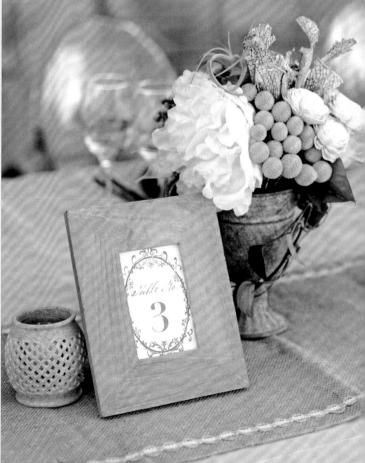

LIA & ALEX ■ SEPTEMBER 17

california chic

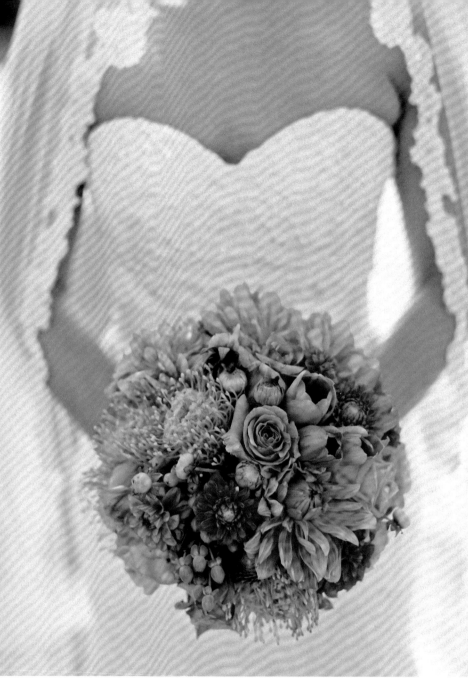

clockwise from opposite: Silver and gray table-scapes blended seamlessly with the modern backdrop of the museum. ■ Lia's bright, monochromatic bunch combined the different blooms from her bridesmaid bouquets. ■ A bold boutonniere brightened up Alex's classic black tuxedo. ■ The minimalist programs featured just a hint of orange, courtesy of the couple's custom monogram.

{ L & A }

The Wedding
of

Lia Angela Benvenuti

and

Alex Jack Sioukas

Saturday, September 17, 2011
Greek Orthodox Church of the Annunciation
Sacramento, California

What better place to host a sleek-and-chic wedding than the courtyard of an art museum? So when Lia and Alex found out that one of their favorite museums in their hometown of Sacramento, California, had undergone an expansion, it made choosing their reception venue a breeze. Their day's contemporary-clean look came alive with splashes of orange and a silver and gray palette befitting the stylish aesthetic of the space.

clockwise from left:
White ceramic knickknacks added artful interest to the tables. ■ A simple fit-and-flare gown was the perfect match for the day's contemporary vibe. ■ The cake pops looked extra-playful iced with a bright orange design.

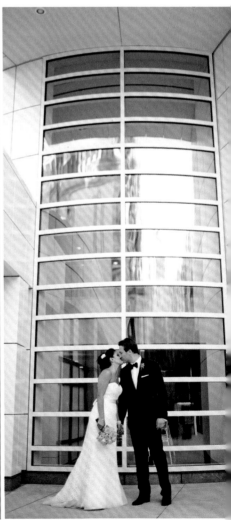

TIP
When it comes to the cake, it's all about the presentation. An ornate architectural pedestal, for example, is a cool contrast to a modern confection.

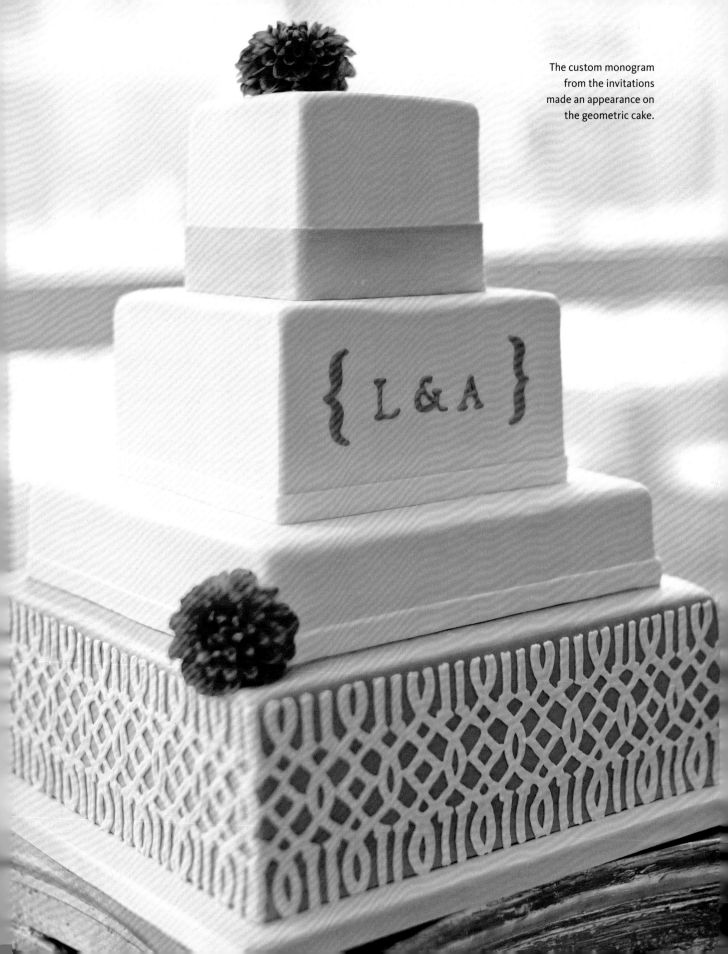

The custom monogram from the invitations made an appearance on the geometric cake.

{ L & A }

JULIE & ALVARO ▪ MARCH 30

colombian charm

clockwise from opposite:
Low centerpieces didn't inter-
fere with views of Cartagena's
colorful buildings. ■ The couple
worked in as many quintessen-
tially Colombian photo ops as
possible. ■ A vintage chandelier
added authenticity to the cere-
mony. ■ A modern lounge made
a stylish contrast to the historic
surroundings. ■ Mini calla lilies,
orchids, and roses starred in
Julie's exotic bouquet.

TIP

Don't feel like you have to
limit yourself to the States.
If you're open to adventure,
consider going abroad to a
city that reflects your
personalities and passions.

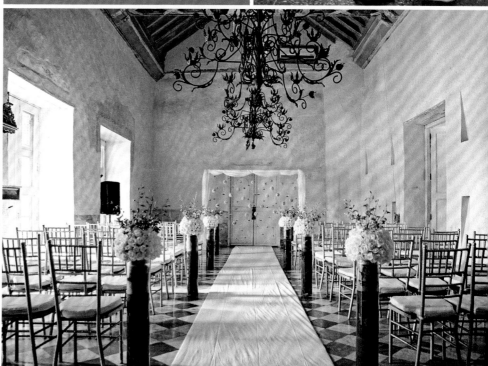

Travel-and-adventure junkies Julie and Alvaro knew
they wanted to wed in a memorable, and international,
way. They headed straight for the historic city of
Cartagena, Colombia. The couple infused their charming day
with local flavor in the form of food, flowers, music, and,
of course, the venue itself—the top of a towering wall that
treated guests to 360-degree views of the surrounding city
and the sea. Swoon!

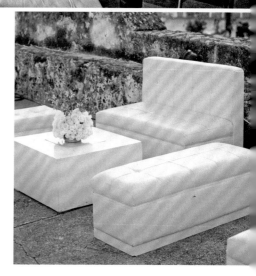

CAKES

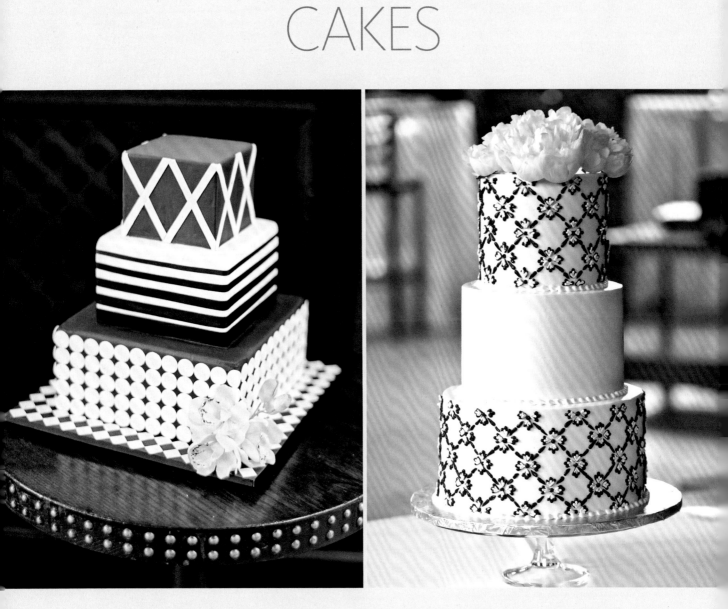

FOR AN URBAN AFFAIR, SELECT A CAKE AS SLEEK AND STYLISH AS THE CITY THAT SURROUNDS YOU.
THINK: CLEAN LINES AND COLORS, GRAPHIC ELEMENTS, AND GEOMETRIC SHAPES.

clockwise from above left: Want to add an extra splash of style to a graphic cake? Go ahead and coordinate your cake plate to the pattern on the bottom tier. ■ Navy embellishments add a posh touch perfect for a sculpture-garden setting or the rooftop of a swanky hotel. ■ Graphic accents give an all-white cake a pop of personality. Need inspiration? Pick up on an interesting detail in your space. Maybe the floor of your courtyard has a cool mosaic design or the museum has a pop-art painted wall. ■ Honor the city you love with a custom-made cake topper in the shape of the skyline. ■ Simple can also be stylish. Case in point: this chic striped confection. ■ Take a cue from the surrounding skyscrapers and stack up a set of square tiers. Finish them off with geometric patterns and a tiny flourish of color.

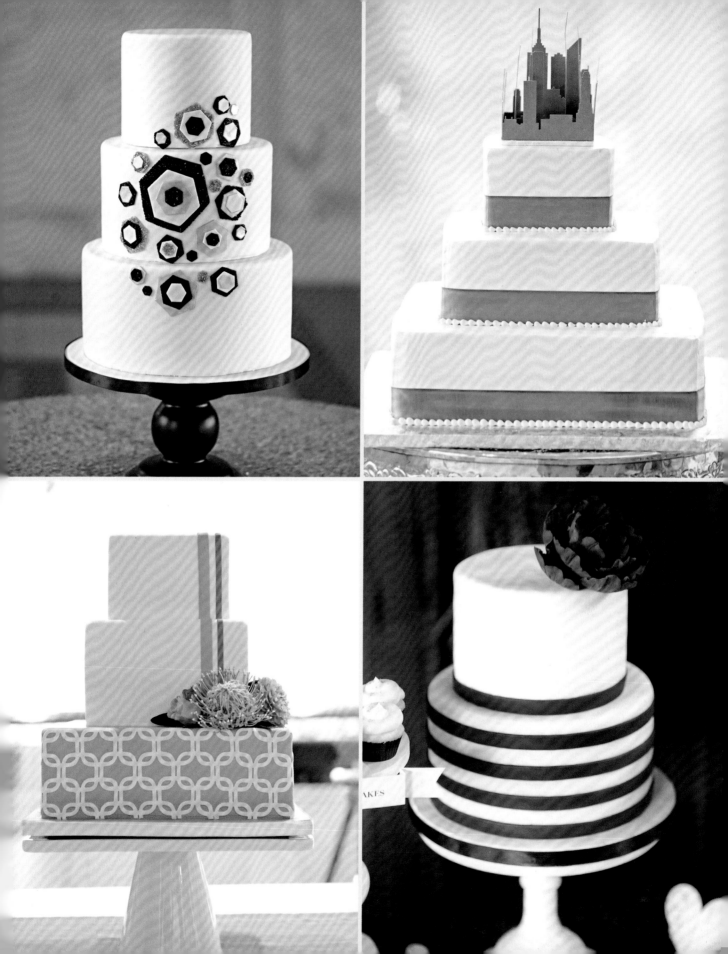

BORA & WILLIAM ▪ JUNE 8

polished and pretty

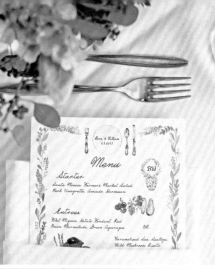

Handmade details, like faux boxwood initials and a whimsical vine motif on their stationery, gave Bora and William's rooftop wedding a seriously personal touch. But it didn't stop there. The bride had plenty of other ideas in mind, including a monogrammed cake, a checkerboard dance floor, and a crystal chandelier that looked like it was floating in the sky.

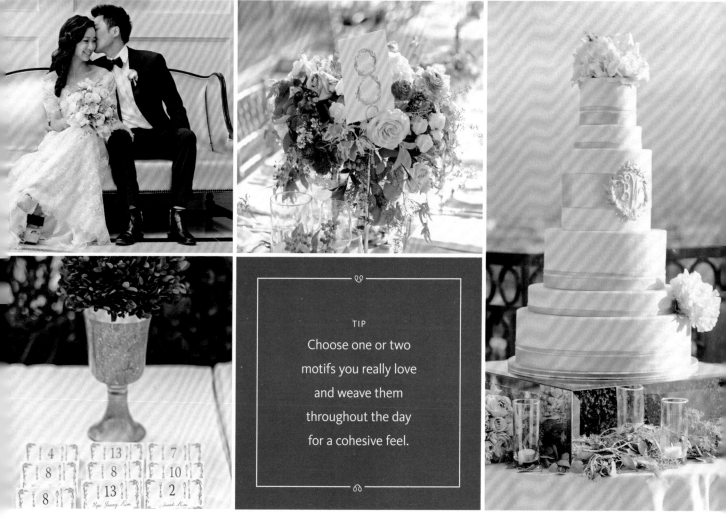

TIP

Choose one or two motifs you really love and weave them throughout the day for a cohesive feel.

clockwise from opposite: Larger-than-life initials and a chic chandelier glammed up the spectacular view. ▪ Watercolor illustrations of the food were a unique addition to the menu cards. ▪ A soft, organic-looking arrangement struck a romantic note. ▪ A crestlike monogram was a regal touch on the gold-rimmed cake. ▪ More boxwood topiaries (one of Bora's obsessions) adorned the escort-card table. ▪ Bora's lace gown evoked a vintage feel as sweet as the rest of their day.

CHANAE & GEORGE ▪ JULY 14

modern regal

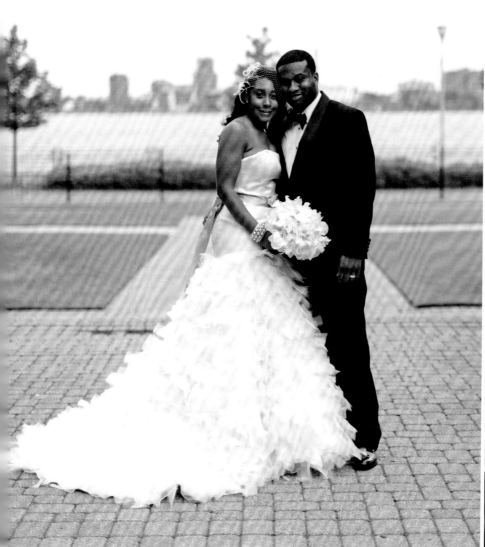

clockwise from opposite: Paper flowers added texture and created a dramatic backdrop for the main table at the reception. ▪ The couple wore a timeless black-tie look. Chanae especially loved the ruffled skirt of her gown. ▪ Menu cards were custom designed to fit in the center of the chargers. ▪ Black-and-gold-foil invitations set the tone for the event.

Chanae and George wanted a classic wedding with a modern-day feel. The pair said their vows in front of the Detroit River, then headed to a chic atrium for the reception. With a minimalist palette of cream and black—and lots of opulent gold details—their venue was transformed into a simple yet glamorous space that reflected the couple's personal style.

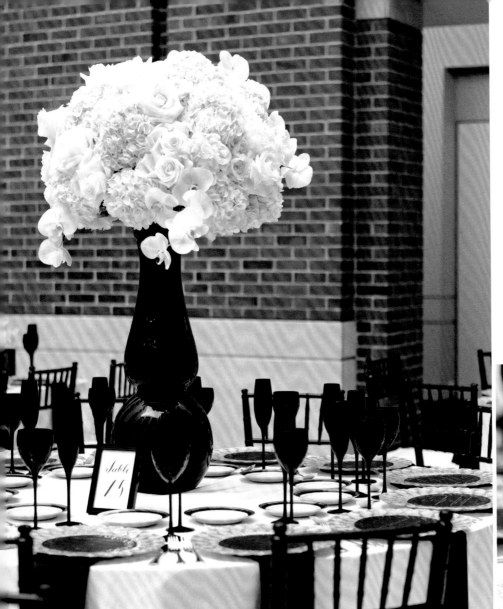

clockwise from left: Black glasses and gold flatware made the place settings stand out. Sculptural vases filled with white blooms complemented the modern mood. ▪ Gold votives created a cozy ambience at the tables. ▪ Even the lounge sofa played along with the color scheme!

TIP

Whether you go with gold, silver, or bronze, metallics can make the perfect accent color, adding plenty of glam and sparkle to your day.

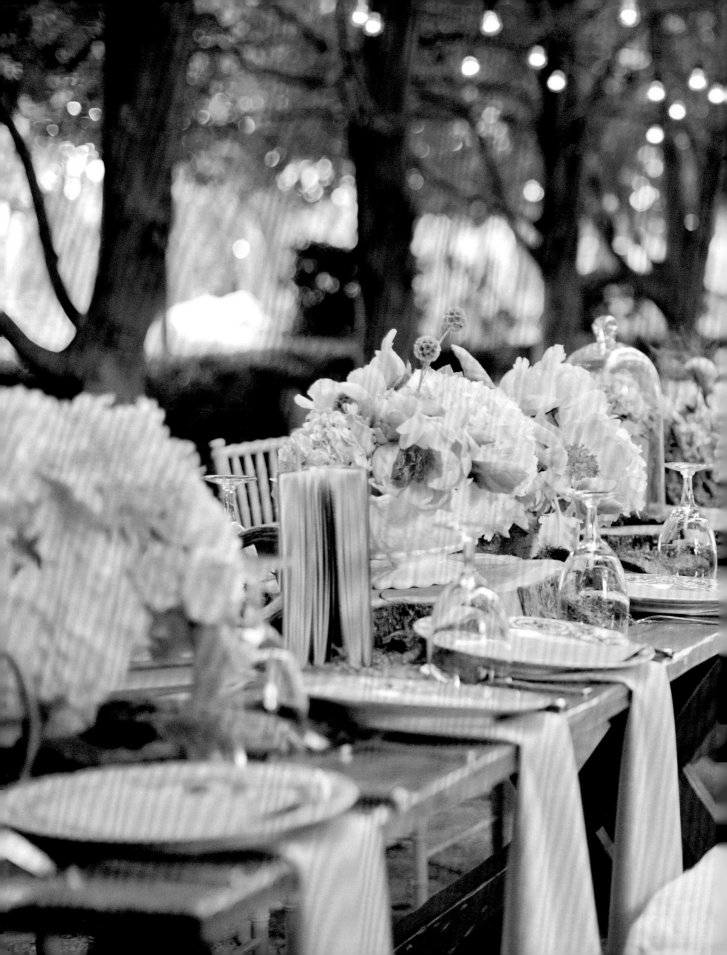

urban escape

Inspired by their venue, a beautiful garden in the center of bustling Dallas, Brittany and Jamie designed a rustic wedding with a sophisticated twist. Soft colors, whimsical accents (think: metallic antlers, vintage books, glass bell jars), and natural elements, such as moss and bark, came together to create one magical evening.

TIP

From old books to vintage glassware, props are a fun way to inject personality. Hit up thrift shops, antiques fairs, and your grandma's attic to score special, and affordable, finds.

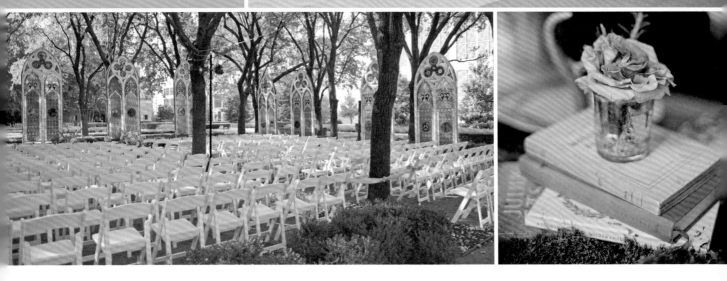

clockwise from top left: Organic touches, such as moss and wood slabs, highlighted the venue's garden vibe. ▪ Pretty pennants hung over a well-curated welcome table that included vintage typewriters. ▪ Nothing exudes romance like a stack of vintage books and a pink rose in a cup. ▪ Under a grove of trees, antique stained-glass panels gave the outdoor ceremony the feel of a church and caught the sunlight.

Good things come in small packages, such as this petite sweet dressed up with a metallic *faux bois* design.

KATIE & JAMES ▪ AUGUST 3

relaxed sophistication

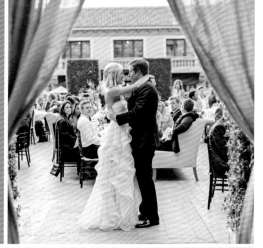
clockwise from opposite: For a casual, chic touch, French-inspired linens capped off each rectangular table. ■ A structured bodice gave way to flirty ruffles on Katie's feminine dress. ■ The couple debuted their new monogram on the lounge pillows. ■ A nest of kumquats gave the centerpiece an adorable dose of farm-to-table flair. ■ A mix of seating styles created variety in the alfresco dining area.

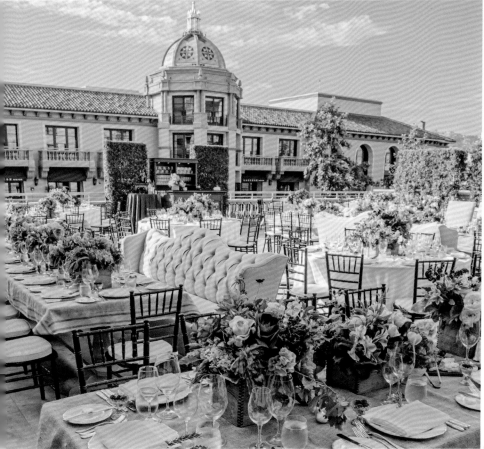

For Katie and James, ambience was key—they wanted their wedding to reflect a casual, but refined, feeling. With help from an event designer, they translated their vision into an elegant indoor-meets-outdoor affair on the terrace of a grand Southern California hotel. Couches and other comfy interior design elements mixed with bright fruits and flowers.

GETAWAY RIDES

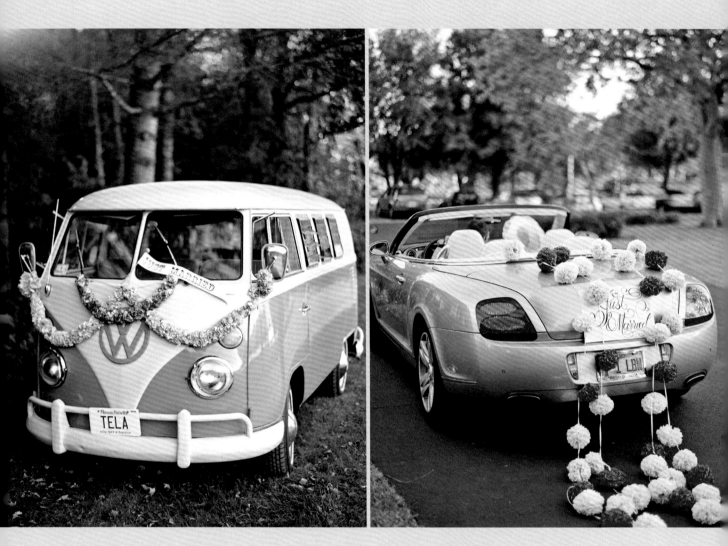

FOR A SUPERBLY IMPRESSIVE SEND-OFF, YOUR GETAWAY SHOULD BE JUST AS GOOD (OR EVEN BETTER!)
THAN YOUR ENTRANCE. LET THESE CREATIVE TAKES ON TRANSPORTATION INSPIRE YOUR EXIT STRATEGY.

clockwise from above left: Tying the knot in the woods? What better way to escape the great outdoors than in a retro VW van dolled up with floral garlands. ▪ Swap tin cans for something more fresh and festive. Let a bright bunch of tissue paper pom-poms cascade down from the back of a sleek convertible. ▪ Double your fun and roll away side by side on cute matching bikes. Simple "Just Married" signs and a hint of moss make the perfect additions to this low-key ride.

▪ A big-city wedding calls for a taxi takeoff. Either hail a passing one or, to give your getaway an extra-classic touch, hire a vintage cab to come fetch you. ▪ Cozy up European-style and jet off on a Vespa. For an even sweeter send-off, load up the luggage rack with a basket of romantic blooms. ▪ Pulling away from a farm, ranch, or vineyard? Head out in a vintage convertible adorned with a lush garland of greenery and flower accents that look freshly picked.

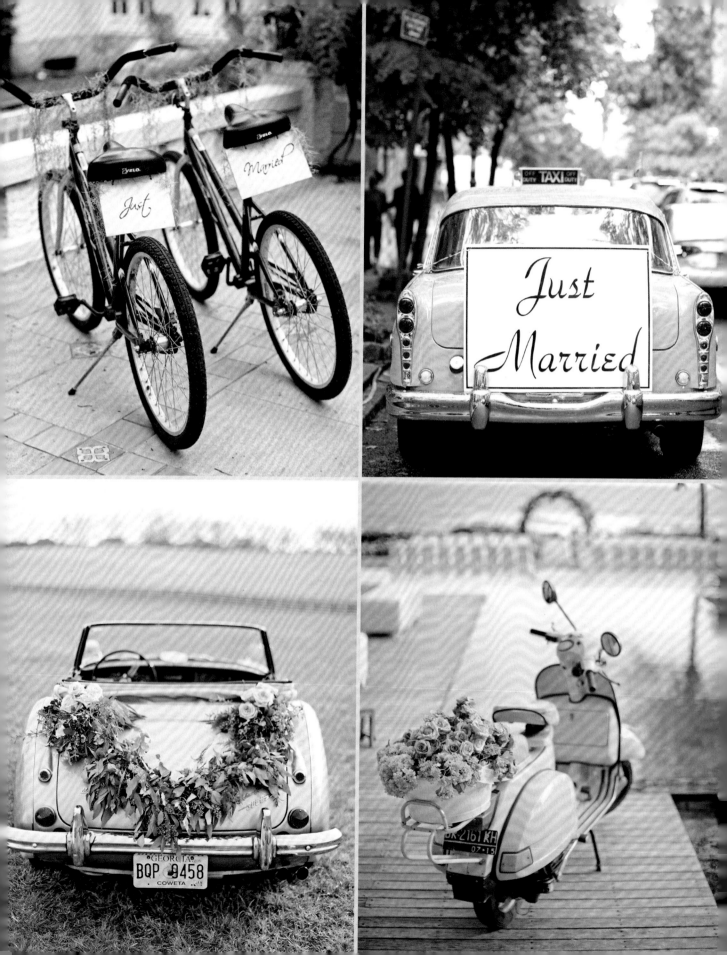

LEIGH & BEN ▪ SEPTEMBER 21

verdant oasis

A one-of-a-kind event space with an impressive vertical garden set the scene for Leigh and Ben's California-cool affair. To complement the urban oasis, they paired two Pantone colors—a rich emerald and a grayed jade—with pops of gold, black, peach, and coral, and then tossed in a few glam touches, such as emerald-sequined cocktail tablecloths and gold flatware.

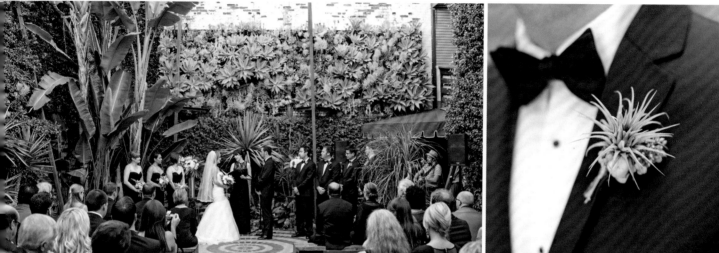

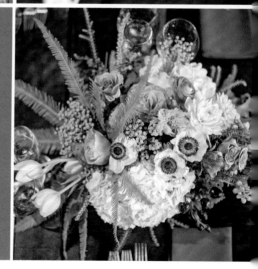

TIP

Flowers can quickly drive up your budget. To keep costs in check, seek out a venue already decorated with plants or flowers, then enhance the look with a few smaller arrangements.

clockwise from opposite: A large protea gave a non-traditional twist to the centerpieces. ▪ Jewel-toned napkins and gold flatware lent a glamorous air to the wood table. ▪ Ben's boutonniere looked as if it were plucked straight from the garden. ▪ A modern mix of flowers, ferns, and anemones felt fresh and fun. ▪ Leigh's loose bouquet suited the casual-cool vibe. ▪ The courtyard's lush vertical garden made for a striking ceremony backdrop.

weatherproof props

THESE FUN AND FUNCTIONAL EXTRAS WILL KEEP GUESTS
COMFORTABLE, COME RAIN OR SHINE.

sandy

A BUCKET OF FLIP-FLOPS IN A VARIETY OF SIZES
IS AN ABSOLUTE MUST FOR A BEACH WEDDING.

chilly

SOFT PASHMINAS IN YOUR COLOR PALETTE WILL KEEP
GUESTS WARM AND DOUBLE AS A POSH FAVOR.

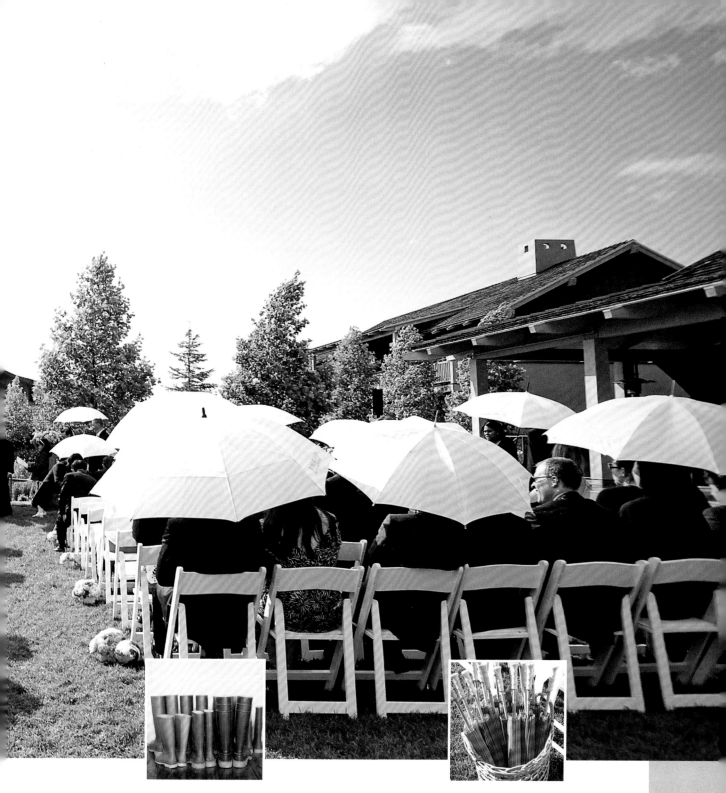

rainy

DON'T LET PUDDLES DAMPEN YOUR DAY. STAY DRY AND
SNAP SOME CUTE PHOTOS WITH GUESTS IN RAIN BOOTS.

sunny

PROTECT YOUR GUESTS FROM SUNBURN AND
SQUINTING BY PASSING OUT PRETTY PARASOLS.

cityscape wedding basics

Ready to plan an urban affair? Here's the inside info you need to pull it off in style.

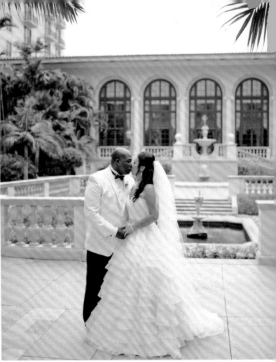

colors

Take color cues from your venue and work with the space rather than against it. For a rooftop wedding, the sky is literally the limit. You can go as bright (think: fuchsia and orange) or muted (ivory and gold) as you like. Parks and museum courtyards are a little bit trickier, since they'll likely have some preexisting décor. Work off of what the space has to offer. If it has exposed brick and ivy, for example, try a neutral color pairing, such as cream and green.

try these
color combos

orange & silver

ivory & champagne

gray & fuchsia

stationery

This is your opportunity to get your guests excited about your wedding location, especially if you're expecting a lot of out-of-towners. Work an image of an iconic landmark—like Golden Gate Bridge for a San Fran affair or the Empire State Building for a Big Apple wedding—into the save-the-dates and carry it through the rest of your stationery. Or if your city has a recognizable skyline, such as Chicago, New York, and Boston, consider using that instead. For smaller but equally awesome cities, a stylized map is a great option everyone will love.

attire

People flock to cities for the freedom to express themselves, so don't worry too much about looking out of place at your urban nuptials. Just make sure your wedding attire matches the vibe of your day. If you're a glitzy glamour girl, wear the glittery ball gown of your dreams, and if you're a bit more alternative, go for the vintage tea-length skirt you imagine yourself in. Just keep in mind the one exception to that "wear what you like" rule: If you're getting married on a city rooftop, you might want to nix the dramatic cathedral-length veil—there's a good chance things will get blustery up there!

menu

Your menu is the perfect chance to introduce guests to the foods your city does best. Barbecue is a must for a St. Louis wedding, as is muffuletta in New Orleans and cheese curds in Green Bay, Wisconsin. Work closely with your caterer and request that he propose a menu he is confident he can execute, having seen the venue and taken the predicted temperatures into consideration. If you're using an outside caterer, remember to build time into your day-of timeline to account for any traffic snarls they might run into.

favors

If you have chosen to host your wedding in a city, you probably have some level of sentimental attachment to it. Think about some of your favorite things to do there as a couple and use that as your inspiration. If you're a Baltimore bride with season tickets to the Orioles, for example, you might consider gifting your guests with key chains or custom jerseys featuring the baseball team. If you love spending time together at a local zoo or museum, consider donating to it in lieu of more traditional favors.

other considerations

When you're planning a big city celebration, it's important to check at least one local calendar before settling on a date. Anything from parades and marathons to holidays and sporting events can jack up travel and hotel prices and cause major traffic headaches for both you and your guests. You'll also want to consider how guests are going to get from their hotels to your ceremony and reception. Public transportation can be confusing and time-consuming. It's probably a good idea to provide specific directions on your wedding website, especially if you're inviting a lot of out-of-towners.

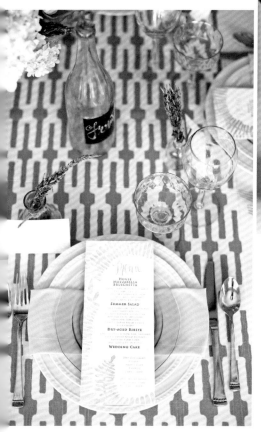

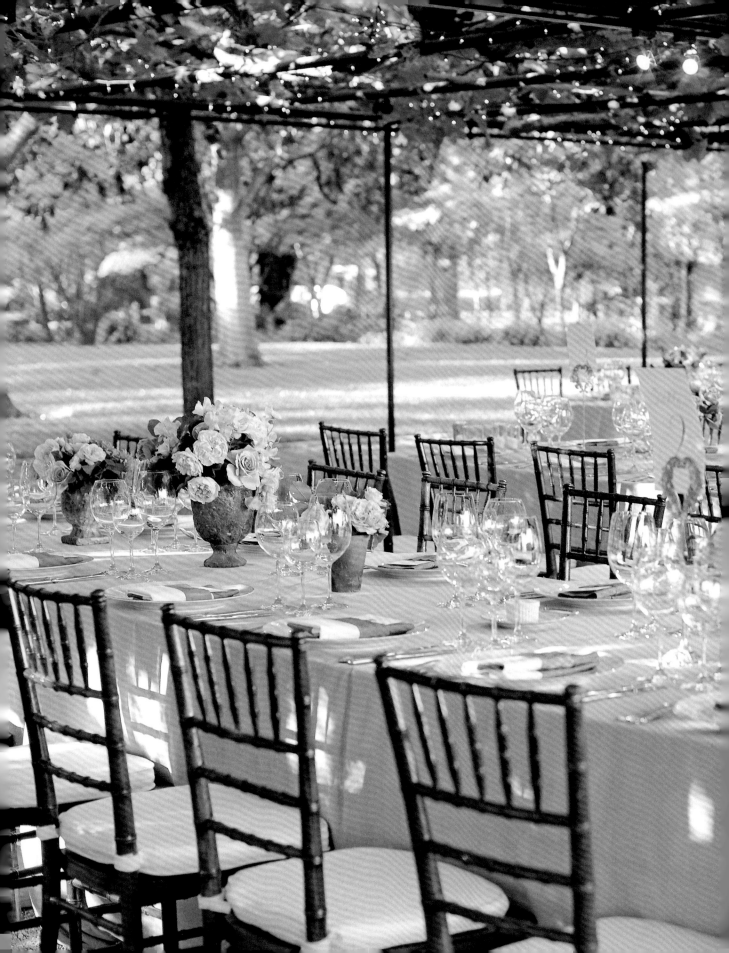

6

VINEYARD

Fields of grapes that go on forever, rolling hills, pastoral landscapes—you don't have to be a wine lover to appreciate the beauty of a vineyard. The setting can be as vast as the landscape of Tuscany or as intimate as a few acres. Regardless of the location, there's no denying that a vineyard is an idyllic setting in which to say your vows. Rustic or elegant, funky or traditional, options are endless for the style and feel of your day. Even the season plays a part in the palette, since wine country looks pretty different throughout the year. During the spring months, flowers are blooming and the fields are green. In fall, vines are fully grown and the crops are ripe, but that means the landscape is browner too, so your setting will have a more earthy vibe.

As for where to celebrate: Find an open lawn or shady grove of trees near the grapevines for your ceremony. A reception under a pergola or side-free tent would be a perfect option, so the vineyard scenery will still be visible all around. In terms of décor, you could play up the vineyard theme with a grape motif on your stationery suite and even incorporate grapes into the flower arrangements on the reception tables. Or you could echo the environment itself by keeping the palette earthy in shades of green, white, and brown and add rugged elements, such as wood tables and furniture. However you decide to decorate, one thing is certain: The stage will already be set in amazing fashion.

Beaulieu Vineyard,
Rutherford, CA

JULIE & AARON ▪ AUGUST 6

effortless
and organic

Fields of grapevines, towering trees, and the open sky starred in Julie and Aaron's easy-going summer nuptials at her parents' home in Sonoma County, California. (It also happened to be where he proposed!) A color scheme of green, white, and brown made it hard to tell where the landscape stopped and the wedding started.

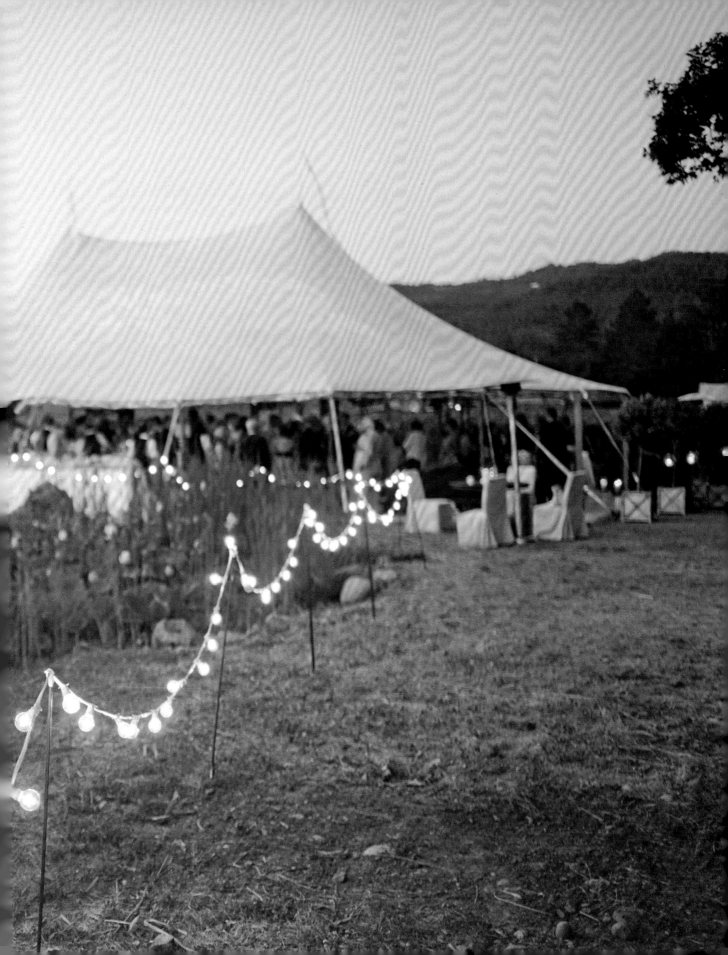

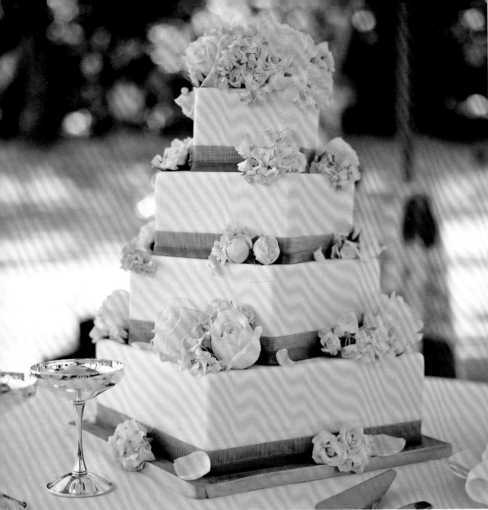

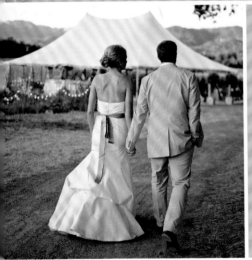

clockwise from top left: Even though it was just a small touch, the jute ribbon border transformed their all-white cake. ■ Moss pomanders and driftwood added earthiness to the lounge area. ■ A tree motif on the invitation suite hinted at the day's outdoor setting. ■ Olive oil made from olives grown on the property was a thoughtful gift to send home with guests. ■ No fuss here! The couple made their way on foot to their celebration, giving them a few moments alone to take it all in.

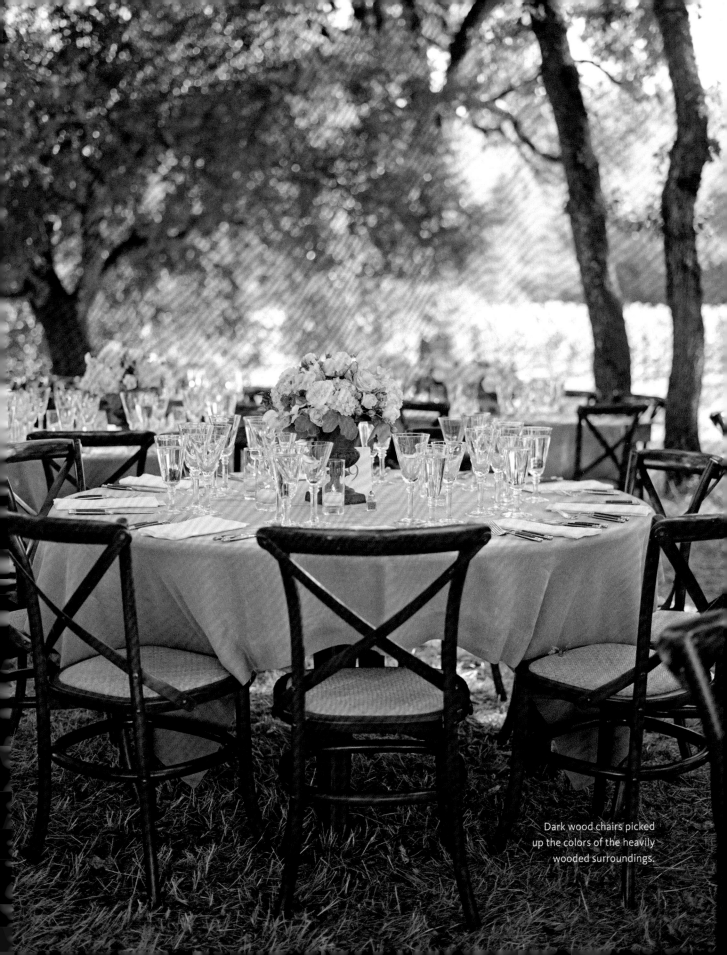

Dark wood chairs picked up the colors of the heavily wooded surroundings.

CATHLEEN & ROSS ▪ SEPTEMBER 15

rustic refined

clockwise from opposite:
The ceremony aisle was marked by petite floral arrangements hanging from shepherd hooks.

■ Guests were invited to fill cones with herbs and shower the couple as they made their way down the aisle as newlyweds.

■ A monogrammed cornhole set was an enjoyable way for guests to spend cocktail hour.

■ A wide assortment of blooms in Cathleen's bouquet created an unfussy, fresh-picked effect.

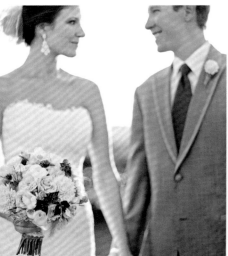

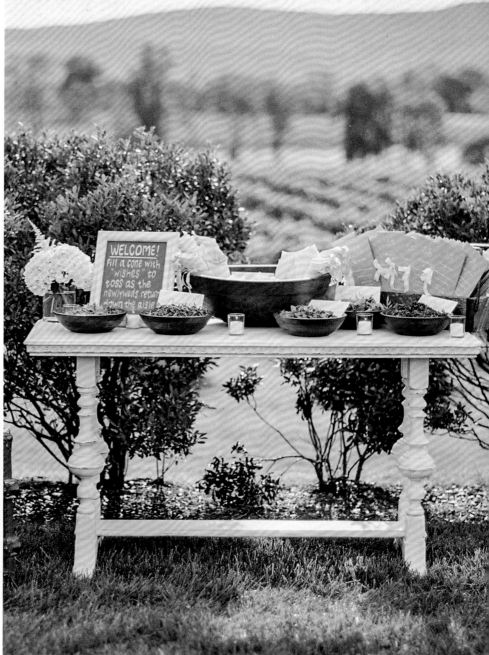

Pairing a homey combination of burlap and lace with a neutral color scheme of muted pink, gray, ivory, and champagne, Cathleen and Ross struck the perfect chord between natural and elevated. Subtle details kept the décor from overpowering the fields of green in Purcellville, Virginia.

TIP

You don't always need to set up a canopy or actual altar, especially when the setting for your ceremony is as inspiring as this one.

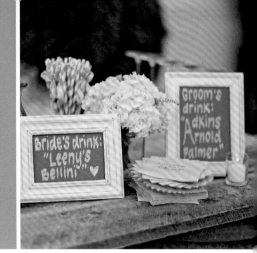

Bride's drink: "Leeny's Bellini" ♥

Groom's drink: "Adkins Arnold Palmer"

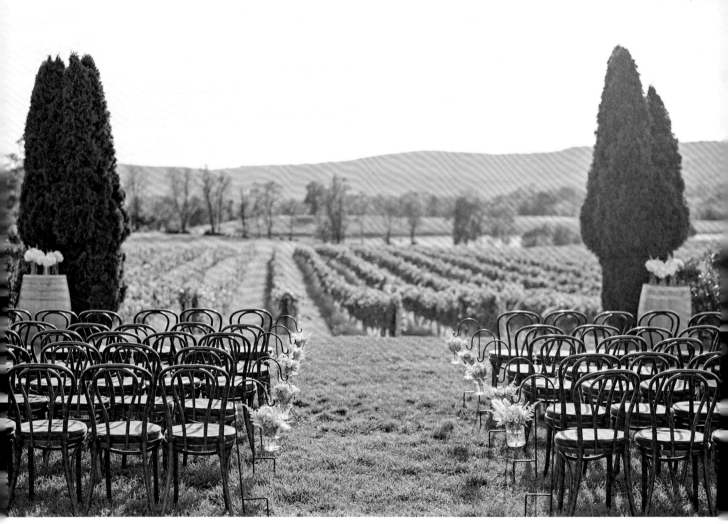

clockwise from top left: The bridesmaids carried understated arrangements to match their soft gray gowns. ■ The signature cocktails were given fun, personal names.

■ Ceremony décor was kept minimal to offset the stunning view of the vineyard. The aisle, lined by flowers at the end of each row, led the way to the land beyond.

Even the wedding cake
mimicked the day's
burlap and lace details.

FLOWERS

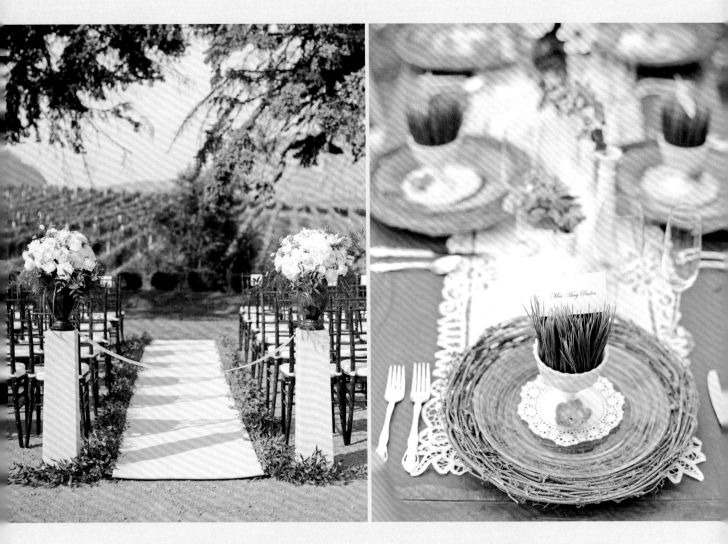

THE BLOOMS YOU CHOOSE FOR A WARM, HUMID CLIMATE SHOULD BE CAREFULLY CONSIDERED.
WORK WITH YOUR FLORIST TO SELECT THE FLOWERS THAT BEST FIT YOUR LOCATION.

clockwise from above left: Start by playing off the winery's existing décor—you know, those miles of rolling grapevines. Leafy garlands line this white ceremony aisle, picking up the green of the vineyards in the distance without overpowering them. ▪ A charger made of woven vines and a coupe filled with grass add color and texture to a wood farm table. ▪ Found branches are used to create a one-of-a-kind ceremony arbor. Oversize floral arrangements soften the look, while vintage wine barrels give a nod to the locale. ▪ Centerpieces of sunflowers, veronica, and dahlias, along with fresh apples, create a bountiful, picnic effect. ▪ Urnlike stone planters evoke an old-world Tuscan vibe, perfect for a winery wedding. ▪ Use your ceremony seating to dress up the space. Here, the chairs on the aisle are adorned with white-and-green bunches of hydrangeas, garden roses, and hanging amaranthus.

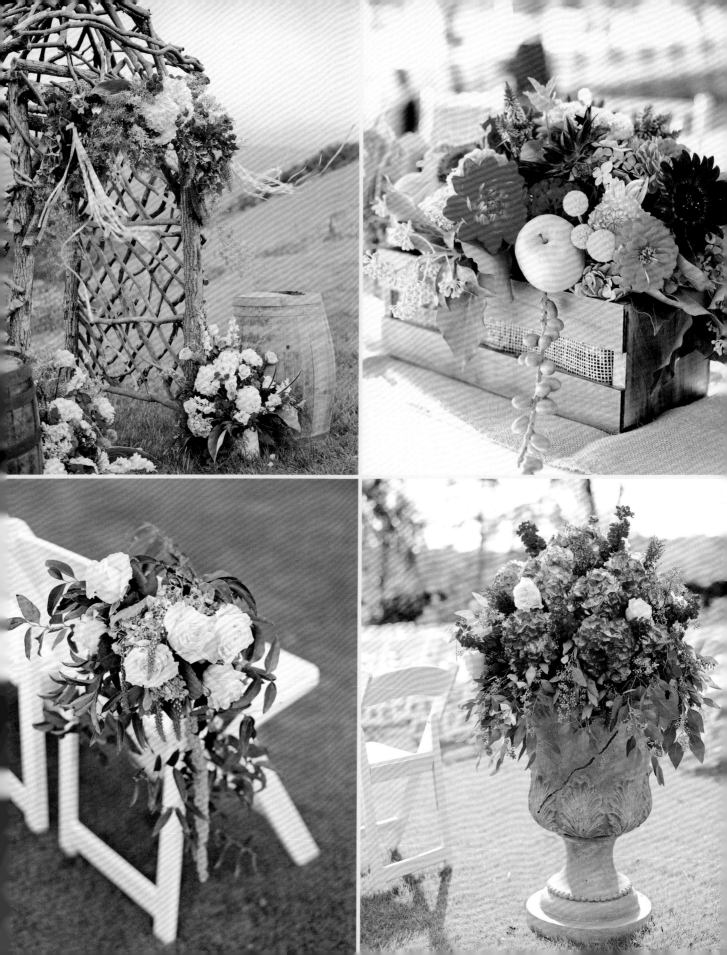

DINA & YUVAL ▪ SEPTEMBER 29

earthy and
understated

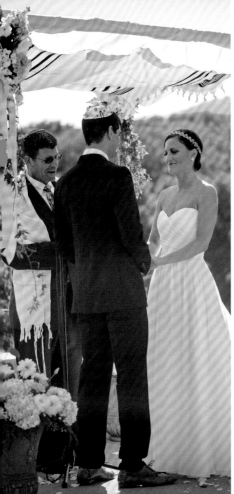

Capitalizing on the natural beauty of Carmel Valley, California, Dina and Yuval added little extra décor to their outdoor wedding venue. As a nod to her heritage (her mother grew up in a town in Israel that exported oranges), they used orange branches throughout and placed oranges at each seat at the reception—one of many personal touches that made the day special.

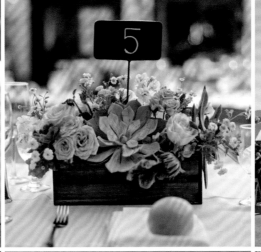

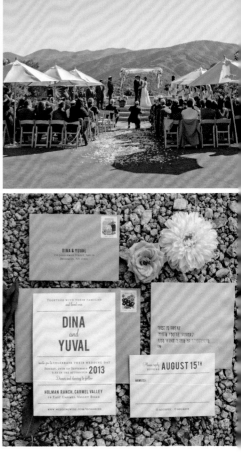

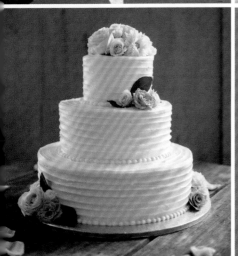

clockwise from opposite: The seating assignments were printed on vintage luggage tags and hung on a clothesline. ■ Organic arrangements accented the couple's huppah. ■ Antique wood wine boxes served as earthy centerpieces and complemented the day's vintage aesthetic. ■ The rugged Carmel Valley landscape was a stunning built-in ceremony backdrop. ■ The rustic, outdoor theme came across early on thanks to the ivory card-stock invitations printed in coffee-brown ink. ■ Rough buttercream frosting on the round wedding cake looked homespun and relaxed.

TIP

Keep in mind that your wedding is a celebration of the two of you. Sentimental touches, like old family photos, will go a long way toward making the day more meaningful for everyone.

Dina and Yuval thought choosing a beautiful venue would simplify the planning process, and they were right!

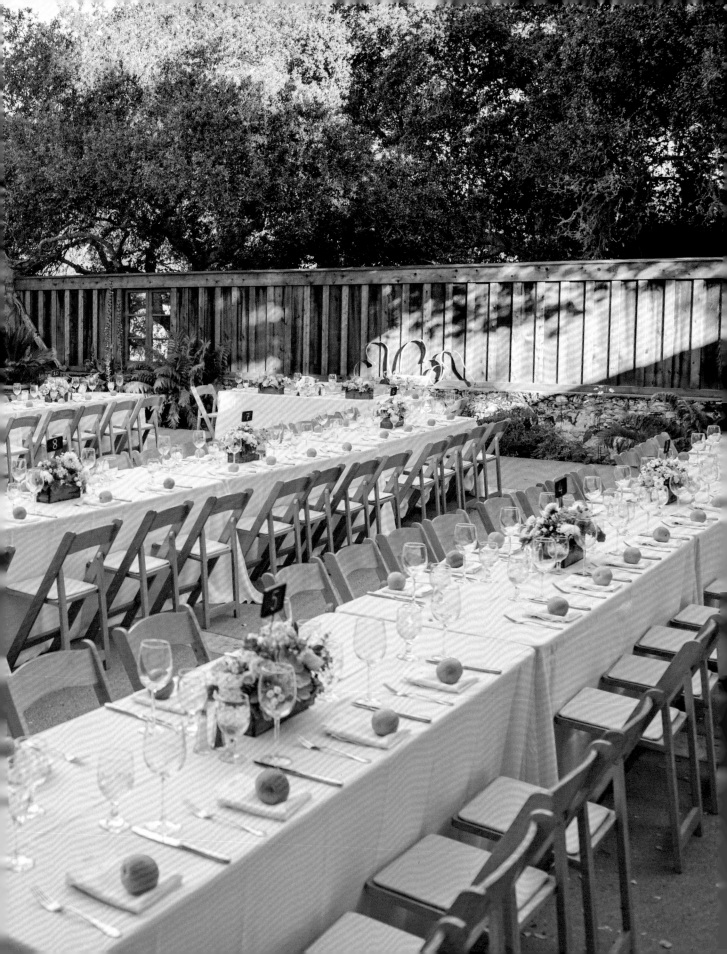

RACHEL & JASON ▪ JUNE 22

epicurean elegance

For their wine country wedding, gourmands Rachel and Jason wanted to re-create the cozy intimacy of one of their famous dinner parties. Inspired by the earth tones of fruits and vegetables, the couple used a color scheme of deep blue and purple accented with soft neutrals to pull off their rustic, farmers-market-themed affair in Santa Ynez, California.

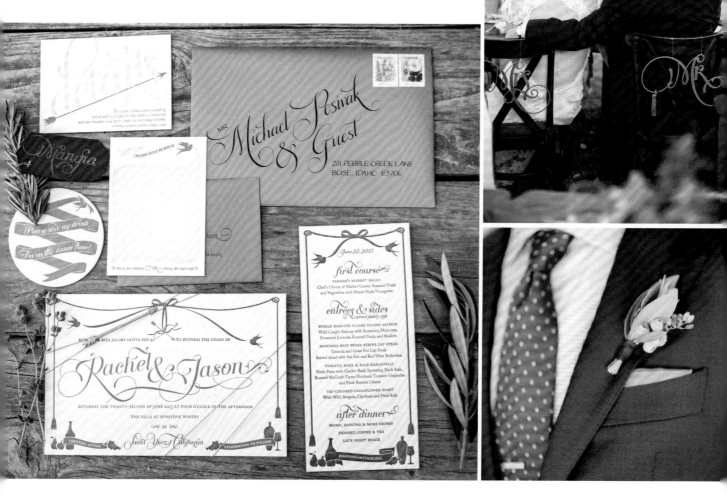

clockwise from opposite: To complement their venue, Rachel carried a textured, unstructured bouquet. ■ "Mr." and "Mrs." signs marked the chairs of honor at the reception. ■ The culinary theme even translated into the boutonnieres!

The groom wore a small (fragrant) bunch of unripened blueberries, thyme, and bay leaves. ■ A berry-inspired palette and wine-related illustrations on the invites hinted at the setting and gave guests a glimpse of what was to come.

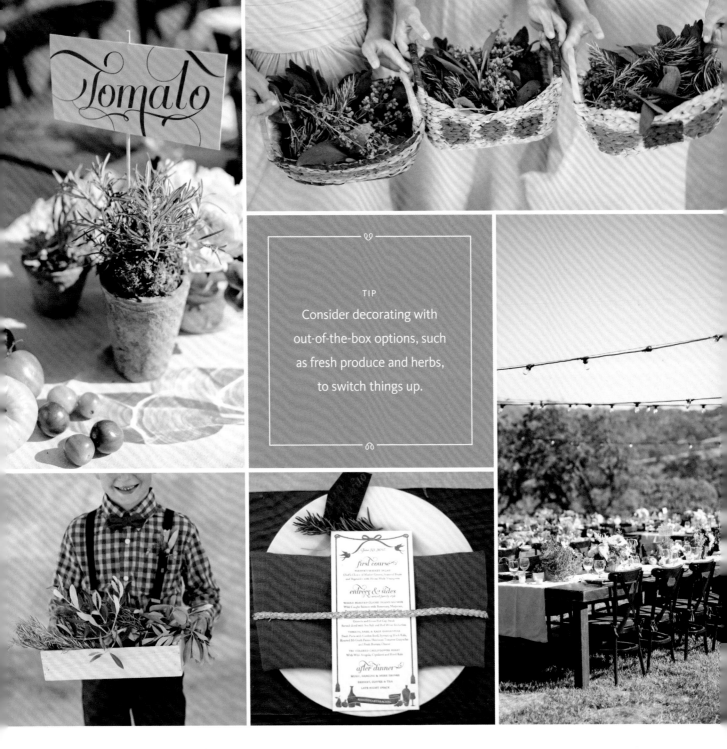

clockwise from top left: Each reception table was named after a different type of produce with fresh "examples" scattered throughout the tablescapes. ■ The flower girls tossed rosemary, sage, and thyme during their walk down the aisle. ■ Wood farm tables evoked the feel of the Italian countryside. ■ Gold braided cords provided a rich addition to the place settings. ■ The ring bearer toted a box of herbs and olive branches down the aisle.

What better place to steal away for a private moment (and a kiss)?

ESCORT CARDS

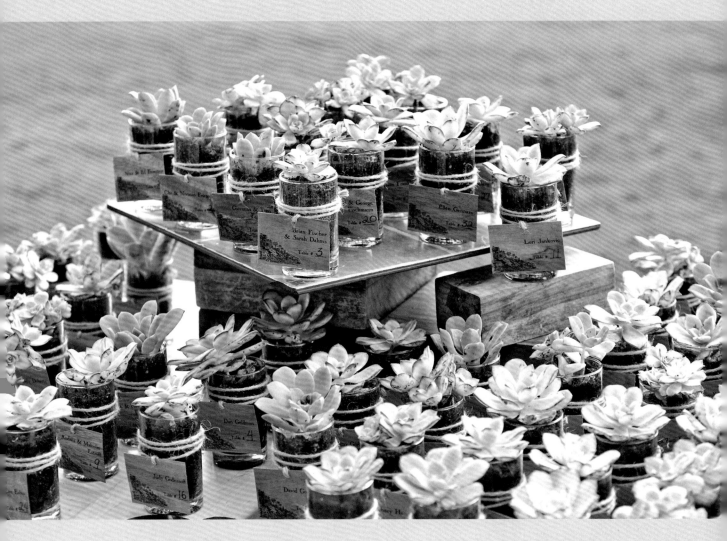

THE WAY YOU SHOW GUESTS TO THEIR SEATS CAN BE AN EXERCISE OF THE IMAGINATION.
LET YOUR WEDDING THEME OR COLOR SCHEME LEAD THE WAY.

clockwise from above: Escort cards that double as favors are guaranteed crowd-pleasers. Make them reusable or, better yet, replantable and you've hit the wedding jackpot! Seating assignments are tied to mini succulents with twine for the perfect welcome to a nature-inspired affair. ▪ A weathered old trellis is reborn as an escort-card display. Plant it in a bed of moss for a garden-worthy touch. ▪ Even if you're not having a winery wedding, repurposed wine bottles never look out of place, especially in a rustic outdoor setting. Relabeling bottles with seating assignments is an easy DIY project that looks like a million bucks. ▪ An oversize gilded frame is transformed with moss and butterfly escort cards arranged to form a heart. An ombré effect adds a modern flair to an otherwise old-world display. ▪ For an earthy effect, prop escort cards in slotted birch branches on fresh fragrant blooms.

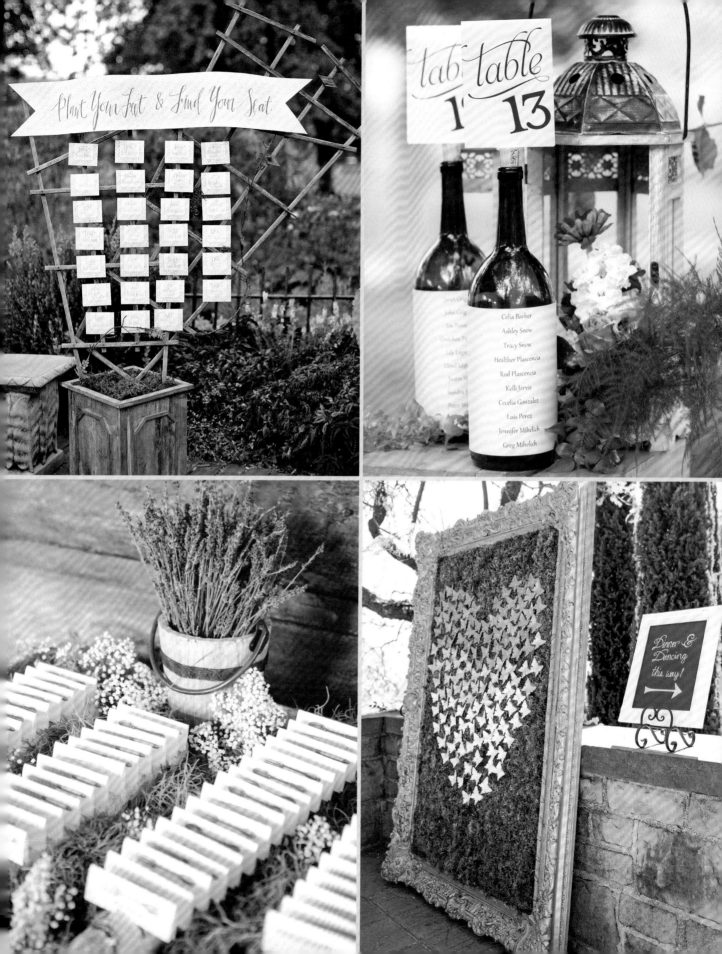

festive farm

V ivid splashes of canary yellow in the décor, flowers, and stationery played off the bright tones in nature to lend a fresh and joyous feel to Beverly and Banjo's central California celebration. The look of a sun-filled vineyard in summertime was captured from beginning to end.

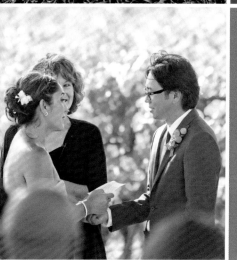

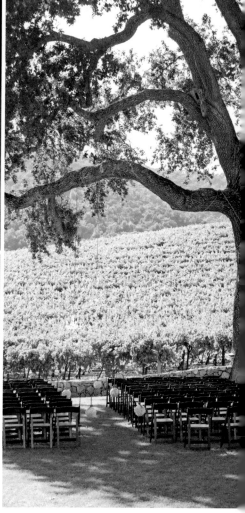

TIP

Saying your vows amid the grapevines offers not only a spectacular memory, it also creates an incredibly picturesque photo backdrop.

clockwise from opposite: Lemons were a colorful place-card idea and a fun alternative to flowers. ■ Fresh blooms and produce paired with antique décor for a unique look. ■ Fluffy pomanders of yellow chrysanthemums marked the aisle.

■ An unexpected dash of glam, crystal chandeliers were suspended over the altar space. ■ Beverly and Banjo said "I do" alongside rows of ripening grapes. ■ Guests learned of the day's color scheme early on thanks to cheery invites.

After dinner, guests danced the night away in a restored barn.

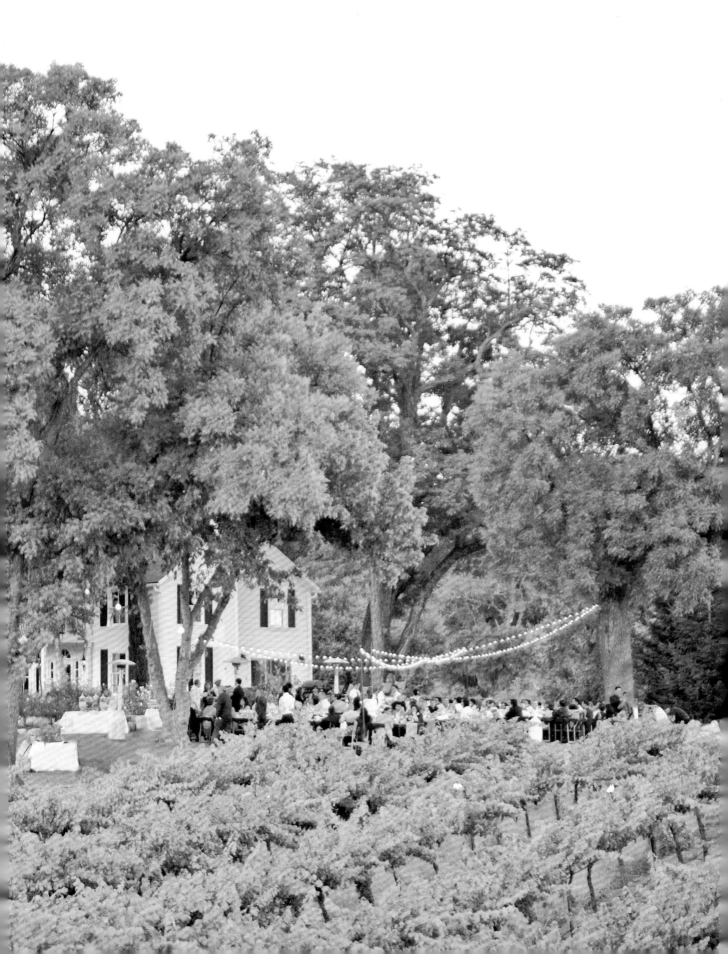

CAKES

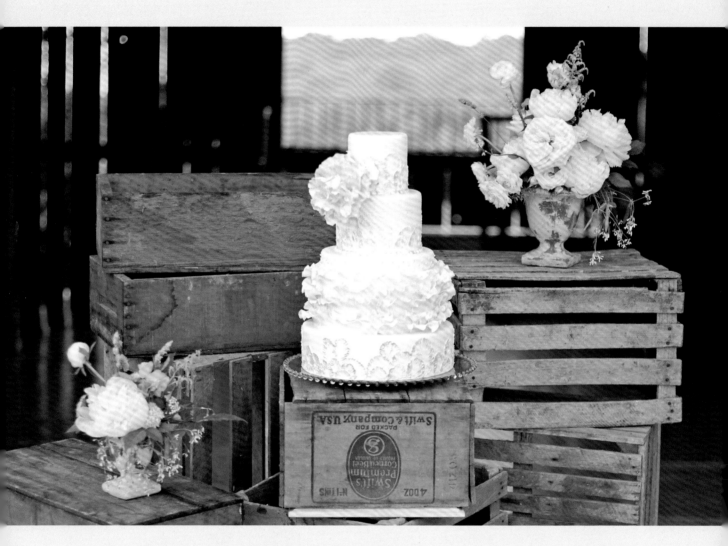

LEAVES, BRANCHES, FIELDS OF GREEN, AND EVEN THE GRAPES THEMSELVES CAN INFLUENCE A CAKE'S DECORATION FOR A VINEYARD WEDDING. ALL YOU NEED TO DO IS LOOK AROUND YOU.

clockwise from above: A cake can be as plain or ornate as you like, as long as it goes with the vibe of the wedding. The presentation is all in the details. Here, a delicate, ruffled white confection could fit in anywhere, yet when surrounded by a pile of wine crates in a weathered barn, you know right away it belongs in a vineyard. ■ Olive leaf garlands on an all-white cake evoke a Tuscan feel reminiscent of Italy's iconic wine country. ■ A "naked" cake has no frills—literally! For a truly undone look, forgo the frosting and bare it all—just don't leave your unfrosted cake in the sun for too long or it will dry out. ■ No elaborate sugar flowers needed: Just decorate each tier of a subtly textured white cake with a few of the same blooms from your bouquet to infuse color and interest. ■ Nothing says "vineyard" like bunches of sugared grapes used as embellishments. A playful Swiss-dot pattern adds texture to the fondant-covered tiers.

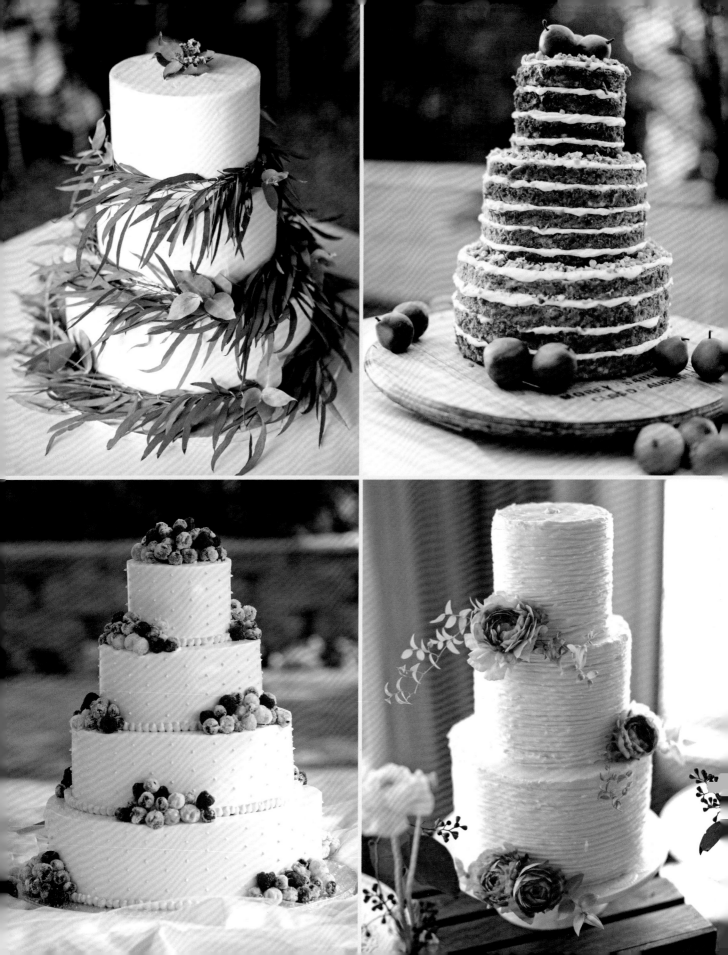

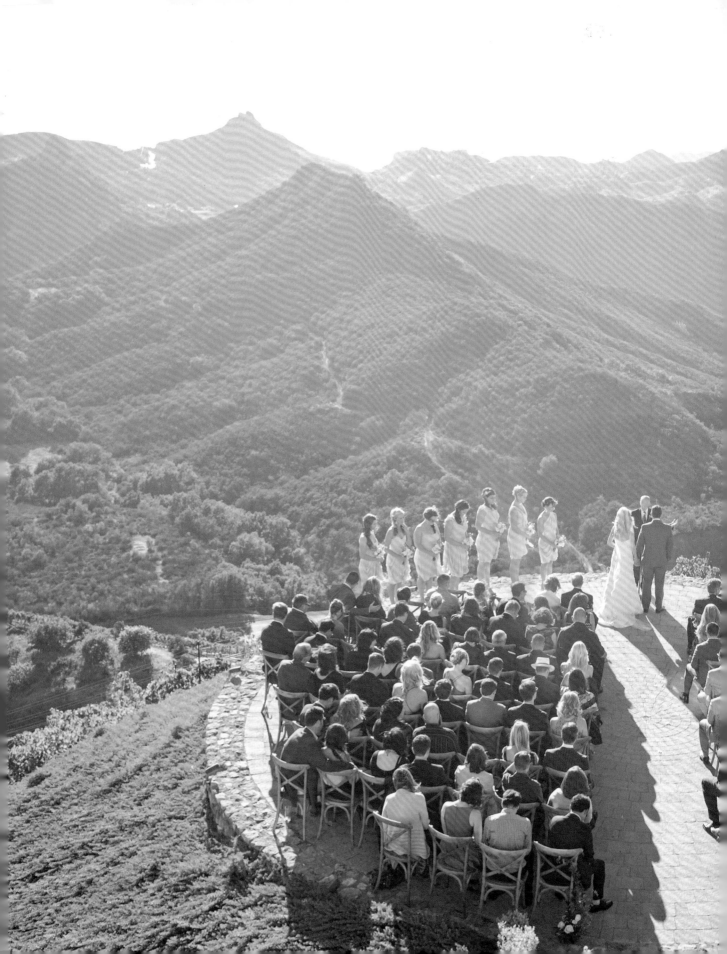

malibu mountaintop

Kristin and Matt wanted their wedding to feel warm and timeless—like a family heirloom. With rustic wood accents, touches of delicate lace, and antiques, they created a welcoming mountaintop affair that felt accessible, despite the altitude of their stunning Malibu, California, venue.

The place settings were finished with vintage handkerchiefs and skeleton keys for an old-world aesthetic.

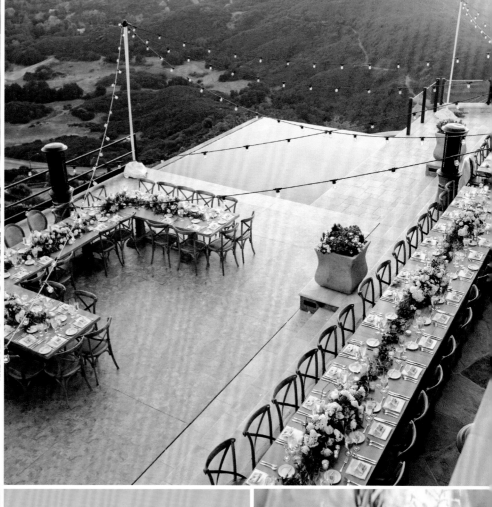

clockwise from top left: An antique camera was a quirky addition to the reception décor. ▪ When it came to decorations, Kristin and Matt let the soaring 360-degree views do the heavy lifting. ▪ Roses, wildflowers, and assorted greenery in organic hues fit the day's timeless ambience. ▪ Kristin looked like the picture of vintage romance in an ivory lace gown paired with a dramatic cathedral-length veil.

wilt-proof flowers

THESE HEAT-RESISTANT BRIDAL BLOOMS WILL OUTLIVE THE LAST DANCE.

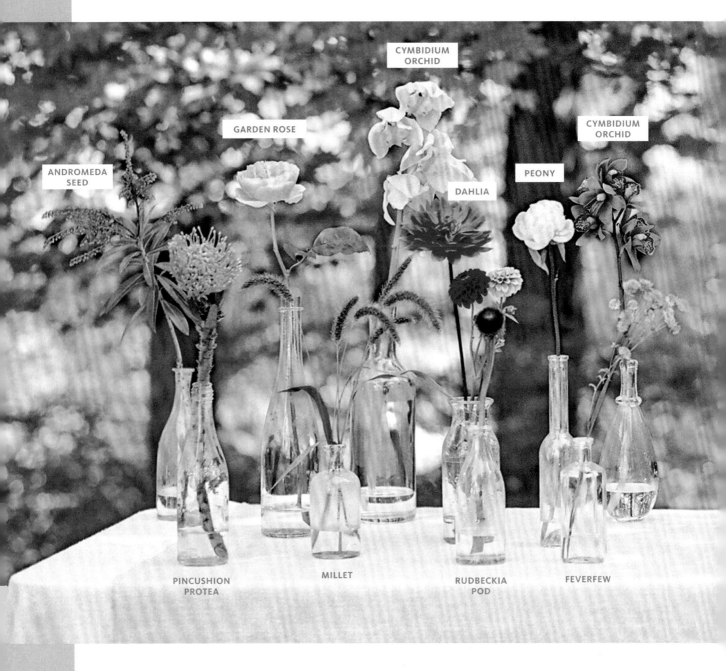

CYMBIDIUM ORCHID

GARDEN ROSE

CYMBIDIUM ORCHID

ANDROMEDA SEED

DAHLIA

PEONY

PINCUSHION PROTEA

MILLET

RUDBECKIA POD

FEVERFEW

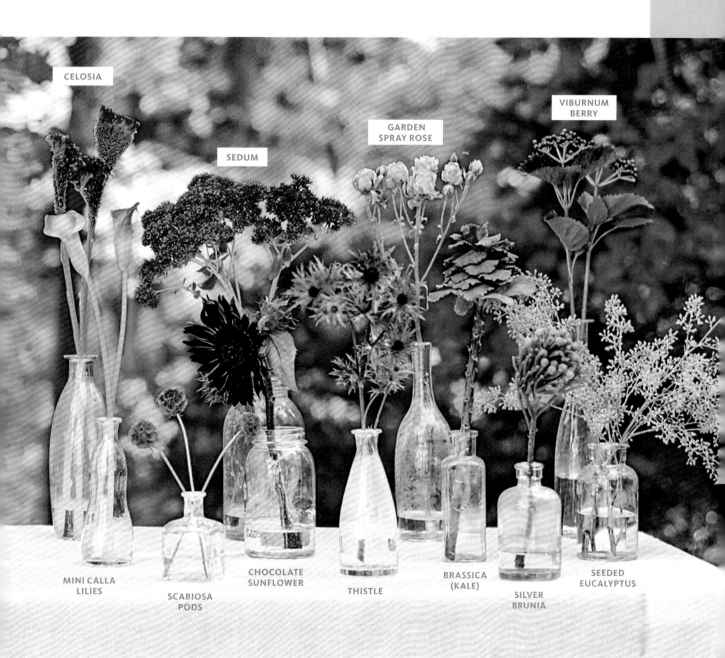

CELOSIA

SEDUM

GARDEN
SPRAY ROSE

VIBURNUM
BERRY

MINI CALLA
LILIES

SCABIOSA
PODS

CHOCOLATE
SUNFLOWER

THISTLE

BRASSICA
(KALE)

SILVER
BRUNIA

SEEDED
EUCALYPTUS

vineyard wedding basics

Plan no further until you read our best advice for creating the ultimate winery wedding.

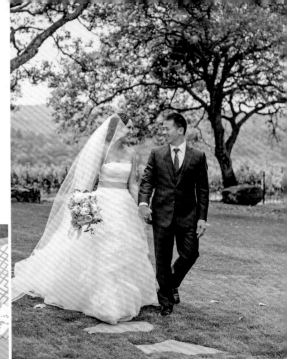

colors

Capture the season with a palette that mirrors Mother Nature. For fall, consider rich brown, burgundy, and orange, while spring and summer call for a lighter palette of buttery yellow, mauve, and soft green. Natural accents and textures, such as wheat, greenery, twigs, burlap, vegetables, and fruit, also lend themselves to the vineyard vibe. And wine colors, such as red, purple, champagne, and rose, are always a hit for vineyard weddings.

try these
color combos

gray & yellow

lavender & taupe

rose & champagne

stationery

While you don't want to go overboard with a theme, incorporating nods to your vineyard setting in your wedding papers is a must. One of the good things about a winery wedding (and there are many!) is that vineyards lend themselves to endless symbols and motifs. If you're creating a custom monogram for your day, why not incorporate a bunch of grapes or a goblet? Less-traditional couples might consider a wine-stain illustration made to look like someone set a glass of red wine down on the paper and left a ring. Words like *cheers* and *toast* also drive the point home.

attire

When it comes to attire for a winery wedding, there are no rules. That said, a poufy ball gown and heaps of bling will probably look out of place in a rustic setting. Instead, lean toward a more relaxed, yet still elegant, look. You can't go wrong with a lace or sheath gown, for instance. As for the guys, encourage them to experiment with earthy colors, such as beige and taupe, and textures, such as tweed and herringbone. The groom can definitely wear a classic black tux, if his heart is set on it; just make sure your look matches the formality of his style.

menu

Great wine and great food go hand-in-hand, so focus your attention on crafting a unique and unforgettable menu. Whether you use the in-house caterer or bring in outside help, highlight the vineyard's offerings by including a wine pairing to match each dish—remember to include the proper glasses for each varietal at the place settings. Other fun ideas include interactive stations, like a cocktail-hour wine tasting (see if a rep from the vineyard can give a brief presentation), a wine and cheese pairing, or a wine slushy or snow-cone bar. Even the cake can get the wine treatment—go for chocolate zinfandel with strawberry filling (and don't forget to finish it off with a grapevine motif or clusters of sugared grapes).

favors

A winery wedding gives you the perfect opportunity to treat your guests to the fruits of the land (literally). Send guests home with mini bottles of wine or have your wedding date etched onto wine glasses, so they can keep the fun going at home. Bottle stoppers and cork drink coasters are other great options for favors. For weddings channeling an old-world, Tuscan vibe, small bottles of olive oil are a more out of the box, yet equally delicious, option.

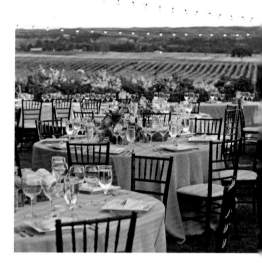

other considerations

Every vineyard has its own specific set of rules and regulations, so you'll want your priorities and plans to mesh with the place you choose. Come prepared with a list of questions to ask each venue you visit. Some major things you'll want to know are: the policies for underage guests; whether you're required to use preferred pros or if you can bring in outside companies; if the winery will close to the public during your event; if they offer a full bar or just wine and beer; and what kind of backup plan they have in case of bad weather. Consider finding a venue that lets you book the entire vineyard for the day, or schedule your nuptials during a quieter time; Thursday evenings and Sunday afternoons are increasingly popular (and can be more cost-friendly) days for weddings.

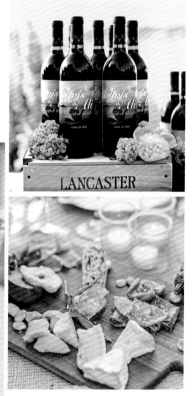

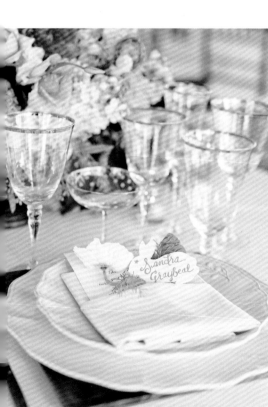

INSIDER PLANNING ADVICE

**CONSIDER THIS YOUR ESSENTIAL CHEAT SHEET CONTAINING TIPS ON EVERYTHING
YOU NEED TO KNOW TO PULL OFF EVERY KIND OF OUTDOOR WEDDING.**

NOW THAT YOU HAVE SEEN AND READ about all the ways to craft your dream outdoor wedding, you will want to make sure all the necessities are in place so the celebration runs as smoothly as possible. Here, we've gathered vital advice to ensure every element—from the food and logistics to the décor and attire—turns out picture perfect.

décor

Take your design cues from the location. Keep in mind, if you are having a wedding overlooking the water or a ceremony in a forest, your centerpieces should not appear as if they belong in a ballroom. Using what is local and native helps make the design cohesive.

Work with the space you are in rather than against it. For example, if your wedding is in a garden, find out what is blooming during your wedding month and try not to compete with those colors.

Wind can become a challenge. Have linen clips for your tables to keep your tablecloths from blowing off. Battery-operated candles or LED votives are a good option as well. And be sure your centerpieces are weighted properly, so they will not topple over.

Provide lighting for the areas around the event, such as the walk to the restrooms or the parking area.

flowers

Keep flowers in a refrigerated area and spray them with lots of water before setting them out on a hot day. Ask if the venue has an indoor space where you can have flowers delivered before the event.

Your floral arrangements should not sit in direct sunlight for more than an hour before guests arrive. Leave your cocktail hour florals and any other outdoor

arrangements tucked inside the tent until 30 minutes before people are expected to arrive.

In hot, humid locales, be careful with blooms such as hydrangeas and lilies. These flowers require a lot of water. They'll be fine in centerpieces with water-filled vases, but these varieties are not recommended for use in arches, bouquets, or boutonnieres.

Keep your bouquet away from direct sunlight; it is extremely delicate and sensitive to heat. If you are concerned about the heat and humidity, have two bouquets—one specifically for your photos and one for your ceremony.

When bouquets are not being used, always put them back in water to extend their longevity. Just make sure that if the stems are wrapped in ribbon, the ribbon is far enough away from the ends so it does not get wet.

Choose your centerpieces based on the tent type. For example, a lower table arrangement will hold up better

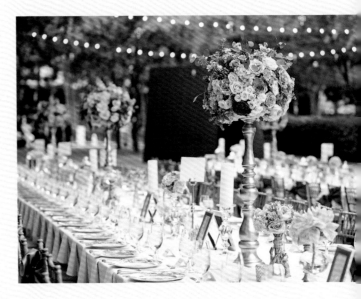

in an open-air tent, especially if it is windy. If weather and wind are not an issue, your centerpieces can be as tall as you want.

Always try to use flowers that are in season for the month of the wedding. By choosing seasonal flowers, you will get fresh, locally grown varieties.

logistics

If you know bad weather is coming (keep track of impending rain on a weather radar app), consider flipping the ceremony and the cocktail hour. Waiting it out and being flexible might pay off.

Walk through the weather scenarios with your venue coordinator prior to the wedding week so you can have a backup plan. This way, you will be prepared, and the weather plan will feel like less of a surprise.

Bring painter's tarps—they are inexpensive, and, if you are worried about the weather, they can protect your escort cards or any cocktail or bar linens that might get wet if a sprinkle rolls through prior to the wedding.

Think about where the waitstaff will change and what restrooms they will use. If you are hosting a wedding with 200 guests, you can have 30 to 50 additional people working. Rent some coat racks for the catering tent so they can hang the clothes they are going to change into.

Figure out where the staff and wedding pros will park their vehicles. Logistically speaking, vendors will want to park as close to the reception site as possible, so it is important to give specific instructions as to where you would like their vehicles to be parked to avoid a sea of cars in clear view of your event.

In some areas, it is essential to have a professional company come in and spray before your wedding to keep bugs at bay. Just be sure to do so before any tableware goes down.

It is always a good idea to have a backup generator. Find out the power needs of each vendor who is bringing equipment, then see if your venue can accommodate them. If you do need to use a generator, make sure it is a "whisper" model.

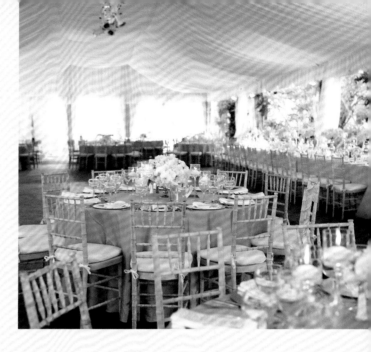

tents

Plan to use clear-top tents only in cooler months, when the temperature is below 75 degrees. The clear plastic can cause these tents to act like greenhouses, so even on a day that is not particularly hot, the heat will build up inside.

Frame tents are often more flexible in where they can be placed—adjacent to buildings, on hard surfaces, and on properties where the deep staking of a pole tent cannot be used.

When the weather is very hot, remember to get fans not only for the main tent but for the kitchen and vendor tents as well.

Discuss options for pulling tent sides open or closed in case of unexpected weather, and make sure you have the ability to add heaters or air conditioners if necessary.

You will need enough lighting for your photographer to get the best shots, but not too much light to remove the intimacy from the event. Depending on the size of the tent and number of poles, consider hanging a few large light fixtures over bars and sconces around the perimeter of the tent.

Do not forget to have sidewalls for your tent on-site in case a storm does blow through.

In addition to the reception tent, you'll need a staging tent and, if you're having a band, a tent for them. All of your other wedding pros will need a place to put their things, so having a 10-square-foot tent to accommodate them is a good idea. Most bands require, by contract, a separate space to rest and gather. Ideally, you should tuck these small tents behind a solid sidewall or draped wall of the main tent to hide them from your guests.

catering

Work closely with your caterer and request she propose a menu she is confident executing, after she has seen the venue and has a good understanding of the predicted temperatures.

Look at what foods are in season to guide your menu selections. Sourcing local, seasonal foods makes it easier to choose.

If you are doing a stationed meal outside, position the stations beneath perimeter fans in the tent. The circulating air will keep the food a bit more temperate and shield the platters from flies.

Serving stationed cheese and fruit displays at an outdoor wedding (especially if they are completely exposed) can be tricky. Cheese does not fare well in direct sunlight, and both are a magnet for bugs and flies.

For summer evenings, skip plated desserts involving ice cream or gelato; however, a quickly passed tray of Popsicles for late-night snacks or a sweet canapé would be a refreshing break from the heat.

Opt for a fondant-based wedding cake for a warm-weather wedding; it is a hearty frosting that will not melt. Buttercream, which is soft in texture, has a tendency to melt easily.

attire

The formality of the wedding gown should go with the overall aesthetic of the wedding, regardless of the locale. If you are a black-tie kind of girl getting married on the beach, then you should choose a gown that goes with the vibe.

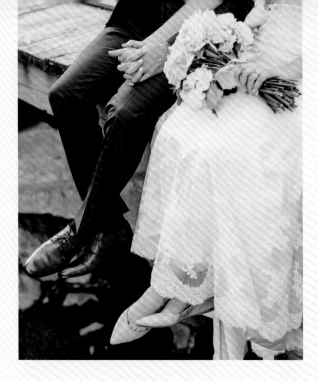

For a warm-weather wedding, look for a dress with sheer or lightweight fabric, such as chiffon or organza, with a minimal amount of petticoat underneath. They are cool, comfortable, and easy to wear.

Consider a tea-length gown. This is a great option for a more casual or rustic celebration.

If your wedding is in the grass or sand, skip the long train and the cathedral-length veil. These will end up dragging and accumulating a significant amount of dirt along the way.

Take your gown with you on the plane if you are flying to your wedding location. Most airlines will even hang a wedding dress in the first-class coat closet.

hair

If you opt for an updo, wash your hair the day before. Once the natural oils from your scalp set in after a day, it is easier to create more texture and a lasting hold. Just-washed hair can actually be too clean and slippery.

To retain volume and curl, do not take down pin curls or rollers until just before pictures, so humidity and time will not drop your hair.

Consider embracing your natural texture if your wedding is in a tropical or particularly humid locale.

The added moisture in the air will just make your hair revert back to its natural state. Instead of fighting it, go for a more polished version. Using a curling iron to re-create your curl pattern will help hold off frizz, and the heat will seal the cuticle, making it shinier.

For a windy location, opt for a tightly secured style, such as a chignon or braided updo. Anything loose and free-flowing should be avoided, since the wind will blow it around. Also consider your accessories: Choose a veil that will not get in your face.

If you do wear your hair down for the ceremony and reception, go for clip-in extensions—these hold the curl well and help your style go the distance.

When it is cold outside, use an ionic blow-dryer. The negative charge of ions will combat the positive charge of static electricity. And if you do have static, rubbing a dryer sheet over your hair will tame it instantly.

makeup

Choose shades that brighten your features and add dimension to your bone structure. Highlighting the higher points of your face, such as your cheekbones, adds radiance in the right areas. Apply powder to your T-zone to eliminate unwanted shine and oil.

Go for a makeup trial before your wedding, so you have an opportunity to see how it looks in photos and how long it lasts. This way, your makeup artist has time to make any adjustments if necessary.

Apply a primer to help keep your makeup on longer. This will help extend its wear well into the night. Look for one that will not clog pores, is oil-free, and has SPF protection, especially since sunscreen can often reflect on camera and make your face look unnaturally white.

Opt for water-resistant and waterproof formulations, especially for the eye area. Amid tears and heat, there will be no room for error. Lip stains, cheek stains, and waterproof mascara will all stay in place.

Keep blotting papers on hand for touch-ups through-out the night, and avoid makeup that is too shimmery since it can look shiny in flash photography.

photography

When it comes to your wedding photos, the time of day makes all the difference. Talk to your photographer and planner before your wedding to go over your must-have photos and come up with a checklist. Keep in mind that it takes time for your photographer to set up the shots, so plan out and stick to a schedule.

If you want your photographer to shoot formal portraits, a first-look session offers more flexibility. Waiting until after the ceremony can limit your time and lighting. Tell your wedding party and family when and where to show up for these portraits. Assign someone, such as the maid of honor or best man, to make sure everyone is in place and on time.

Your photographer may also wish to scout the property before your wedding to find backdrops and spots for specific shots on your list. Since lighting can be harsh at certain times of the day, this will be an opportunity for him to find a location that will work. And don't worry if the weather isn't ideal—your photographer has tricks to make images attractive even on rainy days. Most important, keep an open mind and trust your shooter to get the shots you want.

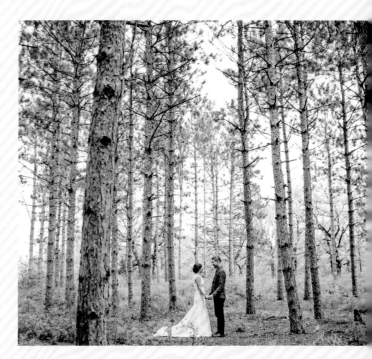

YOUR OUTDOOR WEDDING CHECKLIST

HERE'S WHAT YOU NEED TO DO, AND WHEN, ON YOUR WAY TO THE (ALFRESCO!) ALTAR.

12+ months

- ☐ Think about when you'd like to have your wedding (the question everyone will ask about 20 minutes after you get engaged).

- ☐ Define your wedding style and choose your color palette.

- ☐ Nail down a budget and go to TheKnot.com/budget. We'll help you figure out how much you should spend on flowers, stationery, and your day-of looks.

- ☐ Research and book ceremony and reception locations. This is the first big decision; you'll be amazed at how everything else falls into place once you check it off your list. Discuss indoor options in case of inclement weather.

- ☐ Start your search for your dress.

- ☐ Book any wedding pros you have to have, like a planner or DJ, especially if you live in a competitive market.

- ☐ Get your engagement ring appraised and then insured ASAP.

- ☐ Reserve hotel room blocks.

- ☐ Choose and book an officiant.

- ☐ Start your prewedding beauty regimen; schedule facials, manicures, and so on.

- ☐ Create your wedding website to give guests important info, such as directions and where you have your hotel room blocks. Include some fun details too! Get a free website at TheKnot.com/pwp.

9 to 11 months

- ☐ Finalize your guest list.

- ☐ Book your florist, photographer, videographer, musicians, cake baker, and other pros, such as a rental company (think: tent).

- ☐ Register for gifts. This is another really good reason to put together a wedding website: It will discreetly tell guests where you're registered.

- ☐ Ask your picks for bridesmaids and groomsmen if they're up for being in your wedding party.

- ☐ If your venue doesn't have an in-house caterer, interview and select one. Brainstorm an outdoor-appropriate menu and hash out a rough price per head.

- ☐ Find a stationer and order your save-the-dates. This is really happening!

- ☐ Order your gown and your veil and schedule fittings (for six weeks and one to two weeks before the wedding).

- ☐ Choose the bridesmaid dresses and have your bridesmaids order them and schedule fittings.

6 to 8 months

- ☐ Plan the ceremony with your officiant and discuss any specific religious requirements.

- ☐ Have engagement photos taken so you can get comfortable with your photographer.

- ☐ Book your honeymoon.

- ☐ It's time for the groom to choose his clothes. The groomsmen should also be told what to wear.

- ☐ Send out your save-the-dates.

- ☐ Work with the hosts to start planning the rehearsal dinner.

- ☐ Finalize and order your invitations and thank-you notes.

- ☐ Reserve venues for the next-day brunch, welcome party, and/or after-party.

- ☐ Book a day-of coordinator (if you don't have a full-service planner and a day-of planner isn't included with your venue).

- ☐ Schedule your beauty trials and book hairstylists and makeup artists.

- ☐ Research and purchase wedding insurance (if you are using it).

- ☐ Buy any special lingerie you need.

4 to 5 months

- ☐ Finalize your flower proposal with your florist. Ask about wilt-proof options.

- ☐ Address invitations or give them to the calligrapher (they need several weeks).

- ☐ Finalize the rental list (tent, chairs) with the caterer or rental company.

- ☐ Buy your wedding-day accessories. Think: shoes, purse, and jewelry.

- ☐ Complete your cake order and order the groom's cake, if you're having one.

- ☐ Schedule dance lessons.
- ☐ Arrange for day-of transportation for you, the wedding party, and guests (if needed).
- ☐ Buy or rent any ceremony decorations that are not included in your flower proposal, such as an aisle runner or program basket.
- ☐ Buy your wedding rings.
- ☐ Order your wedding favors.

3 months

- ☐ Finalize your ceremony details with your officiant, and decide if you're writing your vows.
- ☐ Research local marriage license requirements.
- ☐ Finalize your playlist with your band or DJ.
- ☐ Write thank-you notes for gifts as you receive them.

2 months

- ☐ Send out wedding invitations at the six- to eight-week mark. RSVPs should be due one month before the wedding.
- ☐ Work on your ceremony vows, if you are writing them yourselves.
- ☐ Order or start assembling the ceremony programs.
- ☐ Buy your guest book and any supplies for your escort-card display.
- ☐ Confirm room blocks for out-of-town guests.
- ☐ Purchase gifts for your parents, attendants, and each other.
- ☐ Have your first dress fitting—don't forget your shoes and undergarments.
- ☐ Finalize the menu with your caterer.

- ☐ Create a timeline for the weekend and share it with your attendants, planner, and photographer.

1 month

- ☐ Finish assembling your ceremony programs or pick them up from the stationer or printer.
- ☐ It's time to check off your "something old, new, borrowed, and blue."
- ☐ Plan any night-before social activities with family and friends.
- ☐ Compile a must-take photo list.
- ☐ Put together welcome baskets for out-of-town guests' rooms.

1 to 2 weeks

- ☐ Missing RSVPs? Follow up now.
- ☐ Finalize the seating chart.
- ☐ Give your caterer, cake baker, and site manager the final head count.
- ☐ Print or write your escort cards.
- ☐ Confirm all final payment amounts, details, and delivery with pros.
- ☐ Distribute a day-of schedule and contact list.
- ☐ Pick up your marriage license (the most fun you can have at a government office).
- ☐ Have your last dress fitting.
- ☐ Get a final hair trim and touch-up.
- ☐ Put tips for wedding pros in envelopes and give to an attendant (or planner) to distribute.

2 to 3 days

- ☐ Pack an overnight bag for the wedding night (include outfits for any day-after events, like a good-bye brunch).
- ☐ Steam or press your dress, if needed.

- ☐ Touch base with the ceremony and reception sites to go over the schedule.
- ☐ Confirm last-minute details, like flower and cake deliveries.
- ☐ Have your site sprayed to ward off insects.

1 day

- ☐ Get a manicure and pedicure.
- ☐ Bring all ceremony accessories to the site.
- ☐ Rehearse the ceremony and attend your rehearsal dinner. Give gifts to your attendants.
- ☐ Give the marriage license to your officiant—one detail you won't want to forget.

day of

- ☐ Eat breakfast—you may forget to eat later.
- ☐ Hand off your wedding bands to the best man or maid of honor to hold.
- ☐ Give gifts to your parents and each other.

postwedding

- ☐ Have your wedding dress cleaned and/or preserved and return the tuxedo rentals.
- ☐ Freeze the top layer of your cake.
- ☐ Send your pros thank-you notes and submit online reviews.
- ☐ Thank your attendants for standing by you on the day—and during all of your planning.
- ☐ Finish up thank-you notes for gifts.

CREDITS

FOLLOW THE KEY BELOW WHEN LOOKING UP THE DETAILS OF EACH WEDDING.

 Venue

 Event Design/Planner

 Photography

Cake

 Flowers

Stationery

ESTATE

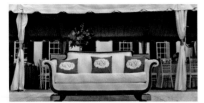

P.16 Lowndes Grove Plantation, Charleston, SC Southern Protocol Marni Rothschild Pictures Fish Stems Scotti Cline Designs

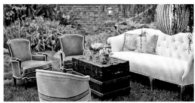

P.20 SLS Hotel Beverly Hills, Los Angeles Beth Helmstetter Events Amy & Stuart Photography Vanilla Bake Shop Flower Wild Momental Designs

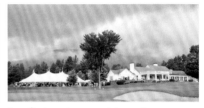

P.22 Ekwanok Country Club, Manchester, VT Janet Dunnington KT Merry Photography Irene's Cakes by Design Michael Cifrino/Clare Frances Events Stationery by Maryellen

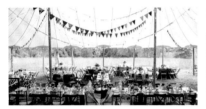

P.28 Belle Haven, Scottsville, VA Shindig Weddings and Events Jen Fariello Photography Maliha Creations Southern Blooms by Pat's Floral Designs If So Inklined

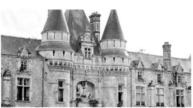

P.32 Château d'Esclimont, France Beth Helmstetter Events Steve Steinhardt Photography Sugarplum Cake Shop L'Atelier Frédéric Garrigues Ceci New York

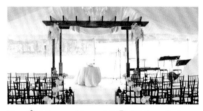

P.34 Private residence, MI NM Event Design Harrison Studio Oak Mill Bakery Bloom Christine Ford

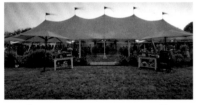

P.40 Private home, Bridgehampton, NY Duke + Van Deusen; Lexi Stolz Design Fred Marcus Studio Sag Harbor Florist Bella Figura; Lexi Stolz Design

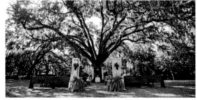

P.44 Eden Gardens State Park, Santa Rosa Beach, FL Serene Occasions Pure 7 Studios Bake My Day Fisher's Flowers Designs by Robyn Love

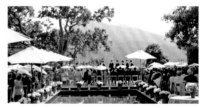

P.50 Private estate, Kentfield, CA Estera Events Simply Jessie Photography Branching Out Cakes Birch Sarah Drake Design

WATERSIDE

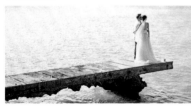

P.58 Round Hill Hotel & Villas, Montego Bay, Jamaica Racquel Bernard KT Merry Photography Round Hill Hotel & Villas Tai Flora Services Ltd. Bureau Blank

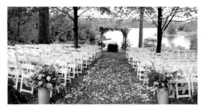

P.62 Basin Harbor Club, Vergennes, VT Orchard Cove Photography Basin Harbor Club Blomma Flicka Flowers Shindig Wedding and Events

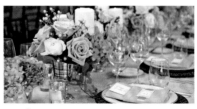

P.66 Private residence, Suttons Bay, MI A Day in May Events Jen Kroll Photography Amy Kate Designs A Day in May Events; Paper Moss

P.70 🏠 Amanusa, Bali, Indonesia 📋 Lisa Vorce Co. 📷 Aaron Delesie 🍰 Ixora Cakes ❀ Mindy Rice Floral and Event Design ✉ Papel Paper & Press

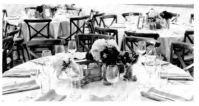

P.76 🏠 South End Rowing Club, San Francisco 📋 Dream a Little Dream Events 📷 Adi Nevo Photographs ❀ A Simple Ceremony ✉ Paper Source

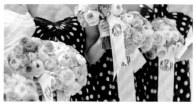

P.78 🏠 Private residence, Grand Haven, MI 📋 Hey Gorgeous Events 📷 Harrison Studio 🍰 Grand Finale Desserts and Pastries ❀ Hey Gorgeous Events ✉ Laura Hooper Calligraphy

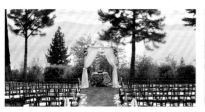

P.84 🏠 FitzHaven, Lake Tahoe, CA 📋 Merrily Wed 📷 The Youngrens 🍰 Katie Cakes ❀ Bellissima Floral Creations ✉ Paper Sky

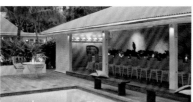

P.90 🏠 La Banane, St. Barts 📋 Lisa Vorce Co. 📷 Aaron Delesie 🍰 Bonito ❀ Mindy Rice Floral and Event Design ✉ Yellow Owl Workshop

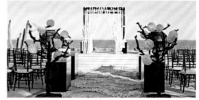

P.94 🏠 Las Ventanas al Paraiso, San José del Cabo, Mexico 📋 Signature Event Consulting & Design 📷 Jillian Mitchell Photography 🍰 Sweet Dreams Los Cabos ❀ Elena Damy Floral & Event Design ✉ Sarah Drake Design

GARDEN

P.106 🏠 Toscana Country Club, Indian Wells, CA 📋 Jesi Haack Design; The Love Riot 📷 onelove photography 🍰 Toscana Country Club ❀ JL Designs ✉ Pitbulls and Posies

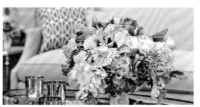

P.110 🏠 Meadowbrook Farm, Napa, CA 📋 Kathy Higgins Weddings 📷 Sylvie Gil Photography 🍰 Perfect Endings ❀ Kathleen Deery Design ✉ Francis–Orr

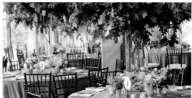

P.116 🏠 Barr Mansion & Artisan Ballroom, Austin, TX 📋 The Nouveau Romantics 📷 The Nichols 🍰 Barr Mansion & Artisan Ballroom ❀ The Noveau Romantics ✉ The Nouveau Romantics

P.120 🏠 San Ysidro Ranch, Santa Barbara, CA 📋 Lisa Vorce Co. 📷 Aaron Delesie 🍰 San Ysidro Ranch ❀ R. Jack Balthazar ✉ Mélangerie Inc.

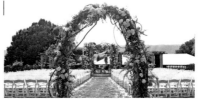

P.124 🏠 Wave Hill, Bronx, NY 📋 Nick Yarmac/ David Beahm Design 📷 Roey Yohai Photography 🍰 Sweet Sisters Cakes ❀ David Beahm Design ✉ Inviting Company

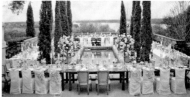

P.128 🏠 Bella Collina, Montverde, FL 📋 La Fleur Weddings & Events 📷 KT Merry Photography 🍰 Party Flavors Custom Cakes ❀ Botanica International Design & Décor Studio ✉ The Paper Shop

RANCH

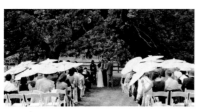

P.136 🏠 Mayowood Stone Barn, Rochester, MN 📋 Premier Planning Services 📷 Laura Ivanova Photography 🍰 Cakes by Jan ❀ Summer Harsh Botanical Artistry ✉ Watermark Stationery

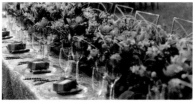

P.142 🏠 Fairchild Tropical Botanic Garden, Coral Gables, FL 📋 B.Belle Events 📷 Justin & Mary 🍰 Elegant Temptations ❀ A Thierry's Catering and Event Design ✉ Bella Figura

P.156 🏠 Devil's Thumb Ranch, Tabernash, CO 📋 A Vintage Affair Events & Rentals; Love This Day Events 📷 Laura Murray Photography 🍰 Intricate Icings Cake Design ❀ Cori Cook Floral Design ✉ Lucky Luxe Couture Correspondence; Pink Ink Paper

RANCH

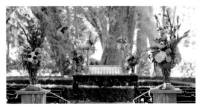

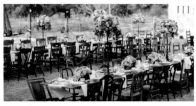

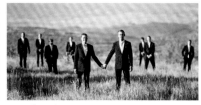

P.160 🏠 Alisal Guest Ranch & Resort, Solvang, CA
📋 Special Occasions 📷 Erin Hearts Court
🎂 Alisal Guest Ranch & Resort ✳ Renae's Bouquet
✉ Tiny Pine Press

P.166 🏠 Shepherd Creek Ranch, Kendalia, TX
📋 Archetype Studio Inc. 📷 Archetype Studio Inc.
🎂 Sentelli's Specialty Cakes ✳ Tamara Menges
Designs ✉ Simply Designed Invites

P.170 🏠 Main & Sky, Park City, UT 📋 Soirée
Productions 📷 (Once Like a Spark) Photography
🎂 Snow Park Bakery ✳ Sean Oviatt Designs
✉ Hello!Lucky

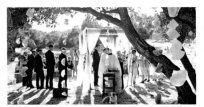

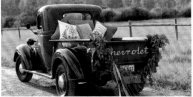

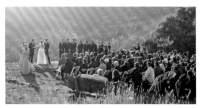

P.172 🏠 Private residence, Santa Ynez Valley, CA
📋 Special Occasions 📷 Braedon Photography
🎂 Enjoy Cupcakes ✳ Blushing Hills Garden Roses;
Renae's Bouquet ✉ Eagle Egg Creative

P.178 🏠 Snake River Ranch, Jackson Hole, WY
📋 Easton Events 📷 Carrie Patterson Photography
🎂 Jackson Cake Company ✳ Lily and Co. ✉ Rock
Paper Scissors

P.182 🏠 Murray Hill, Leesburg, VA 📋 Events in the
City 📷 Rebekah J. Murray Photography ✳ Sweet
Root Village ✉ Intrigue Design Studio, Etsy.com;
JuneBride Lettering, Etsy.com

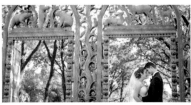

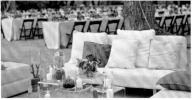

P.188 🏠 The Ritz-Carlton, Lake Tahoe, Truckee, CA
📋 Merrily Wed 📷 The Youngrens ✳ Bellissima
Floral Creations ✉ Crane & Co.

P.192 🏠 Tanque Verde Ranch, Tucson, AZ 📋 Laura
Wright Events 📷 Mel Barlow & Co. 🎂 Ana Parzych
Cakes ✳ Atelier de LaFleur ✉ Ceci New York

P.196 🏠 El Capitan Canyon, Santa Barbara, CA
📋 Sitting in a Tree Events 📷 Birds of a Feather
✳ Sitting in a Tree Events ✉ Kasleberry Design

CITYSCAPE

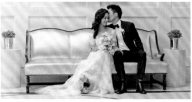

P.204 🏠 Bronx Zoo, Bronx, NY 📷 Brian Hatton
Photography 🎂 Momofuku Milk Bar; Sweet Element
Cakes ✳ Blade Floral and Event Designs ✉ Belle &
Union; Allison R. Banks Designs

P.206 🏠 Café Pinot, Los Angeles 📋 Cassandra &
Company Weddings 📷 Luminaire Images
🎂 Cake Monkey Bakery ✳ Dandelion Ranch
✉ Brenda Himmel Stationery

P.212 🏠 Crocker Art Museum, Sacramento, CA
📋 Kate Whelan Events 📷 Scott Andrew Studio
🎂 Sweet Cakes By Rebecca ✳ The Big Bang
✉ Papyrus

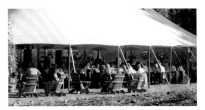

P.216 🏠 Torre del Reloj, Cartagena, Colombia
📋 Mi Boda en Cartagena 📷 Braedon Photography
✳ Florarte

P.220 🏠 The London West Hollywood, Los Angeles
📋 My Bride Story Weddings & Events 📷 onelove
photography 🎂 The Butter End Cakery ✳ Fleuretica
✉ DIY

P.222 🏠 The Rattlesnake Club, Detroit 📋 Dooby
Design Group 📷 Turquoise & Palm 🎂 Iversen's
Bakery ✳ Passionflower ✉ Dooby Design Group;
Molly Jacques Illustration

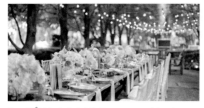

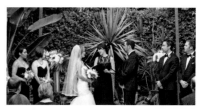

P.226 Marie Gabrielle Restaurant and Gardens, Dallas; n.barrett Photography; Layered Bake Shop; Bows & Arrows; Southern Fried Paper

VINEYARD

P.230 Montage Beverly Hills, Beverly Hills, CA; Brooke Keegan Wedding & Events; Amy & Stuart Photography; Montage Beverly Hills; Mindy Rice Floral and Event Design

P.234 Marvimon, Los Angeles; Sweet Emilia Jane; Birds of a Feather; The Little Branch

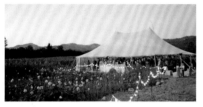

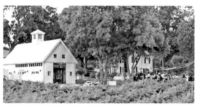

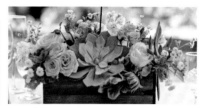

P.242 Private residence, Glen Ellen, CA; Kristi Amoroso Special Events; Meg Smith Photography; Sweet on Cake; Kathleen Deery Design; DIY

P.246 Breaux Vineyards, Purcellville, VA; My Simple Details; Vicki Grafton Photography; Cake Panache; Petals & Hedges; The Dandelion Patch

P.252 Holman Ranch, Carmel Valley, CA; Engaged & Inspired Events; Delbarr Moradi Photography; Freedom Bakery & Confections; Mid-Valley Florist; Paper Source

P.256 The Villa at Sunstone Vineyards & Winery, Santa Ynez, CA; Jesi Haack Design; The Love Riot; Annie McElwain Photography; The Solvang Bakery; Honey & Poppies; Lupa & Pepi

P.262 HammerSky Vineyards, Paso Robles, CA; Allure Event Designs; Mike Larson Photography; The Cakery; Allure Event Designs; Umbrella Tree Design

P.268 Malibu Rocky Oaks Estate Vineyards, Malibu, CA; Couture Events; Luxury Estate Weddings & Events; Birds of a Feather; Sweet and Saucy Shop; Stephanie Grace Designs

ADDITIONAL CREDITS

PAGES WITH MULTIPLE IMAGES ARE PROVIDED FROM LEFT, OR CLOCKWISE FROM TOP LEFT

FRONT MATTER
PP.2–3: Sarah Kathleen Photography; **P.5:** Steve Steinhardt Photography, Beth Helmstetter Events, Saddlerock Ranch, Malibu, CA; **P.6:** KT Merry Photography, Aaron Delesie; **P.7:** Carrie Patterson Photography, Laura Murray Photography, Scott Andrew Studio, Vicki Grafton Photography; **P.8:** Marni Rothschild Pictures, Cherokee Plantation, Yemassee, SC, WED, Sara York Grimshaw Designs; **P.11:** Melanie Duerkopp Photography, Kohl Mansion, Burlingame, CA, The Stylish Soiree, Soulflower Design Studio; **P.12:** Megan Sorel Photography, private residence, Montecito, CA, Tara Bassi Party Design, Mindy Rice Floral and Event Design

ESTATE
PP.14–15: Woodland Fields Photography, Shannon Reeves Events, Missy Gunnels Flowers; **P.26:** Samuel Lippke Studios, Details Details, White Lilac Inc.; **P.27:** Buffy Dekmar, Glenn Albright, Eilas Photography, Kelly Spalding Designs, Robin Proctor Photography, The Aspen Branch, Hunter Ryan Photo, Signature Florals; **P.38:** Haley Sheffield, Sift! Dessert Boutique; **P.39:** Stephanie Fay Photography, Cloud Nine Catering, Chelsea Nicole Photography, Peridot Sweets, Annemari Ruthven Photography, Susan Verwey, Casey Hendrickson Photography, Sky's the Limit! Custom Cakes & More; **P.52:** Erkki & Hanna/ Shutterstock; **P.53:** Jonathan Ross, Diann Valentine; **P.54:** Corbin Gurkin Photography, Hyer Images; **P.55:** Braedon Photography, Jeff Sampson Photography, Brklyn View Photography

WATERSIDE
PP.56–57: Joie de Vivre Photography, Emily Smiley Fine Weddings & Soirees; **P.74:** VUE Photography, Events by Nouveau; **P.75:** Samuel Lippke Studios, Isari Flower Studio, Alchemy Fine Events, Brklyn View Photography, Kim Jon Designs, Meredith Perdue, Sayles Livingston Flowers, Pure 7 Studios, Celestine's Special Occasions; **P.82:** Rebecca Arthurs Photography, A Cake Life, Marni Rothschild Pictures, Wedding Cakes by Jim Smeal; **P.83:** Jocelyn Filley Photography, Val Cakes, Jose Villa Photography, The Scootabaker, ShutterChic Photography, Jana's Creative Cakes, Green Tree Photography; **P.98:** Brooke Mayo Photographers, The Mark Twain, Duck, NC, Platinum Party Planning, Renee Landry Events; **P.99:** Marlon Richardson Photography, Villa Woodbine, Miami, Miranda Hattie Events, Petal Productions;

P.100: KT Merry Photography, Vizcaya Museum & Gardens, Miami, JCG Events, Ines Naftali Floral & Event Design; **P.101:** Paul Morse Photography, private residence, Charlottesville, VA, Easton Events, Pat's Floral Designs; **P.102:** Charlotte Jenks Lewis Photography, Mike Larson Photography; **P.103:** Heather Waraksa, Beaux Arts Photographie, Studio EMP

GARDEN

PP.104–105: Yvette Roman Photography, Mindy Weiss Party Consultants, Mark's Garden; **P.114:** Cyn Kain Photography, Holly Heider Chapple Flowers, Amber Housley, Q Weddings, Merveille Floral & Design Atelier; **P.115:** Charlotte Jenks Lewis Photography, Blush Floral Design, Samuel Lippke Studios, Details Details, Bloom Box, Melanie Duerkopp Photography, The Stylish Soiree, Soulflower Design Studio, Yvette Roman Photography, Mindy Weiss Party Consultants, Mark's Garden; **P.134:** Millie Holloman Photography, One Belle Bakery; **P.135:** Judy Pak Photography, Ana Parzych Cakes, True Bliss Photography, Beverly's Best Bakery, Rebecca Arthurs Photography, Four Seasons Resort Lanai, The Lodge at Koele, The Nichols, Barr Mansion & Artisan Ballroom; **P.140:** Hugh Forte Photography, In the Now Weddings & Events, Found Vintage Rentals, Marisa Holmes Photographer, Brooke Keegan Weddings & Events, AKJOHNSTON Group LLC; **P. 141:** Docuvitae, Lyndsey Hamilton Events, Jose Villa Photography, Kathleen Deery Design, Anne Marie Photography, Viridian Design Studio, Gertrude & Mabel Photography, Amy Nichols Special Events, Classic Party Rentals, Blueprint Studios; **P.147:** Michael Segal Photography, Celebrations of Joy, Arrangements Floral & Party Design, GraSar Productions, Signature Party Rentals; **P.148:** KT Merry Photography, Janet Dunnington, Clare Frances Events; **P.149:** Millie Holloman Photography, Ivy Robinson Events, Party Reflections Inc.; **PP.150–151:** Jen Kroll Photography, In Any Event by Jodi Bos, Modern Day Floral, Special Events Rental; **P.152:** Anita Calero Photography, Arielle Elise Photography; **P.153:** Choco Studio, Hunter Photographic, Maria Mack Photography

RANCH

PP.154–155: Genevieve Leiper Photography, Holly Heider Chapple Flowers; **P.164:** Milou + Olin Photography, A Bud & Beyond; **P.165:** Lauren Fair Photography, I Do Flowers, Woodland Fields Photography, Shannon Reeves Events, Missy Gunnels Flowers, Gertrude & Mabel Photography, Stacy McCain Event Planning, The Nichols, The Simplifiers, The Nouveau Romantics; **P.176:** Red Ribbon Studio; **P.177:** Lavender & Twine, Jana's Creative Cakes, Victoria Photography, For Goodness Cakes, Clove & Kin, Torrance Bakery, Sergio Mottola Photography, Perfect Endings; **P.186:** Kristen Beinke Photography, Alchemy Fine Events; **P.187:** Liz Banfield Photography, Bliss Weddings & Events, Clove & Kin, L'Auberge Del Mar, Jeff Tisman Photography, Oh So Fabulous!, Brian LaBrada Photography; **P.198:** KT Merry Photography, Pierre's Restaurant, Islamorada, FL, Floral Fantasy Weddings, Danny Dong Photography, [seven-degrees], Laguna Beach, CA; **P.199:** Hetler Photography, Red Heels Events, Eastern Floral, Robin Proctor Photography, The Little Nell, Aspen, CO, Lisa Vorce Co.; **P.200:** Heather Roth Fine Art Photography, Laura Murray Photography; **P.201:** Millie Holloman Photography, Carla Ten Eyck Photography, Orchard Cove Photography, Jason+Gina Wedding Photographers

CITYSCAPE

PP.202–203: Gruber Photographers; **P.210:** Amy Carroll Photography, Hey Gorgeous Events; **P.211:** Rustic White Photography, Every Last Detail, FH Weddings & Events, n.barrett Photography, Bows & Arrows, Angie Silvy Photography, The Stylish Soiree, Soulflower Design Studio, Riverbend Studio, Big City Bride, Kehoe Designs; **P.218:** Jen Huang Photography, Ron Ben-Israel, White-Klump Photography, Sarah's Cake Shop; **P.219:** Inga Finch Photography, For Goodness Cakes, Clean Plate Pictures, The Pastry Garden, The Youngrens, Sweet Cakes by Rebecca, Tess Pace Photography, Intricate Icings Cake Design; **P.232:** Jose Villa Photography,

Moon Canyon Design Company, Forêt Design Studio, Justin DeMutiis Photography, Burkle Events; **P.233:** Virgil Bunao, J'Adore Love Photography, The Checker Guy, Erika Gerdemark Photography, Bloomz Fine Flowers, Odalys Mendez Photography, Chancey Charm, Rosegolden Flowers; **PP.236–237:** Vero Suh Photography, Rosewood Sand Hill, Menlo Park, CA; insets: Jenny DeMarco Photography, Meg Perotti, Cooper Carras Photography, Elle Jae Wedding Photography; **P.238:** Jen Huang Photography, Shea Christine; **P.239:** Heather Roth Fine Art Photography, Donna Von Bruening Photographer, averyhouse

VINEYARD

PP.240–241: Lori Paladino Photography, Gloria Wong Design, Cherries Flowers; **P.250:** Melissa Gidney Photography, Legacy Events and Media, Edgy Petals, Troy Grover Photographers, Project Watermark, Floral Occasions; **P.251:** Heather Payne Photography, Downtown Floral and Event Design, Sweet Tea Photography, Silverstems, Buffy Dekmar, Edge Design Group, Buffy Dekmar, Glenn Albright; **P.260:** Next Exit Photography, The Hidden Garden Floral Design; **P.261:** Heather Roth Fine Art Photography, Katie Saeger Events, One Canoe Two Letterpress, Allison Maginn Photography, A Good Affair, Chelsea Nicole Photography, Scheme Events, James Christianson Photography, Hatch Flowers; **P.266:** Tonya Peterson Photography, Hey Gorgeous Events, A Piece O' Cake; **P.267:** iFloyd Photography, Paradise Pastries, Julie Roberts Photography, Magpies Bakery, Betsy Blue Photography, Cakes to Celebrate!, Jess + Nate Studios, Bella e Dolce; **PP.272–273:** KT Merry Photography, Blossom and Branch; **P.274:** Birds of a Feather, Jasmine Star; **P.275:** Jasmine Star, Meg Perotti, Amy and Stuart Photography, Mike Larson

INSIDER PLANNING ADVICE

P.276: Allison Davis Photography; **P.277:** Jonathan Young Weddings; **P.278:** 822 Weddings; **P.279:** Matt Lien

ACKNOWLEDGMENTS

A LARGE TEAM OF TALENTED individuals helped to create this beautiful book. I want to thank The Knot staff: Rebecca Dolgin, Maria Bouselli, Ashley Castro, Meghan Corrigan, Rebecca Crumley, Lauren Daniels, Irina Grechko, Kellee Kratzer, Meghan Overdeep, Elizabeth Roehrig, Carly Steier, and Alice Stevens for scouring the world for the prettiest outdoor weddings, digging up the stories behind them, and putting them together in this gorgeous package.

In addition to the in-house team, I also want to thank Renata De Oliveira, Lauren Greene, and Jennifer Tzeses. Thanks also to the wedding whizzes who let us pick their brains: planners Lynn Easton Andrews, Jesi Haack, Lyndsey Hamilton, and Jill La Fleur; fashion designers Reem Acra, Kelly Faetanini, and Hayley Paige; florists Sarah Brysk Cohen, Elissa Held, and Adam Manjuck; beauty experts Nina Dimachki, Achelle Dunaway, Mark Garrison, Laura Geller, Gregory Patterson, Paul Perez, Joanna Schlip, Carol Shaw, and Jenny Smith.

We'd also like to show our appreciation to all the photographers who shared their work with us—without them, this book would not exist.

A special thanks to our team at Potter Style, including our editor, Aliza Fogelson; our agent, Chris Tomasino; and our patient families. And finally, thanks to all of our Knotties, who keep planning incredible outdoor weddings and who inspired us to create this book.